Fresh Ideas

in Brochure

Design

T E R R I A L E K Z A N D E R

NORTH LIGHT BOOKS

CINCINNATI, OHIO

Fresh Ideas in Brochure Design. Copyright ©1997 by North Light Books.

Printed and bound in China. All rights reserved. No part of this book may be reproduced in any form or by any electronic or mechanical means including information storage and retrieval systems without permission in writing from the publisher, except by a reviewer, who may quote brief passages in a review. Published by North Light Books, an imprint of F&W Publications, Inc., 1507 Dana Avenue, Cincinnati, Ohio 45207. (800) 289-0963. First edition.

This hardcover edition of *Fresh Ideas in Brochure Design* features a "self-jacket" that eliminates the need for a separate dust jacket. It provides sturdy protection for your book while it saves paper, trees and energy.

Other fine North Light Books are available from your local bookstore, art supply store or direct from the publisher.

01 00 99 98 97 5 4 3 2 1

Library of Congress Cataloging-in-Publication Data

Alekzander, Terri.
 Fresh ideas in brochure design / Terri Alekzander.
 p. cm.
 Includes index.
 ISBN 0-89134-755-0 (alk. paper)
 1. Pamphlets—Design. 2. Advertising layout and typography.
 3. Advertising fliers. I. Title.
 Z246.A5 1997
 686.2'252—dc21 97-13998
 CIP

Edited by Kate York
Production Edited by Michelle Kramer
Cover and interior designed by Sandy Kent
The copyright notices and photography credits on page 158 constitute an extension of this copyright page.

North Light Books are available for sales promotions, premiums and fund-raising use. Special editions or book excerpts can also be created to specification. For details, contact the Special Sales Manager, F&W Publications, 1507 Dana Avenue, Cincinnati, Ohio 45207.

dedication

To my mom and dad, Nancy Lee and James Coleman.

acknowledgments

Thanks to the many designers who produced the fine booklets and brochures presented throughout the pages of this book, as well as those who sent their work for consideration. Their talent, dedication and creativity is astounding. Thank you to Kate York for editing and seeing this project through publication; to Sandy Kent, the designer whose aesthetic touch makes these pages a pleasure to turn; and to Lynn Haller for coordinating the judging of the entries, managing all the behind-the-scenes steps and supporting me through the writing. Thank you.

table of contents

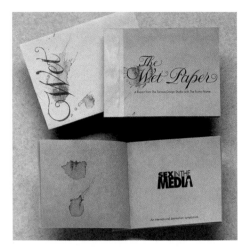

PART ONE

Low Budget Brochures

Don't let a restricted budget affect the quality of your design. In this section, designers traded design work for paper or printing, and used inexpensive special effects to make their designs look like they had a limitless budget.

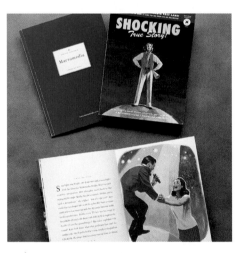

PART TWO

Annual Reports

More than a financial track record for a company, the annual report is frequently the slickest promotion available to augment a company's image of itself and its shareholders. These designs show that an annual report doesn't have to be boring.

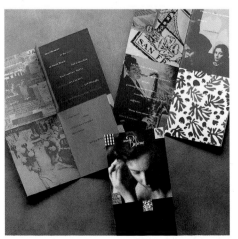

PART THREE

Special Production Effects

Spot varnishing, opaque undercoating, fluorescent inks, die cuts and computer photo refinishing are just a few of the special effects that add pizzazz to the design of these brochures.

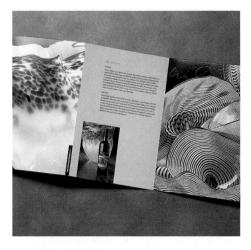

PART FOUR

The Classic Look

Using a seemingly typical arrangement, these designers reach into the archives of success and produce brochures that are concise, straightforward, understandable, classic and long-lasting.

page 86-105

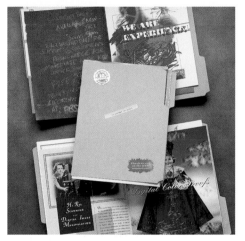

PART FIVE

Ecological Inspirations

Sticks, sisal bindings and uncoated, recycled papers in brochures are evidence of the emergence of environmental awareness and acceptance by the consumer. Designers in this section consider environmental work processes and natural products that don't try to hide the "once-used" look and feel.

page 106-121

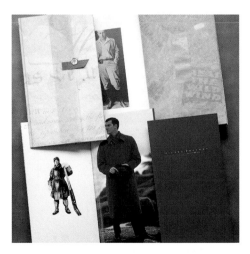

PART SIX

Packaging & Presentation

Want your design to get noticed? Interested in putting the whole piece together from envelope to brochure to business card? Here you'll see the best in packaging and presentation—from folder kits to cardboard suitcases!

page 122-153

In this book, we invite you to enjoy the showcase of talent and interpretation. The designs on the following pages are renderings of concept and ideas into a brochure. Some use the terminology of catalog, booklet or pamphlet; but in the most general sense, they fall into the category of brochure—the most versatile printed media available for promotion.

Why Choose a Brochure?

Why choose a brochure over a flyer, postcard or magazine ad? Or, in some cases, why choose a brochure in addition to a flyer, postcard or magazine ad? Businesses that opt for a brochure do so because it is the most pliable option they have for marketing. A brochure has no boundaries for length or binding styles and can be multifunctional as an ad, product guide or "gift" to a client. Throughout this book you will see a variety of interpretations of brochures that range from perfect-bound books to self-cover trifolds to an LP album-size booklet to a miniature 2" (6.4cm) foldout to a high-quality calendar. All formalized definitions aside, a brochure can be anything the designer and client envision as an instrument to educate clientele on a product or idea.

What Makes a Successful Brochure?

A brochure is a protracted advertisement, an opportunity for a company or individual to show and explain their product. To create a successful interpretation, the designer must become an advocate of the product. He must understand the client's purpose and goal. He must know the client and the client's client.

A brochure can be the definitive representation of a concept, product or service. There will be times when the brochure is the first (or only) piece of information a consumer receives, and therefore, the sole tool used for making purchase decisions. Thus, the designer and client must always understand that a brochure will sometimes stand alone. It must put its best foot forward.

Brochures typically last longer and can be more costly to produce than an advertisement or flyer; therefore, a clear, cooperative relationship must exist between the designer and client. All of the designers represented in this book were asked for their perception of the concept behind their brochures. Why did the brochure's concept work for their client? Which production techniques were integral to the interpretation? Why? And finally, how was this interpretation achieved? Some used special production techniques while others opted for a simplistic, classic approach.

Flexible Length

Because of a brochure's flexible length, it can communicate thoroughly and visually. It is not limited to a thirty second commercial or a half-page magazine ad. The physical brochure has both a literal and perceived weight. A heavy paper stock with brightly colored type or eye-catching graphics draws the consumer in to read, learn and form an opinion. The brochure may be an item kept by the consumer as a reference tool like the calendar for Overlake Press on page 140. This calendar is not just "eye-candy"; each month in the calendar exemplifies a technique in printing with an actual sample and a written description.

Although the option for length is available, a brochure doesn't have to be long—it can be just as convincing by its brevity. Just take a

look at the minibrochure for Ideal Graphics/ Color Now by Hal Apple Design on page 55. They call it the "World's Smallest Brochure" and at 1¼" x 2⅝" (3.2cm x 6.7cm), it's tough to argue.

Furthermore, the brochure has the extravagance of long-term existence. Design: M/W's brochure for Takashimaya of New York is an attractive thirty-two-page, perfect-bound book (see page 131). Because it appears to be an actual minibook, it conveys a sense of longevity to the consumer and is less likely to be thrown away. It just seems ludicrous to toss a book!

Variety

The designer of a brochure enjoys variety. With concept in hand and budget in mind, the world of papers, inks, binding styles and artwork unfold. Should the brochure be a newspaper foldout like the 12" x 18" (30.5cm x 45.7cm) Cabrillo Music Festival Brochure by Charney Design + Hamblin Design on page 73, or the fancy fanfold on translucent paper that plus design inc. used for the Margarett Sargent publication on page 42? Is the design for an annual report? Go the extreme in formal versus informal like Cahan & Associates' perfect-bound, hardcover children's book interpretation for Adaptec, Incorporated on pages 26 and 27. Consider the implied meaning behind an informal, spiral binding tucked inside a die-cut textured wrap for S&S Graphics, Inc. designed by Grafik Communications, Ltd. on page 141. By including a physical example of the special effects that S&S Graphics could perform on their presses, they conveyed more by example than text. Visual success is a designer's dream come true.

For self-promotion, the brochure provides a forum whereby the designer can create a three-dimensional representation of his or her work. Wet Paper Bag's self-promo brochure on page 14 is a cost-efficient piece that allows a sturdy design studio to poke a little humor at its name. They used a stock that represents brown paper bags and graphics throughout to make it look as if water and ink had been spilled on the pages. This is a promotional piece that forms an impression. On page 11, The Alcorn/Fascione Studio & Gallery shows a tasteful 11" x 8½" (27.9cm x 21.6cm) brochure of linocuts. The production behind this brochure is simple, yet the variety of images shows the studio to be an adaptable source of art and design.

Multifunctional

In addition to being an informational piece that a sales department sends to potential customers or leaves at the counter of a department store, some of the brochures included in this text serve a dual purpose. They are gifts or reference materials that a customer can keep, such as the trip diary by Segura, Inc. for XXX Snowboards on page 137 or the Sunflower Book (complete with sunflower seeds and instructions for growing) by Trace Rea & Associates, Inc. for Gilbert Paper on page 128. Kudos to the designer to have created such a masterful and universal component for an industry!

A successful brochure shows the designer's ability to translate concept to form—a tangible, informative piece that the client can put into the hands of a potential customer. Examine the remarkable brochures within these pages. Marvel at the variety of sizes and shapes, the complex versus the simple. We hope they teach and inspire you. Enjoy.

Part One

Low Budget

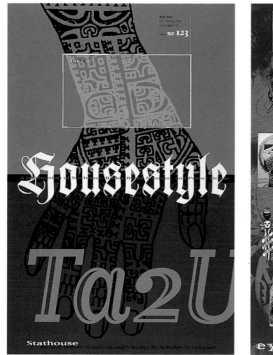

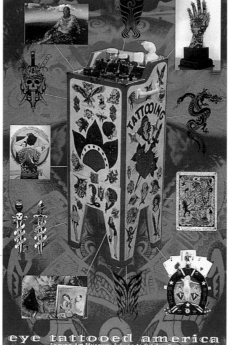

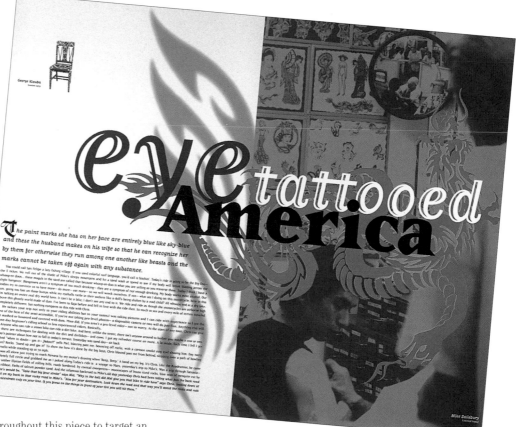

Art Director/Studio Mike Salisbury/Mike Salisbury Communications Inc.

Designers/Studio Sander Van Baalen, Sander Egging/Mike Salisbury Communications Inc.

Client/Service Stathouse, Los Angeles, CA/Service bureau

Paper Newsprint

Type "Housestyle" (cover), Matrix/Matrix Inline Script (text/titles)

Software Adobe PageMaker

Printing Offset

Color 4, process

Binding Tabloid fold

Job Length 1 year

Initial Print Run 10,000

Cost Design, production and printing costs were done for trade and credit

Concept An older, established service bureau in Los Angeles, Stathouse wanted to captivate a new customer base with its message of full electronic capabilities. The concept of tattooing America with artwork and logos was used throughout this piece to target an audience of younger art directors and designers who hadn't been attracted to Stathouse with previous promotions.

2Rebels (Fonts) Product Catalog

Art Directors/Studio Denis Dulude, Fabrizio Gilardino, Anna Morelli/2Rebels

Designers/Studio Denis Dulude, Fabrizio Gilardino, Anna Morelli/2Rebels

Photographer Pol Baril (cover & back)

Client/Service 2Rebels, Montreal/Fonts

Paper French Dur-O-Tone Butcher Off-White (cover), French Speckletone (text)

Type 2Rebels collection

Dimensions 7" x 5" (17.8cm x 12.7cm)

Pages 24 plus cover

Software QuarkXPress, Adobe Photoshop, Adobe Illustrator

Printing Offset

Color 2, match

Binding Saddle stitched

Job Length 15 hours

Initial Print Run 1,500

Cost $2,800

Concept 2Rebels' typography relies on the philosophy of letter as image. They generated new styles and in the front of this brochure, they called their approach "subversive" by creating fonts "that stray from the beaten track, that talk to the world and deliver a message." This brochure provided 2Rebels a forum for displaying many of their contemporary fonts and typefaces.

Cost-cutting technique Pages were mounted in QuarkXPress ready to go to plates.

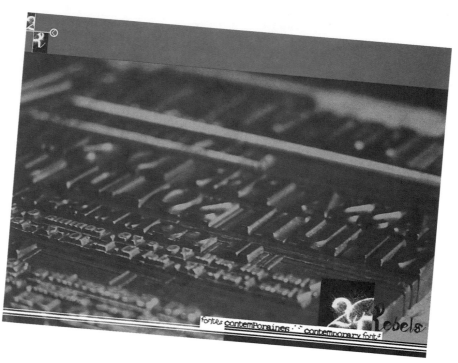

Art Director/Studio Stephen Alcorn/The Alcorn/Fascione Studio & Gallery

Designer/Studio Stephen Alcorn/The Alcorn/Fascione Studio & Gallery

Illustrator Stephen Alcorn

Paper Mohawk Superfine Cover Regular Finish Ivory 65# (cover), Mohawk Superfine Cover Regular Finish White 65# (text), Ticonderoga Text Gray 70# (endpapers)

Type Hand cut (Stephen Alcorn) (headings), Bodoni Book (text)

Dimensions 11" x 8½" (21.6cm x 27.9cm)

Pages 16 plus cover and endpaper

Printing Offset

Color 8, match

Binding Saddle stitched

Job Length 16 hours

Initial Print Run 4,000

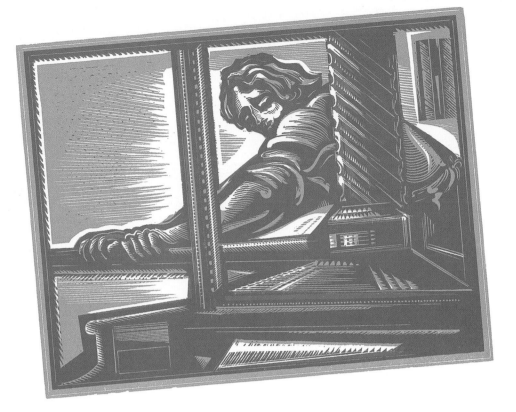

Concept The brochure featured the wide range of techniques and styles this designer developed within the constraints of black and white and two- and three-color relief-block print. The sequence of artwork showed a variety of eclectic themes resulting in a stylistically diverse representation of linocuts. To ensure that the colors were in keeping with the original works, the designer mixed each color prior to going on press.

Cost-cutting techniques Services were donated (printing and paper) in exchange for a credit line. To keep cost at a minimum, the designer positioned each piece so that the inside sixteen pages used only one sheet of Superfine paper.

K2 Snowboard Zine

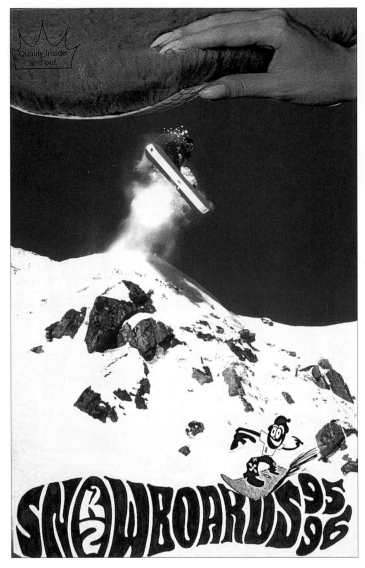

Art Director/Studio Luke, Hayley & Brent/K2

Designers/Illustrators/Studio Michael Strassburger, Robynne Raye, Vittorio Costarella, George Estrada/Modern Dog

Photographers Eric Berger, Jeff Curtes, Aarron Sedway, Jim Clarke, Reuben Sanchez

Client/Service K2 Snowboards, Vashon Island, WA/Apparel and accessories

Paper Simpson Evergreen Matte 60#

Type Clarendon, Avant Garde, Bauhaus, Akzidenz, Courier, Franklin, Freehand, Balloon, Times, Hand-lettering

Dimensions 5⅜" x 8⅜" (13.6cm x 21.3cm)

Pages 30

Software QuarkXPress, Adobe Photoshop, Adobe Illustrator

Printing Offset

Color 4, process

Binding Saddle stitched

Job Length 3 days; 4 designers

Initial Print Run 80,000

Concept The designers managed to "stuff a ton of information into a tiny space." The Zine is a style based on underground and basement low-budget art with a "Do-It-Yourself" attitude. This was very appropriate for the intended audience, who consider themselves outside of the mainstream.

Cost-cutting techniques All photography was scanned in house with no fancy special effects. A simple cut-and-paste technique was used.

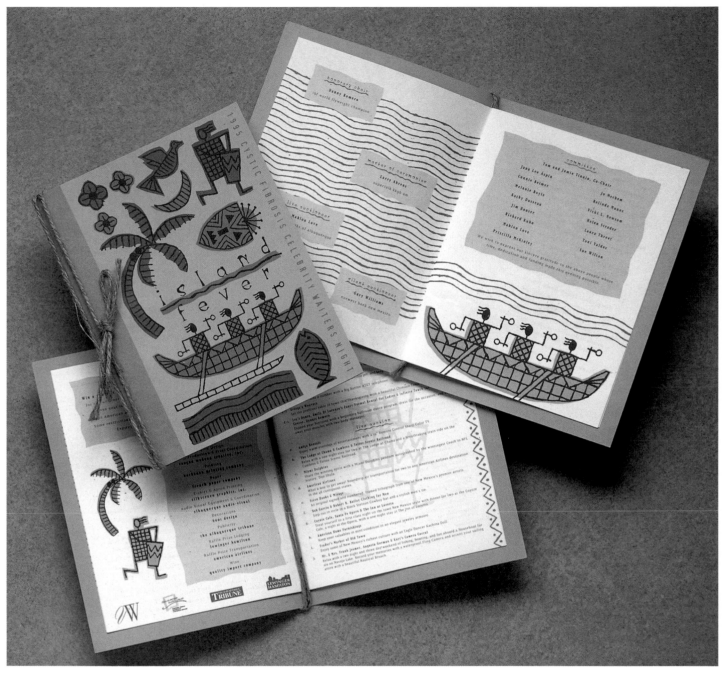

Art Director/Studio Rick Vaughn/Vaughn Wedeen Creative

Designer/Studio Rick Vaughn/Vaughn Wedeen Creative

Illustrator Rick Vaughn

Production Artist Heather Scanton

Client/Service New Mexico Cystic Fibrosis Foundation, Albuquerque, NM/Fund-raiser to help find cure for CF

Paper French Speckletone, French Dur-O-Tone; papers were mixed and matched in all pieces

Type Freedom Normal, Matrix Book, Matrix Extra Bold, Anto Confidential; typefaces were mixed throughout

Dimensions 7½" x 10" (19cm x 25.4cm)

Pages 12 plus cover and flysheet

Software QuarkXPress, Adobe Photoshop, Macromedia FreeHand

Printing Offset

Color 3, match opaque inks

Job Length 100 hours

Initial Print Run 700

Cost This was a pro bono job. Printing and paper were also donated.

Concept The theme for this year's event was "Island Fever" and the graphics reflected a tropical island flavor (e.g., palm trees, flowers, birds, beaches, nautical items). Hand-tied jute was added to give a tropical, native look.

Special production techniques To ensure the printed pieces had strong colors on the colored stock, the designer used opaque inks. Because they were unable to print hits of white as undercolor, draw-downs were done before the actual printing began.

Cost-cutting technique Only three colors of ink were used. For a colorful feel, the designer mixed inks and textures of paper.

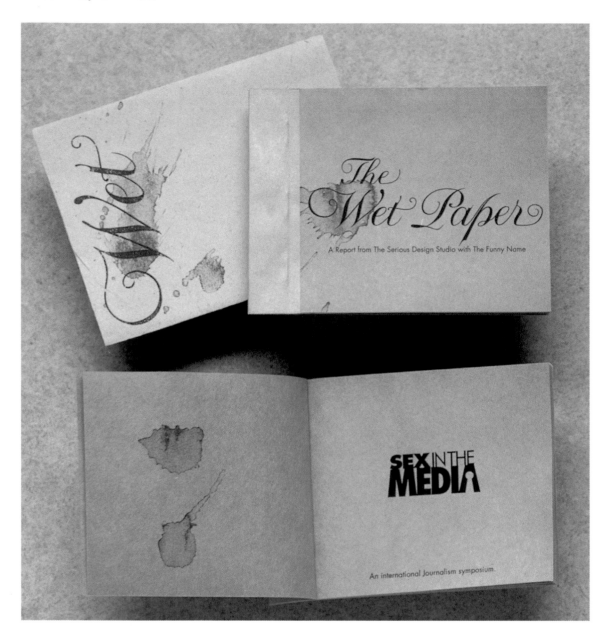

Art Director/Studio Lewis Glaser/Wet Paper Bag Graphic Design

Designer/Studio Lewis Glaser/Wet Paper Bag Graphic Design

Calligrapher Lewis Glaser

Client/Service Wet Paper Bag Graphic Design, Fort Worth, TX/Graphic design, art direction, copywriting

Paper French Speckletone Kraft (envelope), Ironkraft Wrap (book)

Type Calligraphy (cover), hand-lettering (page 1), Adobe Futura (interior)

Dimensions 5½" x 4¼" (14cm x 10.8cm)

Pages 24, self cover

Software Adobe Illustrator

Printing Laser, colored-toner photocopy

Color 2, process

Binding Side stitched and taped

Job Length 3 hours

Initial Print Run 100

Cost $310

Concept This self-promotion brochure used humor to convey the studio's otherwise serious image. Everything about the piece—from the paper stock to the type to the language—translated into a friendly invitation to prospective clients to use the studio's services. For mail distribution, a matching envelope was used.

Cost-cutting techniques Laser printing combined with colored-toner photocopying was very economical for short runs. The toner created a continuous-toned image, thereby avoiding halftone dots. Binding tape was hand-applied by the studio employees.

Art Director/Studio Lin Ver Meulen/Square One Design

Designer/Studio Laura Powell/Square One Design

Photographer Andy Terzes

Client/Service La Fontsee Galleries/The Underground Studio, Grand Rapids, MI/Custom framing, art gallery

Paper 100# Centura Cover Matte Finish

Type Bodoni, Trade Gothic

Dimensions 4¾" x 17" (12cm x 43.2cm); unfolds to 17" x 24" (43.2cm x 61cm)

Software QuarkXPress

Printing Waterless press

Color 4, process; 2, spot color; varnish

Binding Accordion fold

Job Length 50 hours

Cost $3,000 (printing was in trade)

Concept The La Fontsee Galleries and The Underground Studio are both owned and operated by Scott and Linda La Fontsee. Although each gallery has a specific service, together they embody the art purchasing experience. This piece presented both galleries in one place to strengthen the concept of their combined capabilities. The "Form" side represented original pieces of art, and the "Function" side emphasized framing and accessorizing the art. The unusual size of the brochure enhanced the artwork shown on the oversized pages and created visual awareness in the mail.

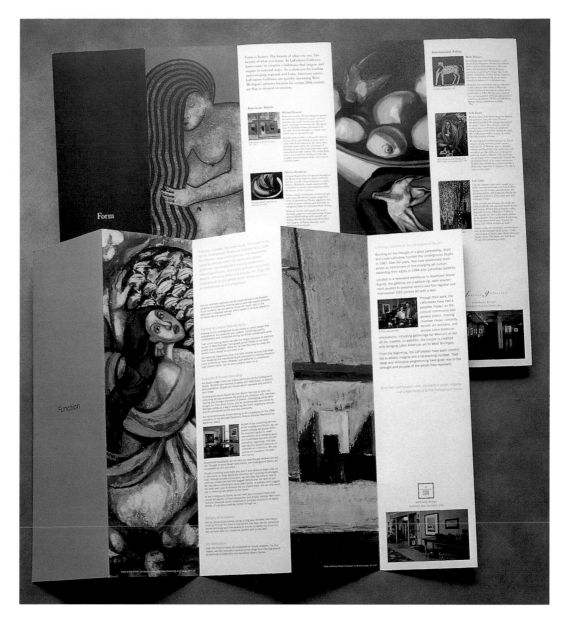

Cost-cutting techniques The printer set the size of the sheet for maximum efficiency on their press. The paper was also an economical solution since it was some of the printer's floor stock.

1995 CHAAMP Call for Entries—"Making Art Work"

Art Director/Studio Brian Priest/Lierman & Associates, Inc.

Designer/Studio Brian Priest/Lierman & Associates, Inc.

Client/Service Advertising Club of Champaign-Urbana, Champaign, IL/Professional organization

Paper 100# Lustro Gloss Cover

Type Spire, American Typewriter, Zeal, Carta, Weiss, Alison, Chasline, Helvetica, Univers, Today

Dimensions 4⅝" x 4⅝" (11.7cm x 11.7cm); unfolds to 37" x 4⅝" (94cm x 11.7cm)

Pages 16 panels

Software QuarkXPress, Adobe Photoshop, Adobe Illustrator

Printing Offset

Color 4, process

Binding Accordion fold

Initial Print Run 700

Cost Donated

Concept This piece was one component of a Call for Entries series for an advertising/design competition. The interesting accordion format of the piece was successful in generating interest and entries for the competition. One side of the brochure depicted the word "artwork"; the other side spelled the word "CHAAMPS," with each letter acting as an idea for an advertisement. The concept and photography worked well to reflect the awards program that was held in a fine arts museum.

Cost-cutting techniques To save time and money, the designer chose to use "Phototone Alphabets" CD-ROM photography that they already owned. These images were further enhanced using Photoshop.

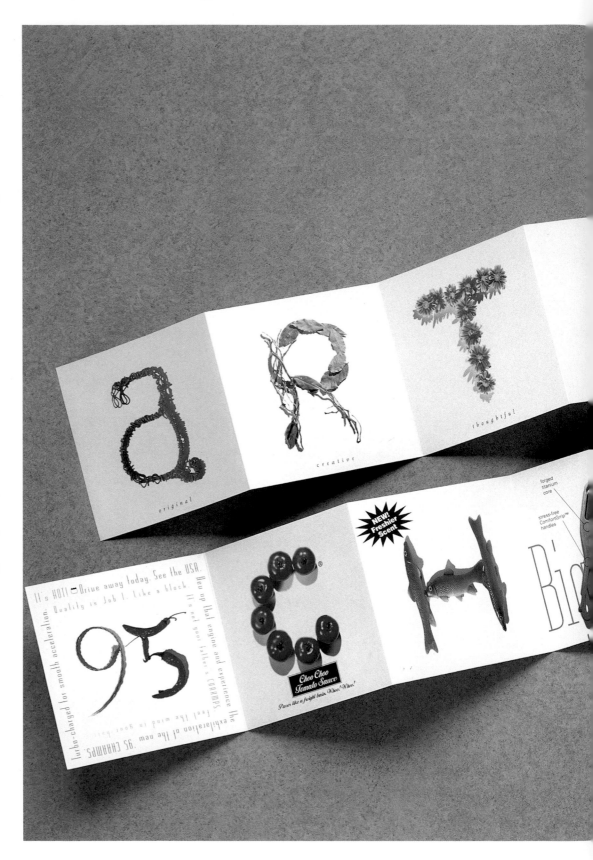

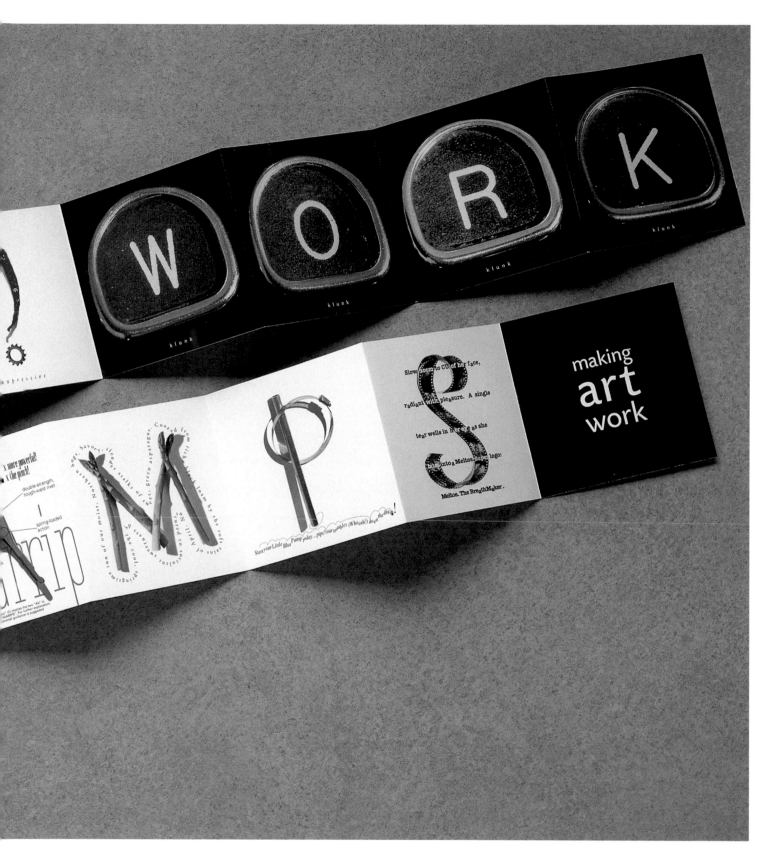

Automatic I Am

Art Director/Studio Charles Wilkin/Automatic Art and Design

Designer/Studio Charles Wilkin/ Automatic Art and Design

Client/Service Automatic Art and Design, Columbus, OH/Graphic design

Paper Champion Benefit

Type Martino, De Scripto (used for logo section)

Dimensions 7½" x 9⅜" (19cm x 23.8cm)

Pages 20

Software QuarkXPress

Printing Laser, photocopy

Color 1, black

Binding Tape binding

Initial Print Run 25

Cost $100

Concept The tape binding allowed the designer to update and custom-tailor the book often. To give the brochure a handmade feel, the pages were numbered using a numbering machine. In addition, the tape binding and use of a photocopy machine roughened and distorted the design.

Cost-cutting techniques Laser printing then photocopying the pages avoided costly reprinting when new logos were added.

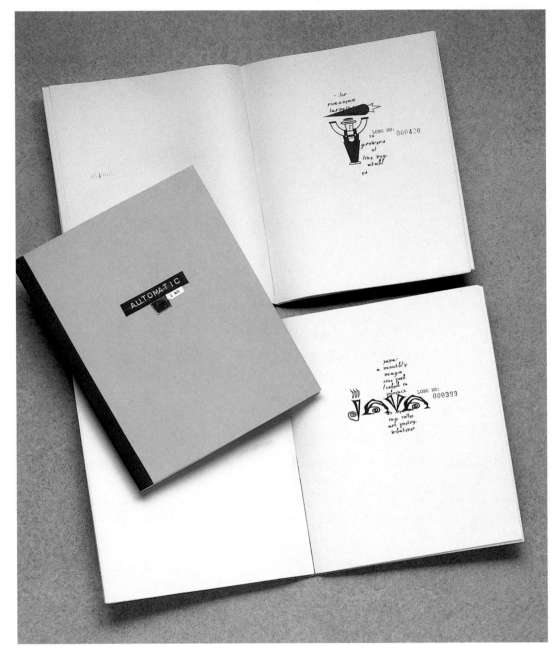

Art Director/Studio Catharine Bradbury/Bradbury Design

Designer/Studio Tania Wolk/Bradbury Design

Illustrator Tania Wolk

Client/Service Saskatchewan Lotteries/Lotteries

Paper Luna Matte 100# Text

Type Helvetica Condensed Black, Linoscript (cover), Linoscript (headings), Helvetica Condensed Black, Bodoni (body copy)

Dimensions 7⅝" x 9⅝" (19.4cm x 24.4cm); unfolds to 15¼" x 19⅝" (38.7 cm x 49.8cm)

Software QuarkXPress, Adobe Photoshop, Macromedia FreeHand

Printing Offset

Color 3, PMS

Binding folded

Job Length 30 hours (15 hours paid, 15 hours donated)

Initial Print Run 1,000

Cost $2,500

Concept The design conveyed a western theme in a fun, energetic and colorful way. The purpose of this brochure was to motivate retailers who sell lottery tickets to attend a convention that provided retailer tips. This simple, foldout brochure communicated the dates, registration information and schedule of the convention in an easy-to-read format.

Cost-cutting technique The printer donated some of the cost.

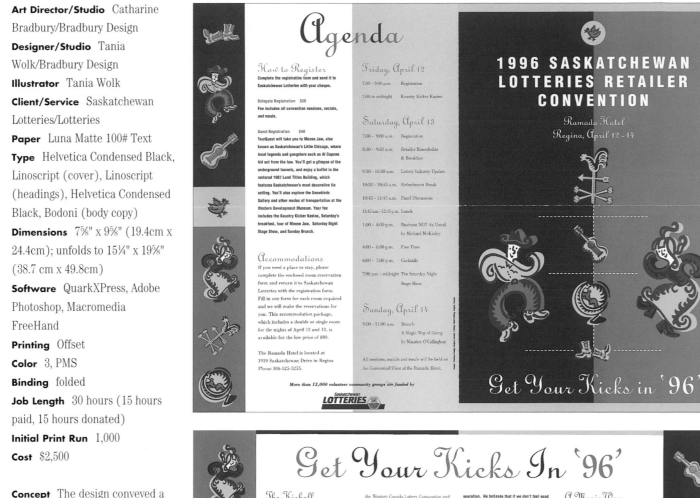

Peter Morneau Self-Promotion Brochure

Art Directors/Studio Pol Baril, Denis Dulude/K.-O. Creation

Designers/Studio Pol Baril, Denis Dulude/K.-O. Creation

Photographer Peter Morneau

Client/Service Peter Morneau, Montreal,Quebec/Photographer

Paper Supreme Gloss 230M

Type Cover: Nameless (2Rebels); Entropy, Time in Hell ([T-26]); Back cover: Razzia, Boggle (2Rebels); Interior: Missive, Entropy ([T-26])

Dimensions 6" x 7" (15.2cm x 17.8cm)

Pages 16, self cover

Software QuarkXPress, Adobe Photoshop, Adobe Illustrator

Printing Offset

Color 4, process

Binding Saddle stitched

Job Length 8 hours

Initial Print Run 750

Cost $3,500

Concept The client wanted to show commercial work in a non-commercial approach. This brochure concentrated on the photography of Peter Morneau, letting the work sell itself. The only copy was the client's studio name, address and telephone number shown on the covers.

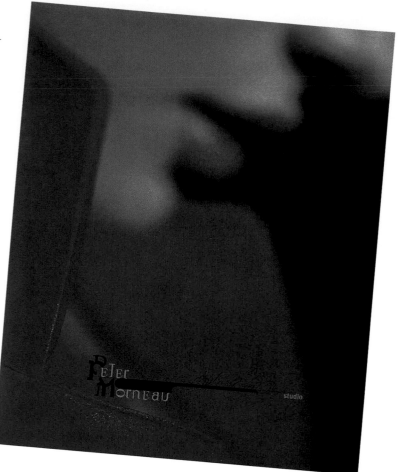

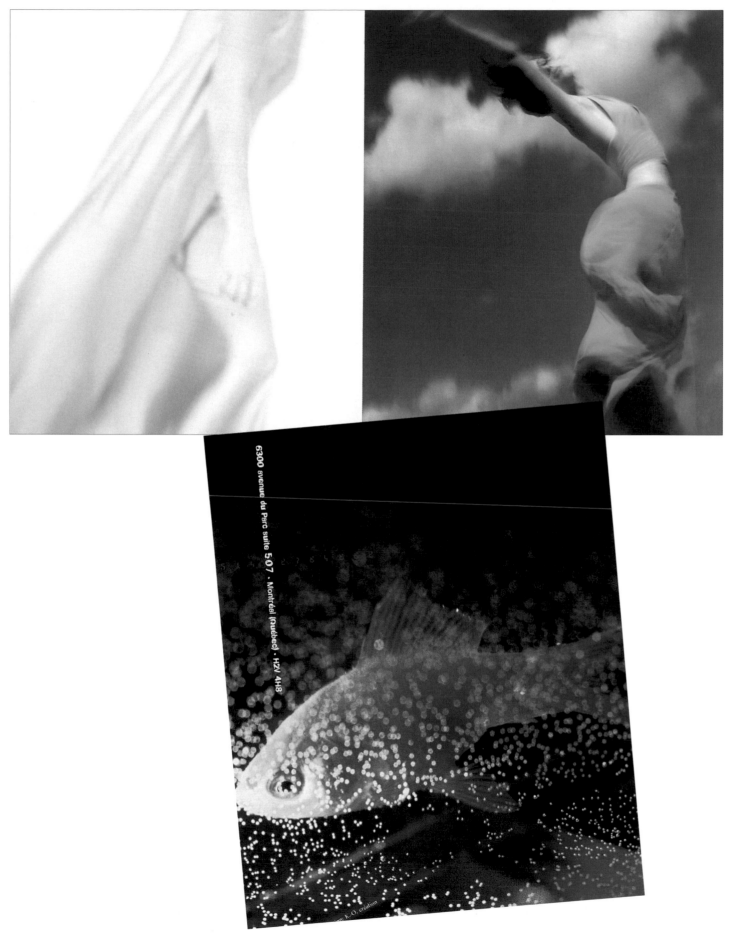

Central Pennsylvania Festival of the Arts 96

Art Director/Studio Lanny Sommese/Sommese Design

Designer/Studio Marina Garza/Sommese Design

Illustrator Lanny Sommese

Client/Service Central Pennsylvania Festival of the Arts, State College, PA/Annual summer arts festival

Paper Hammermill 70# Recycled Paper Stock in Blue Spruce, Pecan, Grey, Almond

Type Stone Sans Bold and Italic, main headline was done by hand

Dimensions 4" x 9" (10.2cm x 22.9cm); open size varies from 8" x 9" (20.3cm x 22.9cm) to 16" x 9" (40.6cm x 22.9cm)

Pages varies

Software QuarkXPress

Printing Offset

Color 1, black

Job Length 12 hours

Initial Print Run varied

Cost $4,800

Concept Each brochure was a Call for Entries for the Festival of Arts in one of four different areas (e.g., banners and fine arts). The look of the brochures was a spin-off from a large, full-color poster for the event. Although the design elements of each brochure were identical, each one used a different illustrated letter from the word "arts." In addition, different colors of paper for each brochure allowed for individual differences and yet tied the brochures to the poster for a cohesive look.

Cost-cutting technique The designer used black ink on different colors of stock.

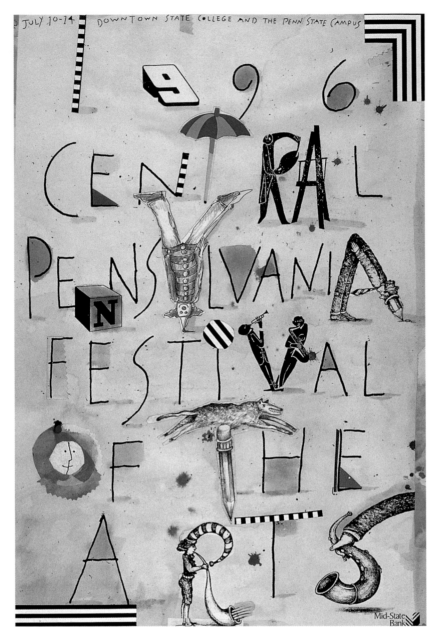

Art Directors/Studio David Butler, Todd Brooks/Copeland Hirthler design + communications

Designers/Studio David Butler, Todd Brooks/Copeland Hirthler design + communications

Photographer Sonny Williams

Editors Diana Thorington, Melissa James Kemmerly

Client/Service Creative Club of Atlanta, Atlanta, GA/Awards show for annual competition

Paper Nekoosa Linen (cover), Mead Offset Enamel (text)

Dimensions 8½" x 11" (21.6cm x 27.9cm)

Pages 84 plus cover

Software QuarkXPress, Adobe Illustrator

Printing Offset

Color 4, process

Binding Perfect bound

Job Length 160 hours

Cost Donated

Concept Show South is a Regional show, and the designers looked for a way to communicate the whole concept of "The South" in this book of competition winners. The design and typography were approached from a primitive or folk artist's point of view. Mixed among the winning entries were quotes from area designers and art directors in answer to the question, "What Does the South Mean to You?" The type in the quote sections changed sizes and styles to reflect the variety of opinions and voices.

Cost-cutting technique Work with some really talented people and ask them to do everything for free!

Part Two

Annual Reports

Art Director/Studio Kevin Bailey/Sullivan Perkins

Designer/Studio Kevin Bailey/Sullivan Perkins

Illustrator Kevin Bailey

Photographer Jeff Ott

Client/Service Interphase Corporation, Dallas, TX/Computer hardware

Paper Simpson Coronado SST 100# Text

Type Excelsior, Helvetica Neue Extra Black Condensed

Dimensions 8½" x 11" (21.6cm x 27.9cm)

Pages 24 plus cover

Software QuarkXPress, Adobe Photoshop, Adobe Illustrator

Printing Offset

Color 4, process; 2, PMS

Binding Saddle stitched

Initial Print Run 5,000

Concept Since the Interphase Corporation is a sophisticated, complex, high-tech company for networking and mass data storage, the designers wanted the annual report to illustrate the products in simple end uses. Lots of text broke the products into easy-to-comprehend layman terms. The information was straightforward, but enhanced with bright colors in what the designer calls a "graphically interesting fashion."

Adaptec Annual Report

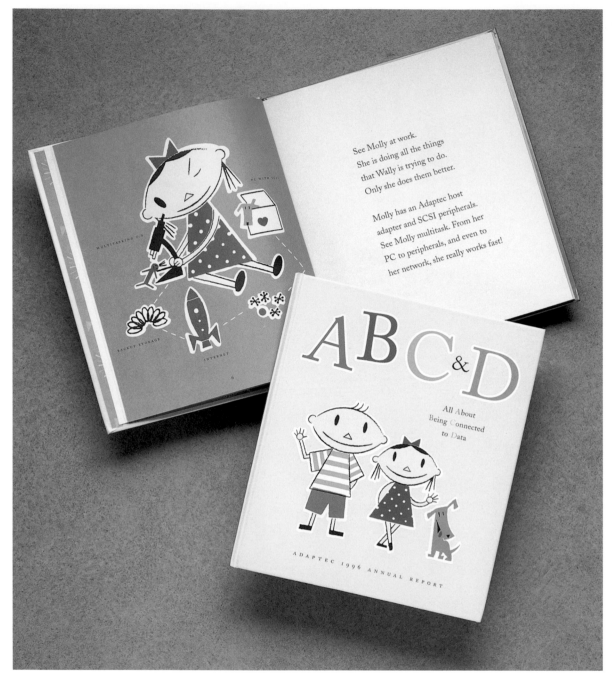

Art Director/Studio Bill Cahan/Cahan & Associates

Designer/Studio Kevin Roberson/Cahan & Associates

Illustrator Richard McGuire

Client/Service Adaptec, Inc., Milpitas, CA/High technology

Paper Kashmir (cover), Cougar vellum (text)

Type Caslon

Dimensions 8½" x 10" (21.6cm x 25.4cm)

Pages 54 plus cover

Software QuarkXPress, Adobe Photoshop

Printing Offset

Color 8, match

Binding Smythe sewn

Initial Print Run 70,000

Concept This annual report was a hardbound book with smythe-sewn pages. Using a children's book design, it conveyed the message of "moving the data that moves the world" in a form that everyone could easily understand. Bright colors were used throughout including small detail illustrations in the financial section.

Special production techniques The illustrations were created using layers of plates that overprinted one another, a technique used in children's books during the 1940s and 1950s.

James River Corporation 1995 Annual Report

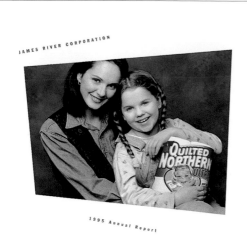

Art Director/Studio Steve Ferrari/The Graphic Expression, Inc.

Designer/Studio Kurt Finkbeiner/The Graphic Expression, Inc.

Client/Studio James River Corporation, Richmond, VA/Consumer products

Type Bodoni Book, Franklin Gothic condensed

Dimensions 8¾" x 11" (22.2cm x 27.9cm)

Pages 68 plus cover

Software QuarkXPress, Macromedia FreeHand

Printing Offset

Color 4, process; 2, match; aqueous coatings on cover

Binding Perfect

Concept The mix of four-color product shots and black-and-white work-in-progress shots highlighted the wide range of consumer products James River manufactures. In the front of the report, letters and conversations with CEOs and managers used a whimsical layout of text flowing at angles for a more approachable and casual appearance. By contrast, the design of the financial pages was more serious and firmly structured.

Special production technique The designers used a Scitex to combine four-color product shots with duotone images.

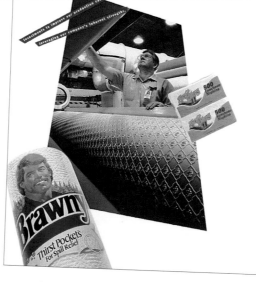

Designer/Studio Sue Miller/Purdue University, Office of Publications
Photographer Vincent Walter
Writer Dalene Abner
Client/Service Purdue University, School of Education, West Lafayette, IN/Education
Paper Mead Offset Enamel 80# Cover (cover), Mead Offset Enamel 100# Text (text)
Type Futura (cover), Garamond, Futura (text)

Dimensions 7" x 11" (17.8cm x 27.9cm)
Pages 16 plus cover
Software Adobe PageMaker, Macromedia FreeHand
Printing Offset
Color 4, PMS match
Initial Print Run 3,300
Cost $5,783 (printing only; no charge for design through the university)

Concept This annual report, a first for the School of Education, served to inform multiple audiences about the school's existence and extent of its activities. The theme "Taking Shape" effectively communicated that although the school was young, it was quickly taking shape. Throughout the report, shapes were used to crop photographs or quotes. These shapes, along with bright colors, gave the report a contemporary look.

Cost-cutting technique The duotone effect of the halftones was created by overprinting a one-color PMS halftone over a solid one-color PMS ink.

COR Therapeutics Annual Report

Art Director/Studio Bill Cahan/Cahan & Associates

Designer/Studio Kevin Roberson/Cahan & Associates

Illustrator Bob Dinetz

Photographer Tom Collicott

Copywriter Joyce Knapp

Client/Service COR Therapeutics, Inc., San Francisco, CA/Biotechnology

Paper Glama Natural, Vintage Velvet

Type Bembo

Dimensions 8½" x 11" (21.6cm x 27.9cm)

Pages 38 plus cover

Software QuarkXPress, Adobe Illustrator, Adobe Photoshop

Printing Offset

Color 4, process; 2, PMS

Binding Perfect

Concept COR Therapeutics' annual report had to cover a wide audience of doctors, pharmacists, medical providers, patients and families that would potentially use one of their drug therapies for heart disease. Each group had their own distinct questions and concerns about potential drugs. This annual report was designed in a question and answer format to provide clarity to what could be a confusing and overwhelming topic. Overlapping transparent photographs reinforced the concerns of each group and COR's responsiveness to those concerns.

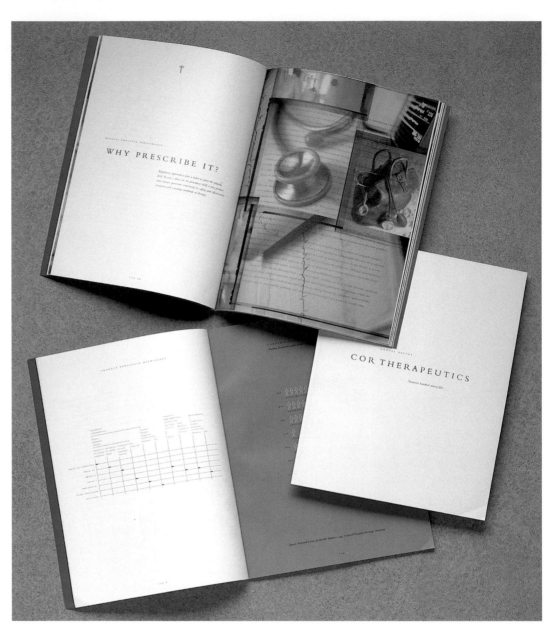

Who Wins?

CYRIX 1995 ANNUAL REPORT

Designer/Studio Kelly Allen/Sullivan Perkins

Photographer Scogin Mayo

Client/Service Cyrix, Richardson, TX/ Computer chip design and manufacturing

Paper Mead Moistrite Matte

Type Janson (text), Triplex (headings, subheadings), Trade Gothic (cutlines and charts)

Dimensions 8½" x 11" (21.6cm x 27.9cm)

Pages 44

Software QuarkXPress, Adobe Illustrator

Printing Offset

Color 4, process; gold metallic

Initial Print Run 60,000

Concept The "Who Wins" concept established Cyrix as a smaller company whose innovative technology offers a challenge to its competitors and an alternative for consumers. The narrative section addressed the wide audience of Cyrix— from end users to PC manufacturers— with readable text and inviting, technical photographs. This section presented Cyrix as a company that keeps the industry, consumers and stockholders in mind throughout product development and manufacturing.

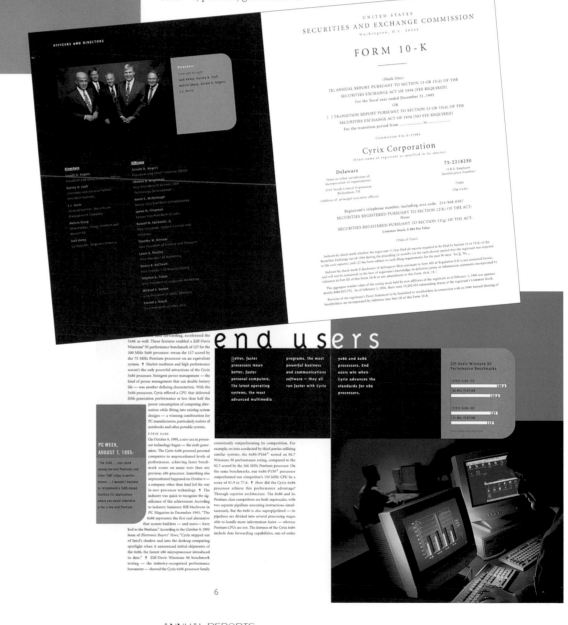

Barnes & Noble 1994 Annual Report

Art Director/Studio Kiku Obata/Kiku Obata & Company

Designer/Studio Joe Floresca/Kiku Obata & Company

Illustrator Maira Kalman

Client/Service Barnes & Noble, Inc., New York, NY/Book retailer

Paper Potlatch Quintessence Remarque Velvet 100# (cover), Quintessence Remarque 80# (text), Simpson Evergreen 70# (financial sections)

Type Gill Sans, Garamond

Dimensions 8½" x 11" (21.6cm x 27.9cm)

Pages 42 plus cover

Software QuarkXPress, Adobe Photoshop, Macromedia FreeHand

Printing Offset

Color 4, process; 2, PMS

Binding Perfect

Job Length 500 hours

Initial Print Run 30,000

Concept A fictitious character, Penelope Wise, takes the reader on a tour of an imaginary bookstore, Barnacles and Noodles. Through Maira Kalman's playful illustrations and creative writing, Barnes & Noble was not only able to make the annual report fun to read but also demonstrated their "spirit of imagination and willingness to explore uncharted territories."

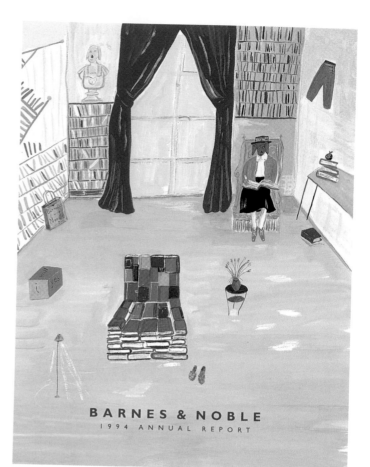

BARNES & NOBLE
1994 ANNUAL REPORT

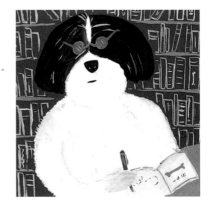

The bliss of beginnings. Every word savored. *Ishmael. Tessellated.* **What would my word be?** Another word for lettuce perhaps. *Liflaf?*

This is no ordinary bookstore. It is the largest bookstore in the solar system. Some skeptics say there may be a larger bookstore on Jupiter, but I say, be logical.

There are so many fantastic people at the store. I feel like I am part of a special club or at my cousin Kasimir's wedding (*before* the fight). I am tempted to talk to all of them but they are transported into an ecstatic world of first sentences.

In the Celebrity Hoopla Room, a vivacious Shih Tzu named Cookie Primavera is signing copies of her philosophical best seller, "The Bone of Existence." She is holding forth about the difference between ennui and Henri, holding the room spellbound with her frisky wisdom.

Barnacles & Noodles **5** *Annual Report*

The *Officiously Smooogie* NYSE:BKS

Barnes & Noble is the world's largest bookseller and the fastest growing. Each quarter since our public offering in October 1993, we have met or exceeded our expectations.

During the past three years we have turned doubters into believers, believers into advocates, and advocates into investors. **The fiscal year began with our stock trading at $21.00 and ended at $29.50,** an increase of 40%. **Two secondary offerings of 9.9 million shares improved the liquidity of our stock. We now have 20.3 million shares trading in the public market, with the majority institutionally held, and the rest held by almost 11,000 individual investors. In turn, BKS is now followed by more than 10 analysts from leading brokerage houses.**

Another financial highlight was the upgrading by Moody's Investor Service of Barnes & Noble's senior subordinated notes to B1 from B2; the implied senior rating was upgraded to Ba2 from Ba3.

Barnes & Noble, Inc. 14 *Annual Report*

A t Barnes & Noble, we are committed to creating shareholder value. We believe this entails not just running our company well, but also communicating our goals and our mission clearly to our investors.

The discipline with which we operate our business is equally matched by the force of our vision. Our track record of bookselling innovations is one that we intend to build on. While our formal business plan is mapped out for the next three years, we also have our eye focused on bookselling in the next millennium. We know that successful retailers are those who are able to adapt to a fast-changing marketplace.

In 1994, Barnes & Noble not only adapted to, but also anticipated the marketplace by enlarging our superstores, by introducing CD-ROMs into our inventory, and by expanding our music selection. Our ideas are moving forward at increasing speed. Fast track retailing—especially bookselling—is not for the weak of mind or faint of heart.

Another particularly pleasing development was the rapid rollout of our cafe business, due in large part to the expertise of the professionals at Starbucks. It's hard to believe we have already opened 102 wonderful cafes, with 75 more planned for 1995. Certainly our marketing partnership with Starbucks has made a big difference.

The most encouraging development of 1994 was the strong comparable store sales performance from our superstores. We attribute this in great part to our large and growing base of experienced booksellers. Our superstores have been able to attract some of the very best talent from the world of specialty retail, and our bookseller training program is turning them into great booksellers.

In 1994, we invested $89 million in new stores, fixtures and equipment. That investment paid local workers to build and handle renovations, expanding the local economic base. More important, we created upwards of 5,000 new jobs for booksellers nationwide.

Overall, 1994 demonstrated that we are booksellers foremost who understand and appreciate the value of strong retailing; at the same time, we are proud that we are able to contribute in many vital ways to the American communities we serve.

Barnes & Noble, Inc. 15 *Annual Report*

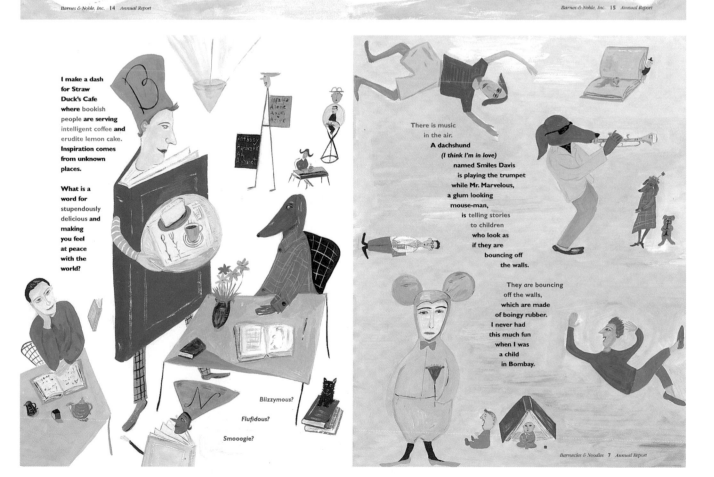

I make a dash for Straw Duck's Cafe **where** bookish people **are serving** intelligent coffee **and** erudite lemon cake. **Inspiration comes from unknown places.**

What is a word for stupendously delicious **and** making you feel at peace with the world?

Blizzymous?

Flufidous?

Smooogie?

There is music in the air. **A dachshund** *(I think I'm in love)* named Smiles Davis is playing the trumpet while Mr. Marvelous, a glum looking mouse-man, is telling stories to children who look as if they are bouncing off the walls.

They *are* bouncing off the walls, which are made of boingy rubber. I never had this much fun when I was a child in Bombay.

Barnacles & Noodles 7 *Annual Report*

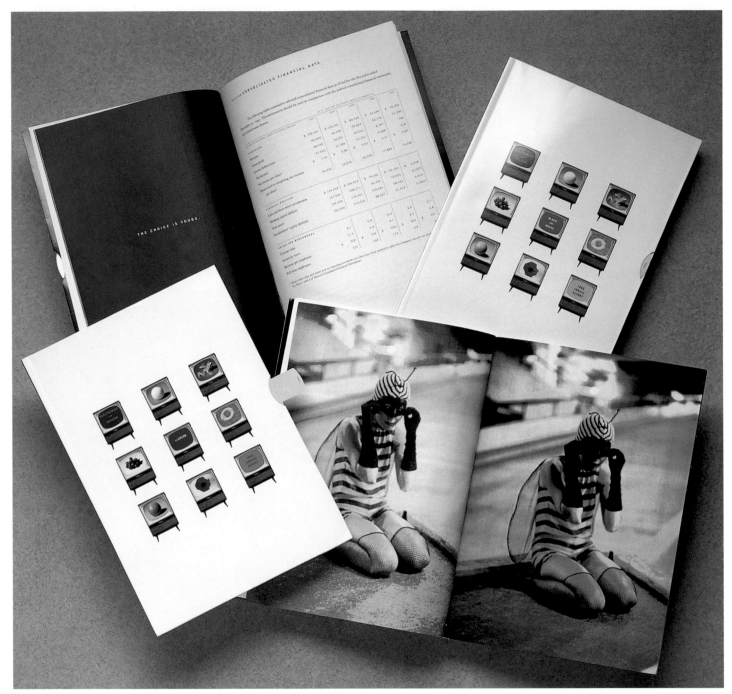

Art Director/Studio Bill
Cahan/Cahan & Associates

Designer/Studio Kevin
Roberson/Cahan & Associates

Photographers Kate Swan, Jason
Beaupre, Tony Stromberg, John
Acurso

Client/Service Electronics for
Imaging, San Mateo, CA/Color out-
put devices for computers

Paper Cougar, Kashmir Gloss
(cover), Hammermill (insert)

Type Janson, Trade Gothic (sub-
heads)

Dimensions 8" x 11½" (20.3cm x
29.2cm)

Pages 32 plus cover

Software QuarkXPress

Printing Offset, Fiery color output
(insert)

Color 4, process; spot color;
varnish

Concept The cover had a special
die cut with a pull tab. When
closed, the die cuts showed
through to a black-and-white
image. When the tab was pulled,
the images popped into color. As
on the cover, the entire brochure
displayed the revolutionary power
of color over black and white. The
graphics were displayed in side-by-
side fashion with black and white
on one side and a color version

facing it. The designer used the
client's Fiery color server to print
the comparison section inside the
brochure. Thus the report gives an
actual visual representation of
their product and its abilities in
the same forum as the financial
information.

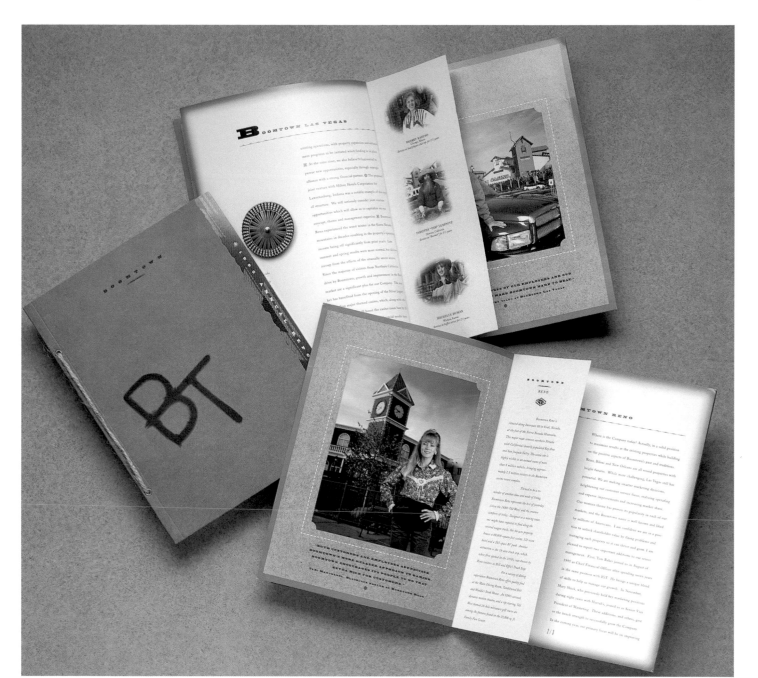

Art Director/Studio Thom Page/White Design

Designer/Studio Jamie Graupner/White Design

Photographer Tom Engler

Client/Service Boomtown, Verdi, NV/Entertainment

Paper Kimdura Buckskin (cover), Simpson Sundance, Vintage Velvet (text)

Type A Caslon, Willow, Black Oak, Wood Type Ornaments 2

Dimensions 8½" x 11" (21.6cm x 27.9cm)

Pages 32 plus cover; 8 pages of half sheets

Software QuarkXPress, Adobe Photoshop, Adobe Illustrator

Printing Offset

Color 4, process; 1, match; spot varnish

Binding Twine tie through grommets on spine

Job Length 370 hours

Initial Print Run 11,000

Cost $83,000

Concept Boomtown needed a report that balanced the good qualities of their entertainment business with the negative financial results they faced in 1995. This report gave visual emphasis to their reputation for excellent service and hospitality using employee testimonials. The design supported their 1870s western theme. Tucked inside the narrative section of the annual report were half sheets that acted as sidebars of information and featured employee photographs. This gave the company a personal touch.

Special features Twine was hand tied through the two grommets on the spine. The cover had a ragged die-cut edge that showed the front edge of the report, inviting the reader to open the book.

1995 Haggar Corp. Annual Report

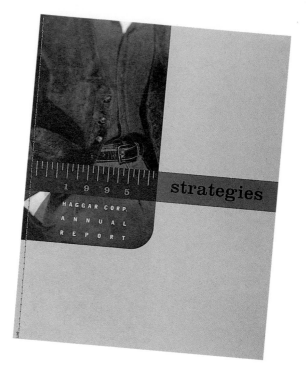

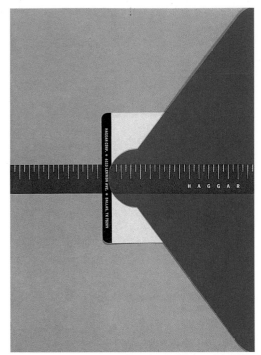

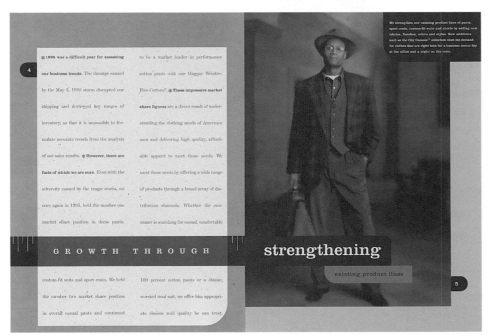

Art Director/Studio Rob Wilson/Sullivan Perkins

Designer/Studio Rob Wilson/Sullivan Perkins

Photographers Tim Boole, Gerry Kano, Jim Erickson

Writers Michael Langley, Carla Morgan

Client/Service Haggar Corp., Dallas, TX/Manufacturer of men's apparel

Paper Genesis, Husk

Type Clarendon, Devinne, Grotesque

Dimensions 8½" x 11" (21.6cm x 27.9cm)

Pages 40 plus cover

Software QuarkXPress, Adobe Illustrator

Printing Offset

Color 4, process; 2, PMS

Binding Side stitched by hand on an industrial sewing machine

Initial Print Run 7,500

Concept This year's annual report reflected Haggar's shift in focus from men's dress wear to casual wear. The look and feel of the design partnered their new advertising campaign. The papers and colors revealed a sturdiness about the company as well as a hands-on quality that encouraged readers to pick up the report and take a look. In addition to the annual report, Sullivan Perkins designed a mailer/pocket folder that tied in with the annual report elements.

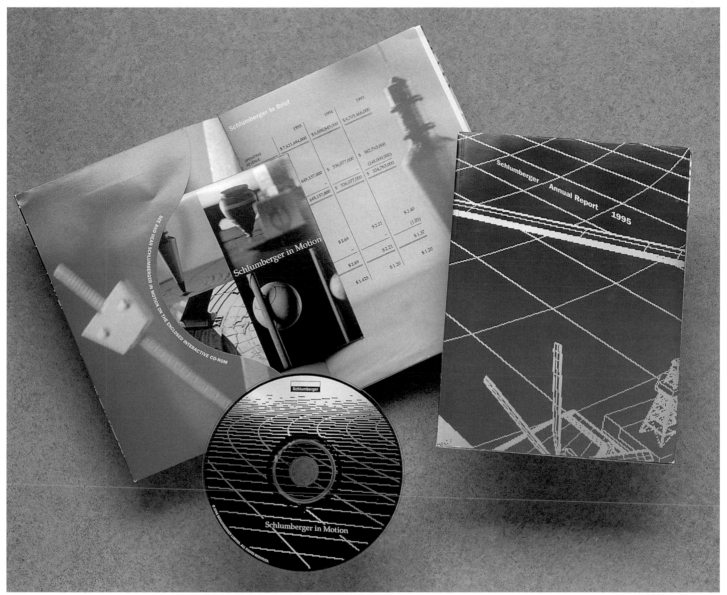

Art Director/Studio Milton Glaser/Milton Glaser, Inc.

Designers/Studio Milton Glaser, David Freedman/Milton Glaser, Inc.

Images Colossal Pictures

Client/Service Schlumberger, Ltd., New York, NY/ Oilfield & measurement services

Paper Westvaco Citation Gloss 80# Cover (cover), Westvaco American Eagle Dull 80# Text (text)

Type Palatino, Franklin Gothic

Dimensions 5½" x 7½" (14cm x 19cm)

Pages 43 plus cover

Printing Offset

Color 3, match; black; metallic silver

Binding Saddle stitched, perfect

Initial Print Run 225,000

Concept Schlumberger wanted to do the feature section of their annual report on CD-ROM. To coordinate the financial printed section, silver inks were used in printing to match the silver of the actual CD. The disk sleeve was designed to slip into a die-cut pocket on the inside cover of the financial report. In this way, the feature and financial sections

were integrated into a consistent whole.

Special production techniques For balance between metallic shine and to provide better trapping with the flat colors used, the silver ink was blended with flat gray ink.

Cost-cutting technique The report was printed in a small "pocket" size, which resulted in some savings on paper.

Art Director/Studio Bill Cahan/Cahan & Associates

Designer/Studio Craig Clark/Cahan & Associates

Illustrator Will Davies

Photographer Tony Stromberg & others

Client/Service Macromedia, San Francisco, CA/High technology

Paper Champion Kromekote c1s 10 pt. (cover), Cougar 70# Text (text)

Type New Caledonia, Zapf Dingbats, 20th Century

Software Adobe Photoshop, Macromedia FreeHand

Printing Offset

Color 4, process; 2, match

Binding Perfect

Concept Macromedia has two distinct personalities, one expressing a straightforward business vision and one that is casual and playful. The two sides to this annual report suited their needs perfectly. There are two different covers along with two different narratives. Opening one side of the annual report presented the reader with a straight-forward analytical and financial vision of the company. By turning it over and opening the other side, a comic book style story unfolds. The fictional portions were illustrated by one of the original Harlequin book cover illustrators, Will Davies.

Part Three

Special Production Effects

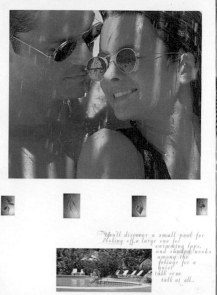

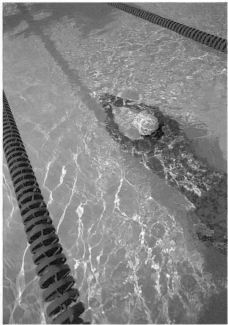

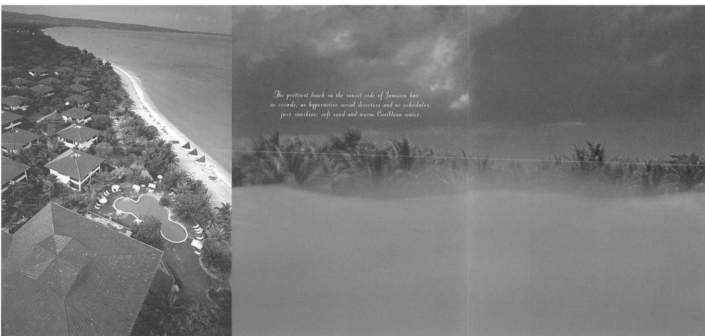

Art Directors/Studio Joel Fuller, Todd Houser/Pinkhaus

Designer/Studio Todd Houser/ Pinkhaus

Illustrator Todd Houser

Photographer Michael Dakota

Client/Service Swept Away Resort, Negril, Jamaica/Resort property

Paper Astrolite

Type Shelley Script, Hiroshiye

Dimensions 12" x 8½" (30.5cm x 21.6cm)

Pages 12 plus cover with foldout

Software Adobe Photoshop, Adobe Illustrator

Printing Offset

Color 4, process; 2, match

Binding Saddle stitched

Job Length 3 months

Initial Print Run 75,000

Concept This brochure, rich with soothing photographs and sweeping typography, reflects the resort atmosphere at Negril, Jamaica. All of the old-paper-looking back-

grounds were duotones of two browns created in Adobe Photoshop. The choice of greens and browns for the brochure provided a dreamy quality that invited the reader to learn more.

Special folds or features French-folded covers.

Margarett Sargent: A Modern Temperament

Art Director/Studio Anita Meyer/plus design inc.

Designers/Studio Anita Meyer, Dina Zaccagnini/plus design inc.

Client/Service Davis Museum and Cultural Center, Wellesley College, Wellesley, MA/Museum

Paper Canson Satin 29#

Type Perpetua, Agenda Light, Bureau Grotesque Three, Roxy Light Italic

Dimensions 6" x 9¼" (15.2cm x 23.5cm); unfolds to 90" x 9¼" (228.6cm x 23.5cm)

Pages 16

Software QuarkXPress

Printing Offset

Color Process black; 1, PMS

Initial Print Run 1,500

Concept The concept communicated an art historical examination of three different perspectives of Margarett Sargent's life and work as an artist. Each voice of the author was reflected by individual typefaces, lending variation to the transition phases of the artist's life. The accordion fold gave the piece a unique feel, as well as symbolizing the evolution of her life, and how her life and work were interwoven.

Special folds or features Four separate sheets were hand glued together, then accordion folded by machine, and lastly, hand folded for the final reverse fold.

Cost-cutting technique With the use of transparent paper, the designer was able to use two colors and get the effect of using more. By printing two colors over one color, the effect was of two colors printing on both sides.

Art Director Brett Stiles

Designer Brett Stiles

Client/Studio Brett Stiles, Austin, TX/Graphic designer

Paper Fox River Paper Co. Confetti 80# Cover (cover), French Paper Dur-O-Tone Newsprint 80# Text (interior pages), Wyndstone Black Corrugated (binding)

Type Letter Gothic

Dimensions 7¾" x 5½" (19.7cm x 14cm)

Pages 14 plus cover

Software QuarkXPress, Adobe Photoshop, Adobe Illustrator

Printing Fiery color laser prints

Color 4, process

Binding Perfect

Job Length 100 hours

Initial Print Run 15

Cost $1,200

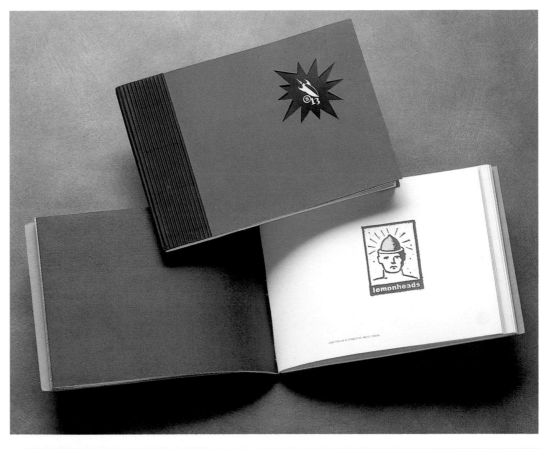

Concept The objective of the piece was to present thirteen logo designs in a book format instead of a traditional portfolio, while keeping the piece on a shoestring budget. Since the book has thirteen logo designs in it, the designer played with the "unlucky" number with an explosion-shaped die cut and crashing rocket design that also bears the number thirteen.

Special folds or features The cover and interior pages were folded over and the open end was then perfect bound using corrugated paper. This gave the piece more weight making it feel like a book.

Cost-cutting techniques The biggest cost savings was using Fiery color laser prints for the interior pages instead of using four-color process. This was cost effective because the print run was so small.

Damn! Lazer Brochure

Creative Director Bill Abramovitz

Art Directors/Studio L. Stock, E. Bianchini/Media Force

Photographer OMS Photography

Client/Service Lazer Systems, Cincinnati, OH/Color separator

Paper Fortune Matte 80# Cover, Text

Type Industria

Dimensions 8" x 12" (20.3cm x 30.5cm)

Pages 10

Software QuarkXPress, Adobe Photoshop, Adobe Illustrator

Printing Offset

Color 4, process

Binding Saddle stitched

Job Length 238 hours

Initial Print Run 5,000

Cost $40,000

Concept This brochure spoke directly to art directors and reminded them of the pitfalls of choosing a bad vendor for color separations with "The Story of the Job From Hell," where everything from registration to trapping color has gone awry. With an abrupt "in-your-face" approach, which was different from the conventional approach of most color separators, this piece gave them every reason to prefer Lazer Systems.

Special features Digital photography was used throughout. Because of the odd angles, each piece had to be hand bound.

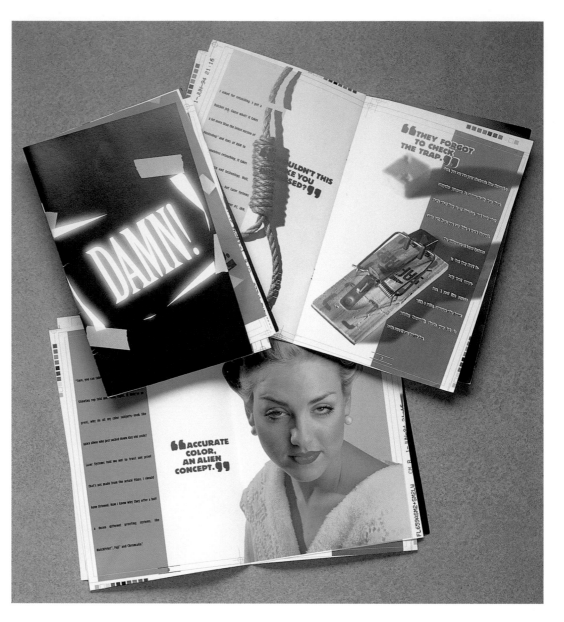

Art Director/Studio John Klotnia/Pentagram Design

Designer/Studio John Klotnia/Pentagram Design

Client/Service Hansberger Global Investors, Ft. Lauderdale, FL/Financial investment

Paper Simpson Gainsborough White 80# Cover (cover), Mohawk Superfine Soft White 80# Text (text), Vintage 100# Gloss Text

Type Goudy

Dimensions 7" x 10½" (17.8cm x 26.7cm)

Software QuarkXPress, Adobe Photoshop, Adobe Illustrator

Printing Offset and blind embossing

Color 4, process; 2, match

Binding Japanese side sewn

Initial Print Run 5,000

Concept Although Hansberger Global Investors focus their investments in the Far East, their clients are primarily from the West. This brochure reflected the focus of their investments, with a mixture of Western and Eastern sensibilities. Throughout the brochure were maps of the world as they have been interpreted through time. Including history as well as geography helped to broaden Hansberger's Global clients' perception of time and its relevance to investing.

Special features Blind embossing on the front cover. All pages were scored to fold along the back spines, then collated and Japanese side sewn with cotton thread.

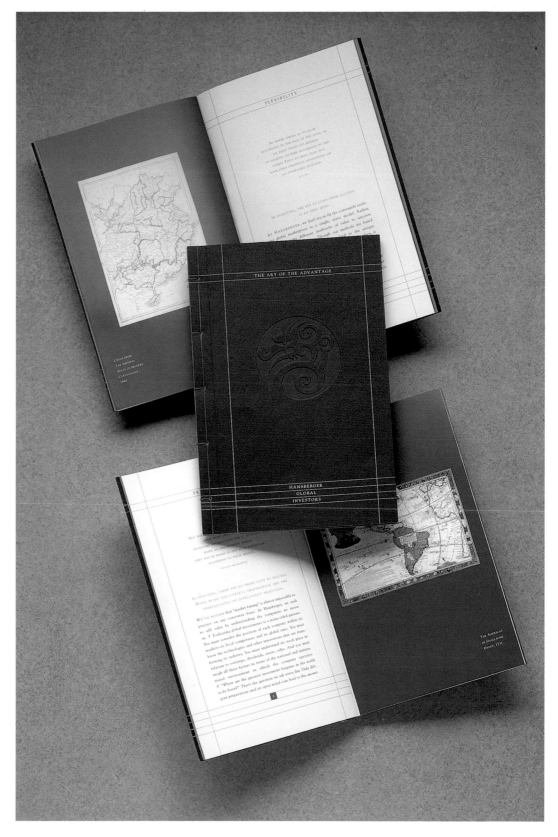

Substance—Karma

Art Directors/Studio Kevin Kuester, Stefan Hartung/The Kuester Group

Designer/Studio Stefan Hartung/The Kuester Group

Photographer various

Client/Service Potlatch Corporation, Cloquet, MN/Quality-coated printing papers

Paper Karma Bright White, Karma Natural

Type Bembo, Meta, Gota

Dimensions 8" x 9" (21.6cm x 22.9cm)

Pages 16 plus cover

Software QuarkXPress, Adobe Photoshop

Printing Offset

Color 4, process; 2, match; 2 varnishes

Binding Saddle stitched

Initial Print Run 60,000

Concept This brochure used the strategic concept of "Substance" throughout to illustrate the special qualities of Karma paper. Various printing techniques were used on the product to demonstrate the versatility of this paper.

Special production techniques Hand-tooled die plus embossing on the front cover, gloss varnish on the embossing and off-line varnishes throughout the text.

Special folds Gatefold inside the back cover. Paper specifications were inside the gatefold.

Art Directors/Studio Kevin Kuester, Bob Goebel/The Kuester Group

Designer/Studio Bob Goebel/The Kuester Group

Photographer Francine Easlow

Client/Service Potlatch Corporation, Cloquet, MN/ Premium-coated printing papers

Paper Eloquence Silk 85# Cover (cover), Eloquence Gloss and Silk 110# Text

Type Univers Condensed, Bembo

Dimensions 8½" x 9" (21.6cm x 22.9cm); unfolds to 25¼" x 9" (64.1cm x 22.9cm)

Pages 16 plus cover

Software QuarkXPress

Printing Offset

Color 4, process; 1, match; 2 varnishes

Binding Saddle stitched

Initial Print Run 60,000

Concept This brochure used the strategic concept of "Virtue" throughout to illustrate the special qualities of the Eloquence paper. The graphics were primarily translucent to show the high quality of this paper line.

Special folds Gatefold inside the back cover. Paper specifications were inside the gatefold.

Cost-cutting technique All printed in one pass on a six-color press.

FutureCom Telephone Brochure

Art Director/Studio Steven Wedeen/Vaughn Wedeen Creative

Designers/Studio Steven Wedeen, Adabel Kaskiewicz/Vaughn Wedeen Creative

Client/Service Jones Intercable, Alexandria, VA/Cable television and telecommunications

Paper Champion Kromekote c2s 12 pt. (text), Zanders T-2000 64# (flysheet)

Type Garamond #3

Dimensions 4" x 12" (10.2cm x 30.5cm)

Pages 10 plus flysheet

Software QuarkXPress, Adobe Photoshop

Printing Offset

Color 4, process (text); 2, PMS (flysheet)

Binding Wire-O

Initial Print Run 1,500

Concept This brochure introduced integrated telephone services with cable television. The design established a distinct user-friendly image and identity, which was carried through on subsequent materials for FutureCom.

Special production techniques Round corners, Wire-O top binding and a translucent flysheet.

Cost-cutting technique The unique but small size allowed the brochure to be printed two up on a small press, keeping the costs down and the perceived value high.

BROADWAY LOCAL

Columbia's Home In Morningside Heights

Art Director/Studio Bryan L. Peterson/Peterson + Company
Designer/Studio Scott Paramski/Peterson + Company
Photographer Gabriel Amadeus Cooney
Client/Service Columbia University, New York City, NY/Education
Paper Warren Lustro Offset Enamel
Type Futura Black (headings), Centaur (text)
Dimensions 7½" x 12" (19cm x 30.5cm)
Pages 16 plus cover
Software QuarkXPress
Printing Offset
Color 4, process; 2, PMS; 2 varnishes
Initial Print Run 10,000

Job Length 200 hours
Cost $20,000 (for design and production only)

Concept This piece explored the personality of Morningside Heights in an effort to make the area appealing and inviting to students considering Columbia University, but were not enrolling for fear of the school's proximity to Harlem in Manhattan. The use of dull and glossy varnishes added a subtleness and visual depth to the design.

Cost-cutting technique Sixteen-page signature utilized the paper and allowed the book, including the cover, to print on two sheets of paper.

The Uncoated Truth—Fashion

Art Directors/Studio Brad Copeland, George Hirthler/Copeland Hirthler design + communications

Designer/Studio Raquel Miqueli/Copeland Hirthler design + communications

Writer Melissa James Kemmerly

Client/Service Neenah Paper, Roswell, GA/Paper manufacturer

Paper Neenah Classic Laid, Classic Linen, Classic Columns, Classic Crest, Environment

Dimensions 7¾" x 11¾" (19.7cm x 29.8cm)

Pages 32 plus cover

Software QuarkXPress, Adobe Illustrator

Printing Laser, thermography

Color 4, process; 27, PMS

Binding Sewn

Job Length 140 hours

Initial Print Run 25,000

Cost $36,000 (doesn't include printing)

Concept This brochure was the second in a series of four created to raise awareness of uncoated papers in specific industries. Typically the fashion industry uses coated papers for their print collateral. This brochure was presented in a full-size wraparound of uncoated stock in the Environment line from Neenah.

Special production techniques On the front page of the brochure, a clear thermography was used over the word "fashion." To illustrate the quality of color, there were several quadtones created in match four-color.

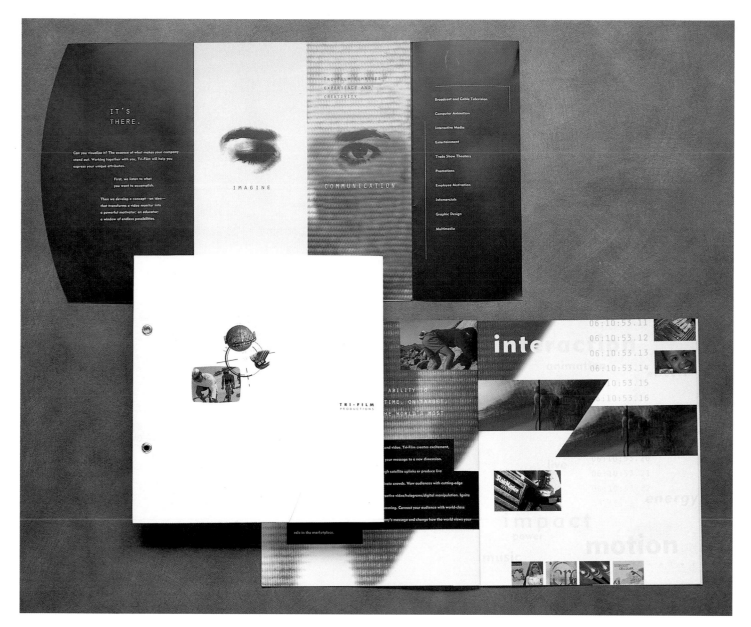

Art Director/Studio Tim Young/The Leonhardt Group

Designer/Studio Tim Young/The Leonhardt Group

Client Tri-Film Productions, Kirkland, WA

Paper Vintage Velvet White 80# Cover and 100# Book

Dimensions 9¾" x 9⅛" (24.8cm x 23.2cm)

Pages 4 plus cover

Software QuarkXPress

Printing Offset

Color 4, process; 1, PMS; varnish

Initial Print Run 1,600

Concept This brochure aimed to solve the problem of how to show the video medium—with its movement and dynamics—in print. The angled graphics and photography made this piece appear mobile. In addition, the curved shape of the cover flap implied movement.

Special features Hinge scores, two-rivet binding, and die-cut cover for curved shape.

Cost-cutting technique All imagery was scanned for Macintosh film output.

UPSI Kit Folder

Art Director/Studio Tim Thompson/Graffito/Active8
Designer/Studio Chuck Seeyle/Graffito/Active8
Illustrator Chuck Seeyle
Photographers Ed Whitman, Lightstruck Studio, Tony Stone Images
Client/Service UPSI, Fairfax, VA/Supplier of uninterrupted power source equipment
Paper LOE Dull 100# Text, Cover (brochure); LOE Dull 120# Cover (kit folder)
Type Bell Gothic, Arrow
Dimensions Brochure: 10" x 8½" (25.4cm x 21.6cm); Kit folder: 9" x 11½" (22.9cm x 29.2cm); Kit folder unfolds to 28" x 15½" (71.1cm x 39.4cm)
Pages 8 plus cover
Software Adobe Photoshop, Macromedia FreeHand
Printing Offset
Color Brochure: 4, process; 1, PMS; varnish; Kit folder: 4, process; black; varnish
Binding Brochure: Saddle stitched; Kit folder: Die cut, scored, folded and glued
Job Length 204 hours
Initial Print Run 3,500
Cost $51,707

Concept This brochure conveyed the vulnerability of today's power supply to a company's daily operations. Through copy and related thought-provoking imagery, UPSI was positioned as the trusted source for dependable power supply equipment. The kit format allowed UPSI to customize the folder inserts to fit a potential client. It also allowed for inexpensive reprinting of individual components.

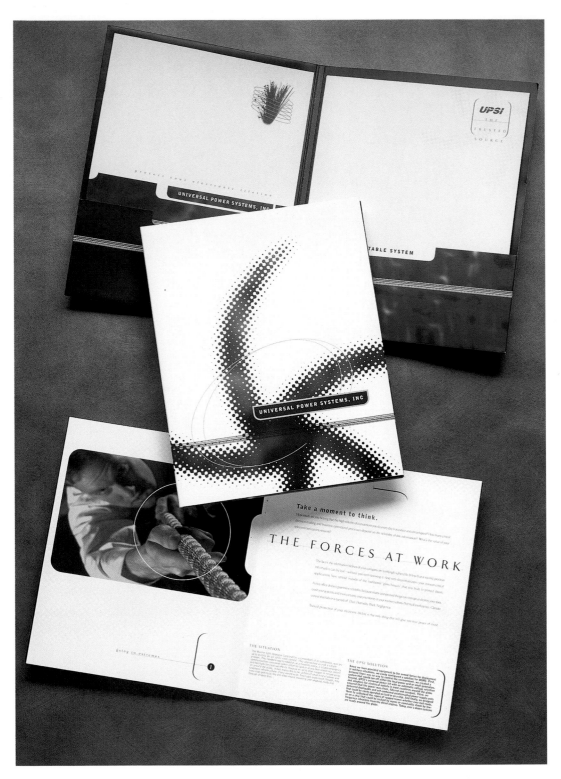

Special production technique A tinted varnish was used as background art throughout.

Art Director/Studio John White/White Design

Designer/Studio Jamie Graupner/White Design

Illustrator Dale Glasgow & Associates

Client/Service Fluor Daniel, Irvine, CA/Diversified services company

Paper Vintage Velvet Cover and Text

Type Univers, Shelly, Bauer, Bodoni, Matrix, Minion, Modula

Dimensions 8½" x 11" (21.6cm x 27.9cm)

Pages 16 plus cover, 18 pages of half-sheets

Software QuarkXPress, Adobe Photoshop, Adobe Illustrator

Printing Offset

Color 4, process; 2, black; 2, match

Binding Perfect

Job Length 385 hours

Initial Print Run 15,000

Cost $60,000

Concept This brochure brought a cohesive look to a company that prides itself on diversity. Here the company's global capabilities were organized into an interactive presentation. Case studies were displayed on half-sheets with running narrative copy on spread pages.

Special feature Alternating half-sheets were used throughout the brochure.

Utopia Brochure

Art Director/Studio John Bielenberg/Bielenberg Design

Designer/Studio John Bielenberg/Bielenberg Design

Photographer Ray Niemi

Client/Service Appleton Papers/Paper manufacturer

Paper Canson Satin (cover), Utopia 2 Blue White Gloss 80# Text (text)

Type Futura, Helvetica Inserat

Dimensions 11" x 14" (27.9cm x 35.6cm)

Pages 12

Software QuarkXPress

Printing Offset

Color 4, process; 2, match

Binding Saddle stitched

Job Length 50 hours

Concept The design's provocative use of a translucent cover page appealed to the designer audience. The third brochure in a series of ten, the designer wrapped the name of the paper around a visual concept. In this brochure he explored the meaning of utopia as compared to "the four walls of a prison cell." The primary purpose was to show off the printability of Appleton's new Utopia #2 sheet.

Special production techniques Ink densities in solid areas were in excess of 300 percent. The second press pass on the text included a special match, dry trap, pearlescent varnish. The outer wrap was printed on one side with low-solvent, low-tack, oil-based oxidizing inks.

THIS IS THE 3RD IN A SERIES OF TEN. IN THIS ISSUE JOHN BIELENBERG SEARCHES FOR THE EXISTENCE OF UTOPIA WHEN THE FUTURE IS REDUCED TO THE FOUR WALLS OF A PRISON CELL. JOHN'S SUBJECT IS A WOMAN AND A CONVICT, INCARCERATED FOR LIFE. UTOPIA IS A NEW COATED LINE FROM APPLETON PAPERS. JOHN'S ISSUE IS PRINTED ON UTOPIA TWO, BLUE WHITE GLOSS, 80LB. TEXT.

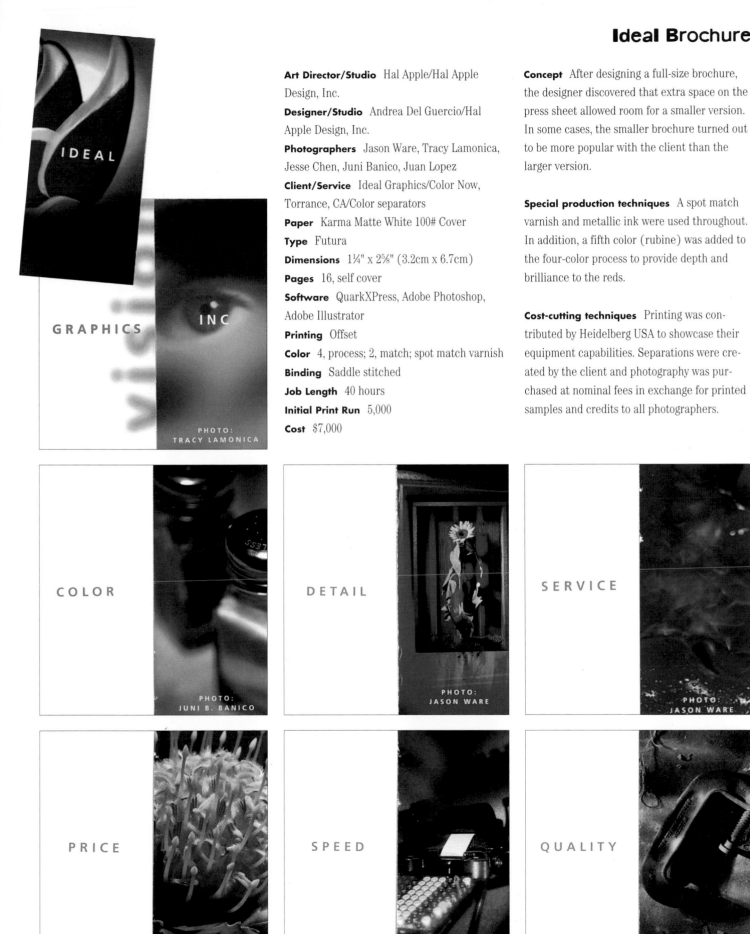

Art Director/Studio Hal Apple/Hal Apple Design, Inc.

Designer/Studio Andrea Del Guercio/Hal Apple Design, Inc.

Photographers Jason Ware, Tracy Lamonica, Jesse Chen, Juni Banico, Juan Lopez

Client/Service Ideal Graphics/Color Now, Torrance, CA/Color separators

Paper Karma Matte White 100# Cover

Type Futura

Dimensions 1¼" x 2⅝" (3.2cm x 6.7cm)

Pages 16, self cover

Software QuarkXPress, Adobe Photoshop, Adobe Illustrator

Printing Offset

Color 4, process; 2, match; spot match varnish

Binding Saddle stitched

Job Length 40 hours

Initial Print Run 5,000

Cost $7,000

Concept After designing a full-size brochure, the designer discovered that extra space on the press sheet allowed room for a smaller version. In some cases, the smaller brochure turned out to be more popular with the client than the larger version.

Special production techniques A spot match varnish and metallic ink were used throughout. In addition, a fifth color (rubine) was added to the four-color process to provide depth and brilliance to the reds.

Cost-cutting techniques Printing was contributed by Heidelberg USA to showcase their equipment capabilities. Separations were created by the client and photography was purchased at nominal fees in exchange for printed samples and credits to all photographers.

Hotel Bohème Brochure

Art Director/Studio Tracy Moon/A E R I A L

Designer/Studio Tracy Moon/A E R I A L

Illustrator John Mattos

Photographers Jerry Stoll, R.J. Muna

Client/Service Hotel Bohème, San Francisco, CA/Hotel services

Paper Starwhite Vicksburg 80# Cover (cover), Quintessence Dull Coated 80# Cover (text)

Type Garamond Bold, 140 percent extended

Dimensions 3⅞" x 9" (9.8cm x 22.9cm)

Pages 12, self cover

Software QuarkXPress, Adobe Photoshop, Adobe Illustrator

Printing Offset

Color 4, process

Binding Saddle stitched

Job Length 160 hours

Initial Print Run 15,000

Cost $25,000

Concept Hotel Bohème is a new, small, local hotel in a colorful and historic San Francisco neighborhood—North Beach, famous for being the favorite haunt of Jack Kerouac and the "Beat/Bohemian" generation of the 1950s. To attract clientele from all over the world, this brochure tied into the art and ambiance of the area with its eclectic pages and poetic quotes.

Special features Interior pages of the brochure were divided/cut horizontally in halves to turn independently, which gave the effect of two interior minibrochures stitched into the cover.

Cost-cutting techniques Duotone effects were created using process equivalents. All hotel business cards and postcards were printed along with the brochures on the same sheet to ensure maximum impact and minimum expense. The cover also stood alone as a smaller brochure for a less expensive trade show handout.

Studio After Hours Creative

Photographer Bob Carey

Client/Service GE Capital, Salt Lake City, UT/Expense management services based on corporate travel cards

Paper Evergreen White 80# Cover

Type Gill Sans (headings), Univers (text)

Dimensions 9" x 12" (22.7cm x 30.5cm)

Software QuarkXPress, Adobe Photoshop, Adobe Illustrator

Printing Offset

Color 4, process; varnish

Binding Saddle stitched

Job Length 150-200 hours

Initial Print Run 10,000

Concept Instead of saddle stitching on the left, this brochure was stitched at the top for a more unusual, dramatic opening. A die-cut window throughout the piece let the reader "see" a real credit card become part of the travel process, graphically demonstrating the beginning-to-end transportation and entertainment expense management from GE Capital Services.

Cost-cutting technique Photos for this piece were used in subsequent materials to manage costs.

Cleveland Institute of Art Catalog 1995-96

Art Directors/Studio Joyce Nesnadny, Mark Schwartz/ Nesnadny + Schwartz

Designers/Studio Joyce Nesnadny, Brian Lavy/Nesnadny + Schwartz

Photographer Robert A. Muller, Mark Schwartz

Client/Service Cleveland Institute of Art, Cleveland, OH/Art school

Paper SD Warren Lustro Dull Recycled 100# (cover), SD Warren Lustro Dull Recycled 80# (text), Gilbert Gilclear Medium Vellum (flysheet)

Type Bodon Meta

Dimensions 9" x 13" (22.7cm x 33cm)

Pages 152 plus cover
Software QuarkXPress
Printing Offset
Color 4, process; 1, match; spot varnish
Binding Saddle stitched
Initial Print Run 48,000

Concept This was the third set of recruiting materials that Nesnadny + Schwartz had produced for the Cleveland Institute of Art. Unlike the last catalog, the current versions did not contain any "dated" information. All data relating to schedules, course descriptions and faculty lists were contained in another simple, two-color publication. The new catalogs were produced with three dramatically different covers to correspond to the next three academic years.

Special production techniques All "duotones" were created from black-and-white originals input using an Agfa Arcus Scanner, manipulated in Adobe Photoshop and output as QuarkXPress documents on a Tektronix Phaser III color printer. These color outputs were used as samples of what Nesnadny + Schwartz wished to achieve in the final job. All original black-and-white prints were then scanned into a DS system as four-color process to simulate a duotone look.

Cost-cutting technique By changing the covers but retaining the same fifty-two pages of content, Nesnadny + Schwartz was able to realize an overall savings in their creative and production budgets of approximately 50 percent.

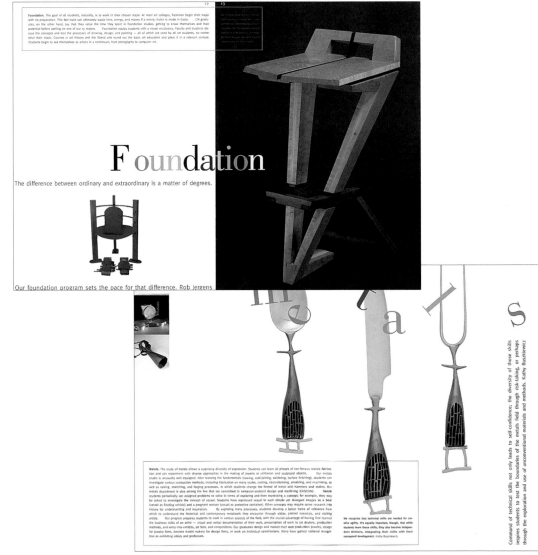

Designers/Studio Mark Popich, Allen Woodard, Melissa Gustafson/The Leonhardt Group

Illustrator Mark Popich

Photographers Doug Dukane, Tom King, Dan Taylor, Don Mason, Allen Woodard

Client/Service O'Brien International, Redmond, WA/Water ski manufacturer

Paper Simpson Evergreen Matte, French Dur-O-Tone

Type Rotis Semi-Sans

Dimensions 8¼" x 11" (21cm x 27.9cm)

Pages 20

Software QuarkXPress, Adobe Photoshop, Macromedia FreeHand

Printing Offset

Color 4, process; spot gloss varnish

Binding Partial saddle stitched/partial loop stitched

Job Length 700 hours

Initial Print Run 60,000

Concept The design of this brochure addressed the traditional water ski market while also catering to the more radical, young and emerging wakeboard audience. Spot gloss varnishes were used throughout to make the products shine off the page.

Special folds or features On dealer version, a loop stitch was added so that it would fit a three-ring binder.

Special production technique Action photography color was tweaked to create a sun-bleached effect by pushing yellow overall and holding back on cyan, magenta and black; product photography was a straight product match.

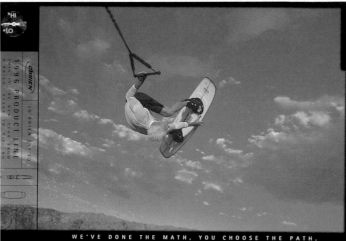

WE'VE DONE THE MATH, YOU CHOOSE THE PATH.

I N F L A T A B L E S

Wake Scooter™

A smaller version of the highly successful DELTA DART, the WAKE SCOOTER™ is designed specifically for riders under 56" in height and weighing less than 100 pounds who want fun and excitement. Features a safety bladder, handle grips and nylon-covered PVC.

Delta Dart™

Planes quicker and slides smoother than a round tube. Made of durable, nylon-covered PVC. Four soft foam handles with neoprene base pads reduce abrasion and heavy webbing provides a secure grip. Second chamber for added safety. Features 3" tow strapping and the new, easy-to-use QUICK CONNECT clip attached to the tow strap. Removable seat cushion provides padding for added comfort. Boston valve reduces inflation/deflation time.

Airborne™

A fast, thrilling ride for one person. Tough I-Beam construction provides durability in the meanest of water conditions. Three-point towing system alleviates structural stress. Grip handles are precisely set to ensure a comfortable ride. Safety bladder and nylon-covered PVC.

Delta Double™

Featuring a quick planing shape, this stable heavy-duty sport inflatable will handle one or two people in any water conditions. Four soft foam handles with neoprene base pads are reinforced with heavy webbing that provide extra grip ability. New, easy-to-use QUICK CONNECT clip attached to the tow strap. Safety bladder, two large floor drains, and Boston valve included. Strong nylon-covered PVC material.

Hydrotread™

Hunker down in this pig and bust through the wake. The Hydrotread is a 66"-diameter, monster inflatable. Heavy-duty, nylon-covered PVC, with electronically welded seams for extra durability. Six soft foam handles with neoprene bases and sturdy webbing on top, with two more grab handles below. The main chamber features a large, recessed Boston valve for easy inflation/deflation, and a floor drain to allow water to escape easily. New QUICK CONNECT clip attached to the tow strap makes hookups a cinch.

Le Tube™

The original! O'Brien's LE TUBE™ offers on-water excitement for all ages. Made with nylon-covered PVC. Four soft foam handles reinforced with durable webbing offer additional safety and security. New QUICK CONNECT clip easily attaches the rope to the tow strap. Safety bladder and Boston valve included.

Scoville Press, Inc. Corporate Brochure

Designer/Studio Eric Kass/Miller Brooks, Inc.

Illustrator Darryl Brown

Photographer Dick Spahr

Client/Service Scoville Press, Inc., Plymouth, MN/Direct response card packs and direct-mail packaging

Paper Lustro Dull

Type Berkeley (text/headings), Univers (captions/sidebars)

Dimensions 8½" x 11" (21.6cm x 27.9cm)

Pages 12

Software QuarkXPress, Adobe Illustrator

Printing Offset

Color 4, process

Binding Saddle stitched

Job Length 150 hours

Initial Print Run 2,500

Cost $20,000

Concept The motion of the images and the movement reflected in the spontaneous typography gave a very contemporary, energetic feel to this brochure. It represented this fast-paced company, which was dedicated to reacting quickly to customer needs. A die-cut pocket on the inside back cover allowed the client to add inserts.

Cost-cutting technique All illustrations were done in house.

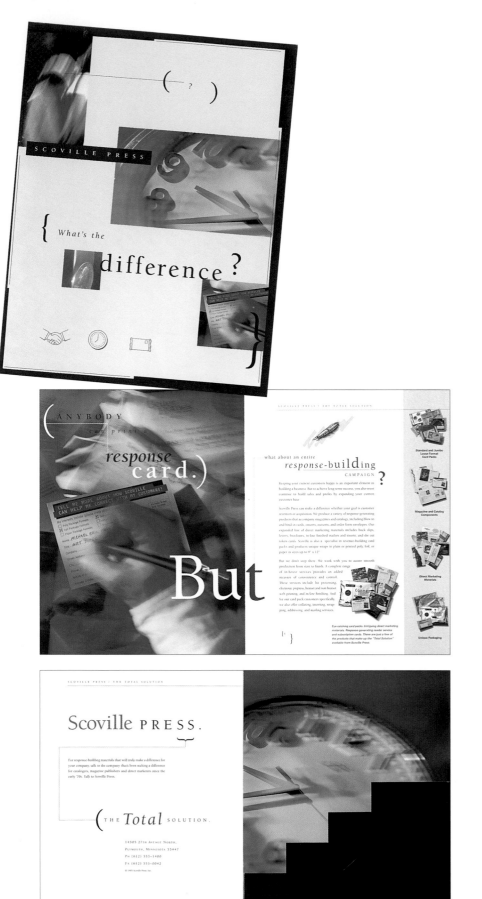

Art Director/Studio Jesse Doquilo/Studio MD

Designer/Studio Jesse Doquilo/Studio MD

Illustrator Jesse Doquilo

Photographer Jesse Doquilo

Client/Service Pyro Media, Seattle, WA/Ceramic die manufacturing

Paper Curtis Flannel (cover); Champion Benefit, Neenah Classic Columns (text); Strathmore Elements

Type Orator, Helvetica Black (headings); Helvetica Condensed (text)

Dimensions 7¼" x 11⅝" (18.4cm x 29.5cm)

Pages 24 plus cover

Software Adobe Photoshop, Macromedia FreeHand

Printing Laser, offset

Color 4, process; 1, PMS

Binding Wire-O

Job Length 90 hours

Initial Print Run 1,000

Cost $12,365

Concept This brochure highlighted Pyro Media's expertise in engineering and ceramic die manufacturing. The actual product of ceramic dies is relatively uninteresting and hard to comprehend; the intriguing die-cut, embossed cover and high-tech photo collages helped the viewer to understand what the product does.

Cost-cutting techniques The piece was cost effective because of its updating and customizing flexibility. The back of each four-color page had a blank page, ready for quick, one-color printing. In the technical part of the brochure, a master page was produced on text stock so that specifications could be printed on a laserwriter and easily updated. The piece was wire-bound in house.

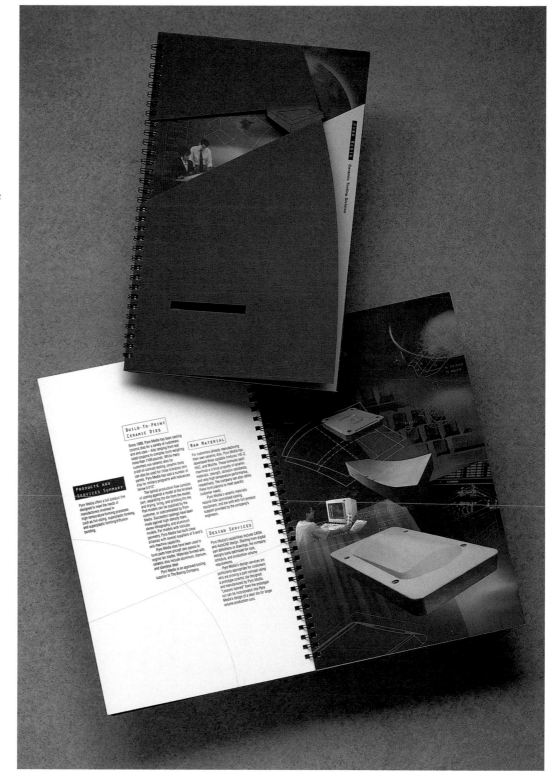

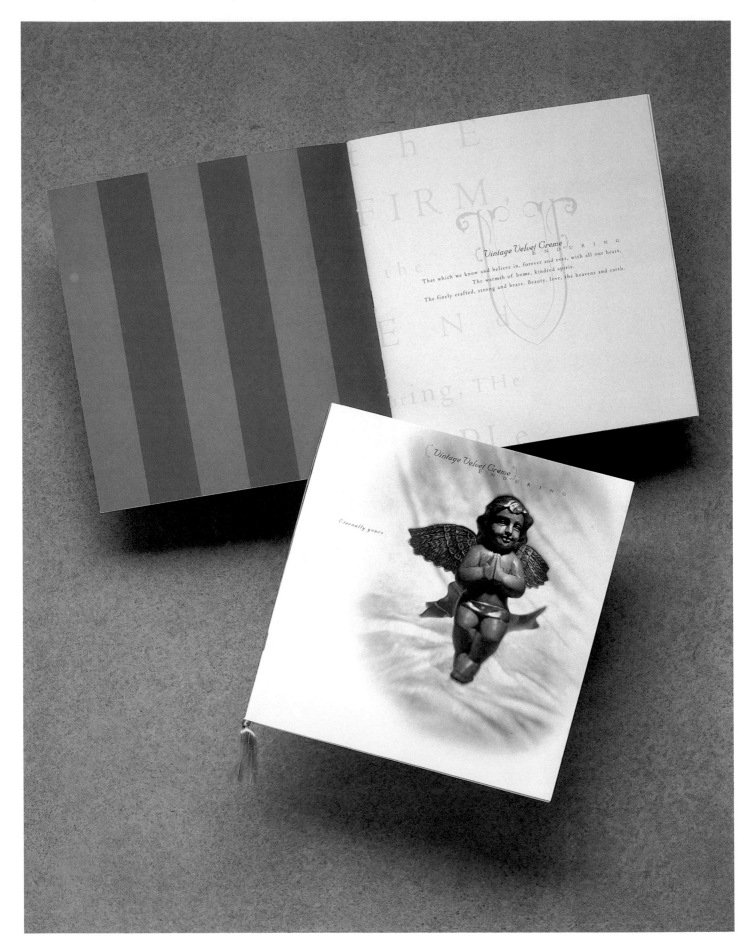

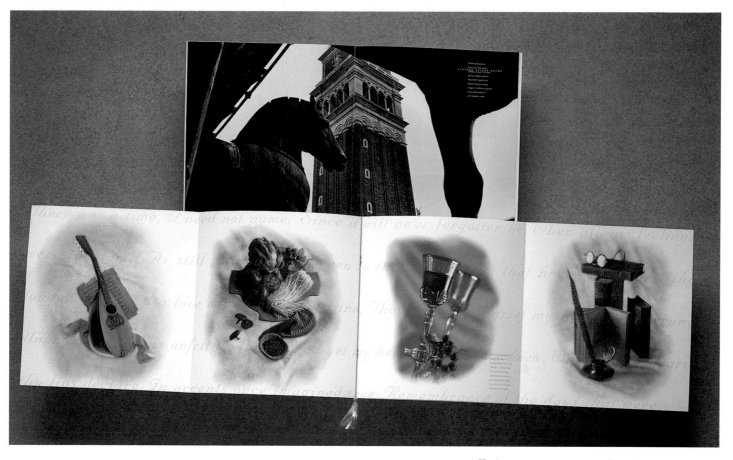

Art Directors/Studio Kevin Kuester, Tim Sauer/The Kuester Group

Designer/Studio Tim Sauer/The Kuester Group

Photographers Buck Holzemer, Craig Cutler, Abrams/Lacagnina, Karen Levy

Client/Service Potlatch Corporation, Cloquet, MN/Quality-coated printing papers

Paper Vintage Velvet Creme 100# Cover (cover), Vintage Velvet Creme 100# Text (text)

Type Missionary (headings); Centaur, Nuptual Script, Gill Sans (text)

Dimensions 8½" x 9" (21.6cm x 22.9cm)

Pages 24 plus cover

Software QuarkXPress

Printing Offset

Color 4, process; off-line tint varnishes

Binding Saddle stitched with gold tassel

Initial Print Run 60,000

Concept The concept was built around the classic image the Vintage Velvet Creme paper represents. This image emphasized the lasting quality and value of the paper. The graphics throughout provided an overall timeless ambiance.

Special folds or features Gatefold in the center and inside the back cover.

Leveraged Compensation Guide

Art Director/Studio Steven Wedeen/Vaughn Wedeen Creative

Designers/Studio Steven Wedeen, Adabel Kaskiewicz/Vaughn Wedeen Creative

Client/Service US West Communications, Phoenix, AZ/Telecommunications company

Paper Mohawk Superfine Ultrasmooth White 80# (cover), Classic Crest Text (text)

Type Blur, Stones Sans, Letter Gothic

Dimensions 6" x 10" (15.2cm x 25.4cm); unfolds to 26" x 11" (66cm x 27.9cm)

Pages 66 plus cover and tabs

Software QuarkXPress, Adobe Photoshop, Macromedia FreeHand

Color 4, process

Binding Wire-O

Initial Print Run 4,000

Concept The high-energy contemporary design made an elective compensation plan look like a desirable one to sign up for. Effective graphics presented complex information in a reader-friendly way.

Special features French-folded cover and semi-concealed Wire-O binding with die-cut pockets and laminated tabs.

Cost-cutting techniques Although the book appears to be full color, the cover and tabs are printed on one four-color form with the remaining text printed in two color for economy. The three-quarter size also helps keep the printing costs down.

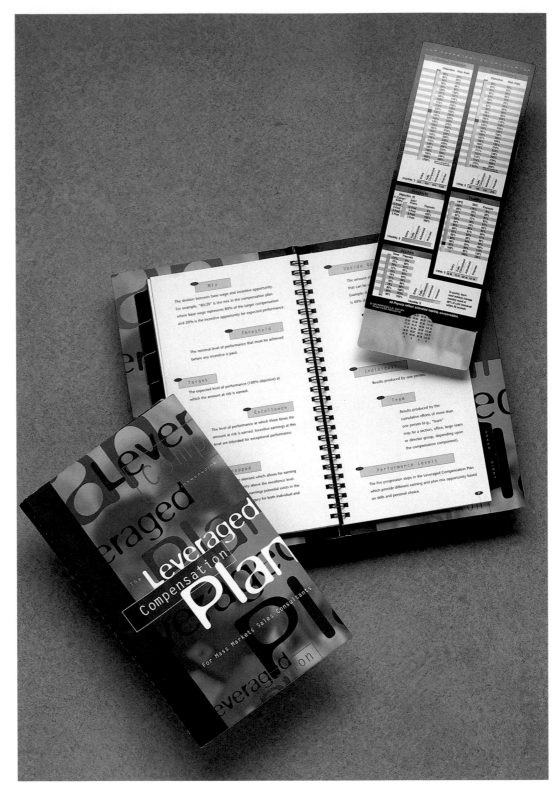

Art Directors/Studio Brad Copeland, George Hirthler/Copeland Hirthler design + communications

Designer/Studio Raquel Miqueli/Copeland Hirthler design + communications

Writer Melissa James Kemmerly

Client/Service Neenah Paper, Roswell, GA/ Uncoated writing paper, text and cover

Paper Neenah Classic Laid, Classic Linen, Classic Columns, Classic Crest, Environment

Dimensions 7¾" x 11¾" (19.7cm x 29.8cm)

Pages 42 plus cover

Software QuarkXPress, Adobe Illustrator

Printing Offset, sculptured embossing

Color 4, process; 18, PMS

Binding Wire-O

Job Length 276 hours

Initial Print Run 25,000

Cost $101,700 (client bought printing)

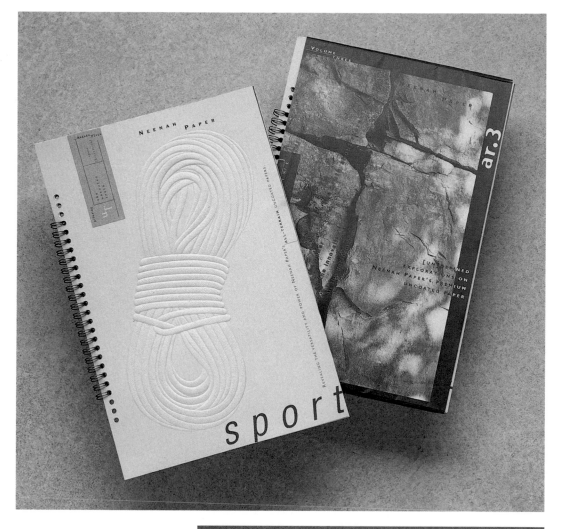

Concept Like the "Fashion" brochure featured previously (see page 50), this "Sports" brochure was promoting the awareness of uncoated papers. It was the third in the series.

For the front cover, an actual rope was sent to the die company to create the emboss die. There were many duotones and tritones with system work throughout the brochure.

Special production techniques To ensure color holdout on the multiple stocks, the designer used Pantone HiFi Hexachrome inks.

Special features The Wire-O binding is not flush top or bottom. The holes drilled for the binding were used as a design element.

World Athletic Series

Art Directors/Studio Todd Houser, Mike Lopez/Pinkhaus

Designers/Studio Todd Houser, Mike Lopez/Pinkhaus

Client/Service ISL Worldwide, Lucerne, Switzerland/Sports and event marketing

Paper Bright Fold 25 pt. Cover (cover), Potlatch Karma White 65# Cover (text), Gilbert Gilclear

Type Wunderlich

Dimensions 13" x 9½" (33cm x 24.1cm)

Pages 38 plus cover

Software Adobe Photoshop, Adobe Illustrator, Macromedia FreeHand

Printing Offset

Color 4, process; 2, match; varnish

Binding Wire-O

Job Length 2 months

Initial Print Run 5,000

Concept The ultimate concept was to show the brand awareness and scope involved in the World Athletic Series. This active and colorful brochure combined the marketing and commercial aspects of sports, blending them attractively with the exhilaration of athletics and the athletes themselves. The four-color images were enhanced through photoimaging in Adobe Photoshop and the use of metallic gold and silver inks and varnishes. The Wire-O binding, although offering a cost-effective option, also served to enhance the pace and atmosphere of the piece.

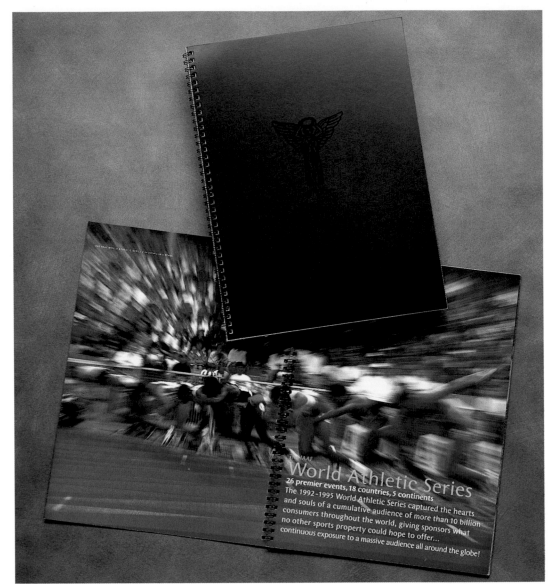

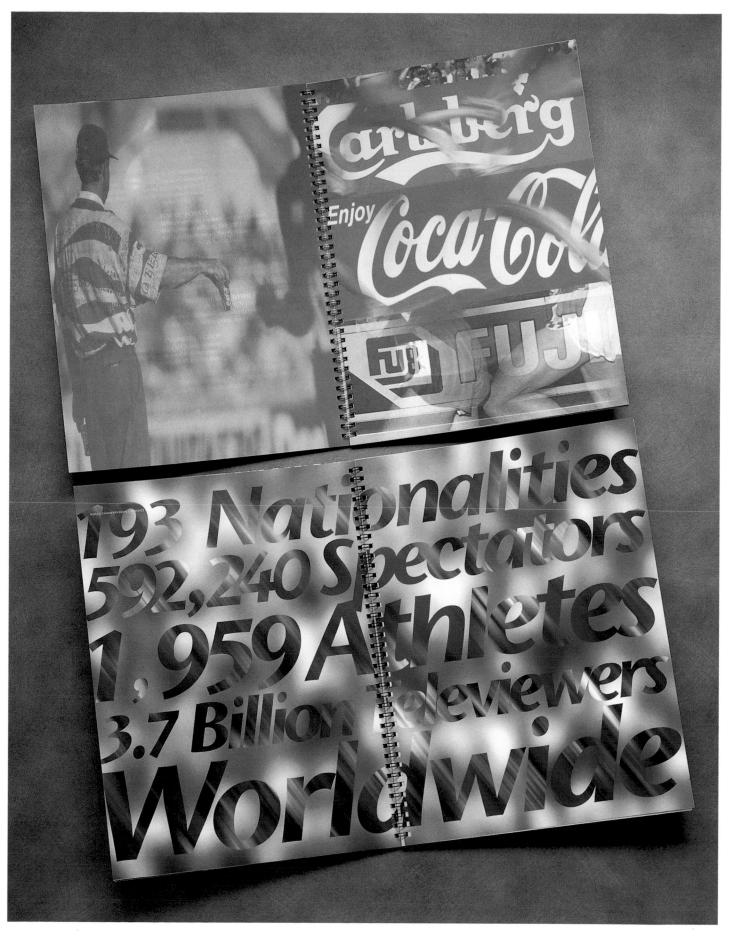

Blown Away

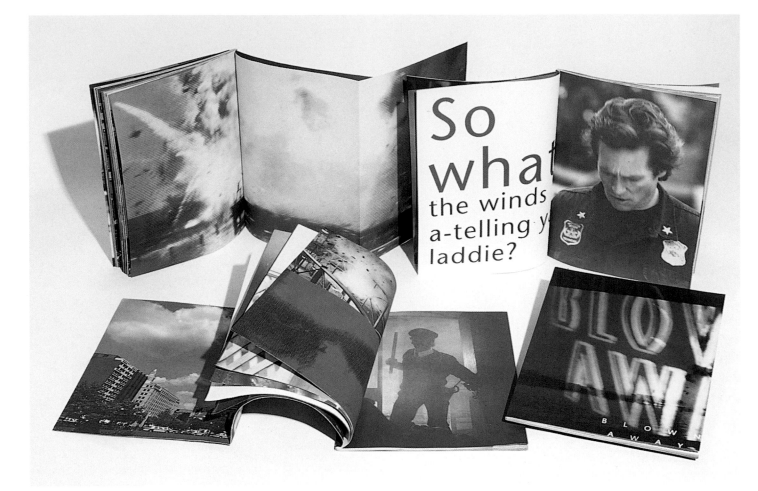

Art Director/Studio Mike Salisbury/Mike Salisbury Communications Inc.

Designer/Studio Patrick O'Neal/Mike Salisbury Communications Inc.

Client/Service MGM, Los Angeles, CA/Motion pictures

Software Adobe PageMaker

Printing Offset

Color 4, process

Binding Perfect

Job Length 30 days

Initial Print Run 5,000

Cost $100,000

Concept The design of this book introduced a documentary feel to this film. The brochure appeared to be the record of a real event rather than a promo for another "bomb" movie.

Special production techniques Feature film segments were shot directly off of an editing machine screen to have a more tactile effect—complete with time code and visual noise.

Special folds Gates, double gates.

Designers/Studio Mark Popich, Jon King, Lisa Aklestad/The Leonhardt Group

Photographer Karen Moskowitz

Client/Service Gargoyles Performance Eyewear, Kent, WA/Sunglasses and protective eyewear

Paper Northwest Dull

Type Univers Condensed Bold and Oblique

Dimensions 8" x 11" (21.6cm x 27.9cm)

Pages 16

Software QuarkXPress, Adobe Photoshop

Printing Offset

Color 4, process; spot gloss varnish

Binding Saddle stitched

Job Length 455 hours

Initial Print Run 20,000

Concept This brochure was sharp and fast-paced. The combination graphics and models were eye-catching and inventive. Because location shoots were not possible, photos of models taken in the studio were dropped into textured backgrounds using Photodisc. Images of the models wearing Gargoyles' products were outlined and given "halos" in Adobe Photoshop before dropping them into the backgrounds.

Special folds or features
Glued pocket inside the back cover.

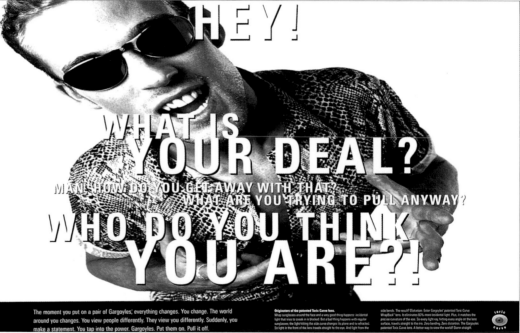

Rock and Roll Hall of Fame and Museum Brochure

Art Directors/Studio Mark Schwartz, Joyce Nesnadny/ Nesnadny + Schwartz

Designers/Studio Joyce Nesnadny, Brian Lavy, Michelle Moehler, Mark Schwartz/ Nesnadny + Schwartz

Photographer Tony Festa (collection)

Client/Service Rock and Roll Hall of Fame and Museum, Cleveland, OH/Museum

Paper SD Warren Lustro Dull Recycled 100# Cover (cover), Lustro Dull Recycled 100# Text (text)

Type OCR, Century (text)

Dimensions 9⅝" x 11¼" (24.4cm x 28.6cm)

Pages 16 plus cover

Software QuarkXPress, Adobe Photoshop

Printing Offset

Color 4, process; 1, match; spot varnish

Binding Letterpress score, die cut, saddle stitched

Initial Print Run 7,000

Concept The Rock and Roll Hall of Fame and Museum brochure communicated its significance to potential donors and supporters in the music industry. Nesnadny + Schwartz designed a brochure that not only recognized the need for this institution, but also captured the excitement and energy of the museum. The brochure included liberal use of photographs of inductees and various memorabilia and artifacts. The result was a colorful, lively and visually engaging piece.

Special folds or features Double gatefold, cover custom pocket.

Special production techniques All "duotones" were created from black-and-white originals input using an Agfa Arcus Scanner, manipulated in Adobe Photoshop and proofed as QuarkXPress documents on a Tektronix Phaser III color printer. All metallic type was manipulated in Adobe Photoshop and printed at either a 45 percent screen or as 100 percent of metallic copper or green.

Art Directors/Studio Brad Copeland, George Hirthler/ Copeland Hirthler design + communications

Designers/Studio Sue Miller, Sam Hero/Copeland Hirthler design + communications

Photographers John Grover, Joel Gilmore, BASF Corporation

Copywriter Melissa James Kemmerly

Account Executives Greg Daney, Jenny Prutz

Client/Service BASF Fibers, Dalton, GA/Carpet fiber manufacturer

Paper Neenah Vintage Dull White 100# Cover (cover), Karma Creme 100# Text (text), Radiant White UV Ultra 17# (flysheet)

Type Helvetica

Dimensions 9¼" x 12¼" (23.5cm x 31.1cm)

Pages 8 plus cover and flysheet

Software QuarkXPress, Adobe Illustrator

Printing Offset, embossing

Color 4, process; special match; 2, PMS; 2 varnishes

Binding Saddle stitched

Initial Print Run 10,000

Concept The designer said "the concept outweighs the client's expectations as a corporate capabilities/product brochure." The inserts provided the flexibility to highlight the most important selling features and could be updated as the products and services developed. This brochure presented the comprehensive story behind BASF's products, services and the ongoing corporate support for research and development.

Special production techniques The Vintage cover stock was not an exact match to the Karma natural color. Because Karma isn't available in 100# cover, the designer mixed a special ink to match the Karma. The emboss on the front was beveled. Many of the images were manipulated to match the signature PMS color after beginning with four-color originals.

Special folds or features Cover and interior pages were die cut with rounded edges. Featured two pockets.

Cost-cutting technique The photography was created for long-term use in mold-image, collateral and trade show applications, and was purchased as a package deal.

Canon Today 1996

Art Director/Studio Alexander Isley/Alexander Isley Design

Designer/Studio Chuck Robertson/Alexander Isley Design

Client/Service Canon USA, Lake Success, NY/Electronics manufacturer

Paper Zanders Ikonofix Dull 50/20 80# (cover), Zanders Ikonofix Dull 50/20 100# Text (text), Gilbert Esse Texture 80# Text (flysheet)

Type Sabon (headings), Egiziano (text)

Dimensions 8½" x 11" (21.6cm x 27.9cm)

Pages 58 total pages for both brochures (24 pages main, 34 product by product)

Software QuarkXPress, Adobe Photoshop, Adobe Illustrator

Printing Offset

Color 4, process; 1, match; varnish

Binding Saddle stitched

Job Length 3 months

Initial Print Run 25,000

Concept These two brochures manage to represent each of the twenty varied divisions of Canon USA. The main brochure (white cover) was a time travel piece that crossed the world showing how Canon products were used in everyday life—from security devices at airports to the stethoscope around a doctor's neck. The product-by-product brochure (black cover) showed each of Canon's divisions from binoculars to medical equipment to cameras. Spot varnishes on images, products and selected text helped to draw the eye.

Special folds or features Foldout flysheet, foldout text page.

Art Directors/Studios Carol Inez Charney/Charney Design and Julia Hamblin/Hamblin Design

Designers/Studios Carol Inez Charney/Charney Design and Julia Hamblin/Hamblin Design

Photographers Paul Shraub, David Castille, Carol Inez Charney

Client/Service Cabrillo Music Festival, Santa Cruz, CA/New music festival

Paper House sheet 70# text

Type Univers (headings), Sabon (text)

Dimensions 12" x 18" (30.5cm x 45.7cm)

Pages 8

Software QuarkXPress, Adobe Photoshop, Adobe Illustrator

Printing Offset

Color 4, process

Binding Folded in half and then in half again for mailing

Job Length 140 hours

Initial Print Run 19,000

Cost $8,400 ($2,000 for design & production; $6,400 for printing)

Concept The rich, photographic design direction served as a visual metaphor for the music of contemporary new American composers—the theme of the festival. The covers were divided into color blocks that facilitated the folding needed for mailing. The unfolded brochure was impressive due to its tabloid size.

Special production techniques Cross process photography; some photos further enhanced through Adobe Photoshop; additional infrared photographic images.

Cost-cutting techniques Designed to be a self-mailer and printing was in four-color without a varnish.

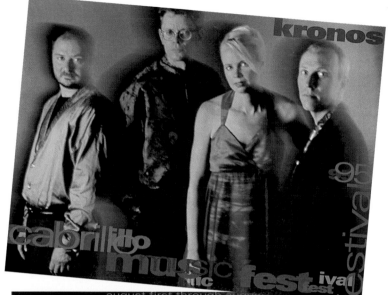

TD Asset Management "We Are Active in Passive"

Art Director/Studio Roslyn Eskind/Eskind Waddell

Designer/Studio Donna Gedeon/Eskind Waddell

Illustrators Donna Gedeon, Gary Mansdridge

Photographer Joel Benard

Client/Service TD Asset Management, Toronto, Ontario/Investment management

Paper Trophy Dull

Type Univers

Dimensions 8½" x 11" (21.6cm x 27.9cm)

Pages 8 plus cover

Software QuarkXPress, Adobe Illustrator

Printing Offset

Color grey and black (duotones), tinted matte varnish, gloss varnish

Binding Saddle stitched

Initial Print Run 2,000

Concept This brochure had a classic professional feel. The duotones provided depth to the black-and-white images and played well against the subtle background colors. Throughout, the type played on the words "active" and "passive" using an italic style for the active sections.

Special production techniques Each collage had selected areas with dot-for-dot gloss varnish and knockout for matte varnish. The matte varnish was tinted. The collages were duotones of black and gray.

Art Director/Studio Morton Jackson/Graffito/Active8

Designer/Studio Kurt Thesing/Graffito/Active8

Photographer Taran Z

Client/Service dbINTELLECT, Golden, CO/One-to-one database marketing solutions

Paper Brochures: LOE Dull White 80# Cover, Gilclear 17#; Kit folder: LOE Dull White 120# Cover

Type Caslon 540, Franklin Gothic Extra Condensed

Dimensions Kit folder: 9" x 12" (22.9cm x 30.5cm); Corporate brochure: 8¾" x 11¼" (22.2cm x 28.6cm); Mini corporate brochure: 4" x 10" (10.2cm x 25.4cm); Line of Business brochure: 8½" x 11" (21.6cm x 27.9cm); International brochure: 8¼" x 11⅝" (21cm x 29.3cm)

Pages Corporate brochure: 20; Mini corporate brochure: 16; Line of Business brochure: 4 panels; International brochure: 6 panels

Software QuarkXPress, Adobe Photoshop, Adobe Illustrator

Printing Offset

Color 4, process; 1, PMS; aqueous coating

Binding Corporate and mini-brochure: scored, folded, saddle stitched; Line of Business and International brochures: scored and folded

Initial Print Run Kit folder: 35,000; Corporate and mini-brochure: 20,000 each; Line of Business brochures: 5,000 each; International brochure: 5,000 each in 4 languages

Concept The concept basis of metaphoric photography combined with new thought-provoking terminology and definitions presented an altogether different approach to dbINTELLECT's audi-

ence. The brochures focused on time and efficiency and how dbIntellect could affect both in a business environment. The photography and the hectic design elements created a feeling of movement—a sense of urgency—within the brochure's pages.

Special folds or features 20,000 brochures were stitched into the kit folder.

Special production techniques Four-color process added a richness to the duotone photography. In combination with the semi-translucent overlays, the photography and graphics created a multileveled picture that corresponded to the theory of dbINTELLECT.

Cost-cutting techniques The 15,000 kit folders without the brochure had an extra panel of copy on the inside, so they were much more cost effective for unqualified leads.

Equifax Utilities Brochure

Art Directors/Studio Brad Copeland, George Hirthler/ Copeland Hirthler design + communications

Designers/Studio Melanie Bass Pollard, David Woodward/ Copeland Hirthler design + communications

Photographers Fredrik Broden, Jerry Burns, Mark Shelton

Writers Marti Nunn, Melissa James Kemmerly

Client/Service Equifax, Atlanta, GA/Financial information management and analysis

Paper Simpson Starwhite Tiara Smooth 80# Cover (cover), Potlatch Quintessence Dull 100# Text (text)

Type Perpetua, Futura, Univers

Dimensions 9⅛" x 12" (23.2cm x 30.5cm); unfolds to 36⅜" x 12" (92.4cm x 30.5cm)

Pages 8 plus cover

Software QuarkXPress, Adobe Photoshop, Adobe Illustrator

Printing Offset

Color 4, process; 1, match; varnish

Binding Saddle stitched

Initial Print Run 5,000

Concept This brochure system promoted Equifax's ability to offer a full range of decision making and financial services to telecommunications and utilities companies. Varnishes were used throughout to draw the eye to a critical graphic or design element that helped to visualize the concepts outlined in the text.

Cost-cutting techniques Considerable dollars were saved by setting up a "library of images" that work across the system in numerous brochures. Many were shot as two images (such as the woman on the phone) to make the artwork more versatile. Shots could be used in various combinations to emphasize different concepts.

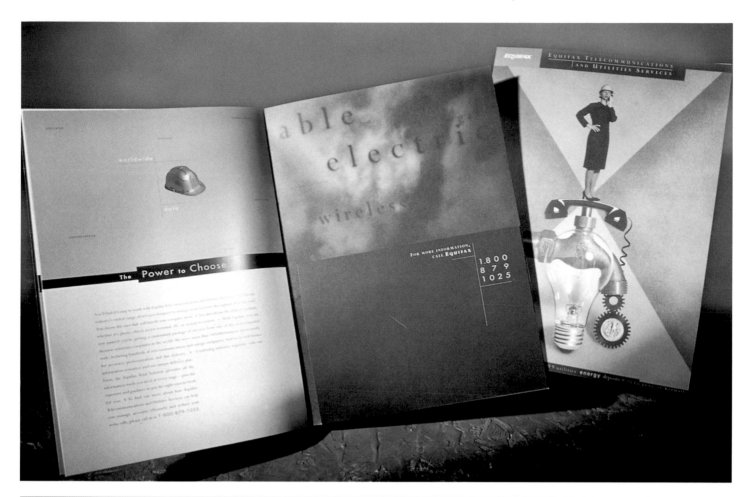

World Bank Global Bonds Brochure—Japanese Version

Art Director/Studio Mary Ellen Vehlow/Pensare Design Group Ltd

Designers/Studio Camille Song, Tim Flynn/Pensare Design Group Ltd

Illustrator Tim Flynn

Client/Service The World Bank—Global Bond Division, Washington, DC/Global bond offerings

Paper Phoenix Imperial Dull 110# Cover (cover), Phoenix Imperial Dull 100# Text (text)

Type Cover and text: Japanese typefaces; Charts: Optima, Futura, Jansen Text

Dimensions 8½" x 11" (21.6cm x 27.9cm)

Pages 24 plus cover

Software QuarkXPress, Adobe Photoshop, Macromedia FreeHand

Printing Offset

Color 4, process; 1, PMS; 2 varnishes

Binding Saddle stitched

Job Length 80 hours

Initial Print Run 2,500

Cost $15,000

Concept The World Bank needed a marketing brochure to identify and highlight the performance of three separate bond issues: the U.S. dollar, the Japanese yen and the German mark. Although varied in availability and performance, the information needed to be presented as comparable. This comparison was accomplished by creating a parallel system of presentation for the text as well as the charts/graphs for each of the three sections. The Japanese ver-sion of the Global Bond brochure was an adaptation/translation of the English version, also designed by Pensare; thus many of the same graphics were used in both. All of the artwork for the identification icons, the backgrounds for the graphs and the sphere-shaped pie charts were created internally from images scanned from actual currency.

Team Scandia Racing Brochure

Art Director/Studio Jack Anderson/Hornall Anderson Design Works

Designers/Studio Jack Anderson, Julie Lock, Alan Florsheim, Joy Miyamoto/Hornall Anderson Design Works

Client/Service Scandia, Redmond, WA/Race car team

Paper Eloquence

Type Meta, Square Serif

Dimensions 9" x 12½" (22.9cm x 31.7cm)

Pages 10

Software QuarkXPress, Macromedia FreeHand

Printing Offset

Color 4, process; 5, PMS

Concept This brochure served as a sponsorship recruitment piece for an Indy Car Racing Team. The use of bright, bold colors and photographs created a standout brochure to help generate excitement among potential sponsors. The large photographs, which covered an entire spread, brought the reader into the action. Coordinating color tints spread across the bottom of the photographs so that text showed up well. These tints also served to extend the visual of the photograph even further on the page.

TEAM SCANDIA

TEAMWORK

YOUR PLACE ON THE TEAM.

Join a Team that has the best of the best, and reap the benefits in terms of promotional value. A sponsor of one of the 33 cars fielded in the Indianapolis 500 gains an estimated $72.4 million worth of exposure. Those are numbers you can live with.

SOLID EXPERIENCE.

Members of Team Scandia have been racing Indy Cars since 1983, racking up pole positions and podium finishes consistently, year after year.

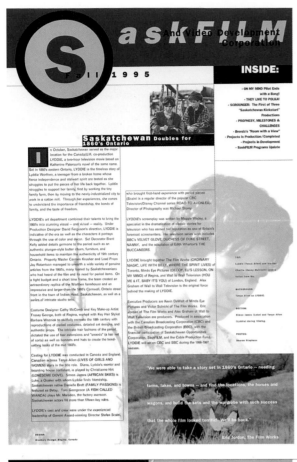

Art Director/Studio Catharine Bradbury/Bradbury Design

Designer/Studio Catharine Bradbury/Bradbury Design

Client/Service Sask Film, Regina, Saskatchewan/Film development and production funding

Paper Luna Matte 70# Text

Type Franklin Heavy (headlines, subheads), Groschen Book (body copy), Franklin Demi (photo captions, credits, numbers)

Dimensions 8½" x 11" (21.6cm x 27.9cm)

Pages 12

Software QuarkXPress

Printing Offset

Color 3, match

Initial Print Run 13,000

Cost $11,272

Concept This newsletter/brochure developed an identity for Sask Film. Because it was distributed as an insert in a national industry tabloid publication, the design had to command the attention of the viewer. The three Pantone colors were repeated throughout the newsletter in duotones, which gave the newsletter visual cohesiveness as well as diversity from using strictly black-and-white halftones.

Art Directors/Studio Pol Baril, Denis Dulude/K.-O. Creation

Designers/Studio Pol Baril, Denis Dulude/K.-O. Creation

Photographer Carl Lessard

Client/Service Steilmann Group/Clothing

Paper Supreme Gloss 8 pt.

Type Pure (Garage fonts), Arbitrary Sans (Emigre)

Dimensions 6⅜" x 8¼" (16.2cm x 21cm)

Pages 12

Software QuarkXPress, Adobe Photoshop

Printing Offset

Color 4, process

Job Length 15 hours

Initial Print Run 8,000

Cost $10,000

Concept The idea behind this brochure was to create a printed piece that displayed men's clothing for the Spring '96 season. At the same time, the brochure effectively generated a classic mood of a "well-established brand." The shots were moody and casual. The clothing lines looked not only established, but casually elegant at the same time.

Special production techniques Dry varnish on a second pass.

Cost-cutting technique The brochure was printed at the same time as the Steilmann women's clothing brochure. The brochures were printed two up.

Eagle Insurance Brochure

Designers/Studio Tim Young, Dennis Clouse/The Leonhardt Group

Photographer David Crosier

Client/Service Eagle Insurance Group, Seattle, WA/Worker's compensation insurance

Paper Fox River Confetti 80# Cover (cover), Zanders Ikonofix Matte Text (text)

Type Warehouse, Gill Sans

Dimensions 7½" x 11" (19cm x 27.9cm)

Pages 16 plus cover

Software QuarkXPress

Printing Offset

Color 6 spot color; tritones

Binding Grommets

Job Length 197 hours

Initial Print Run 5,000

Concept Eagle Insurance provided workers compensation insurance to high-risk industries. Their audience was brokers who sell to shipyards, high-rise iron contractors and so on. Therefore, the use of stencil lettering, metallic inks and the grommet hardware for the bindery was not only appropriate, but also emphasized the concept that the Eagle Insurance Group was a partnership company that was "in touch" with its client base. The brochure appeared durable, which was an attractive image for an insurance company.

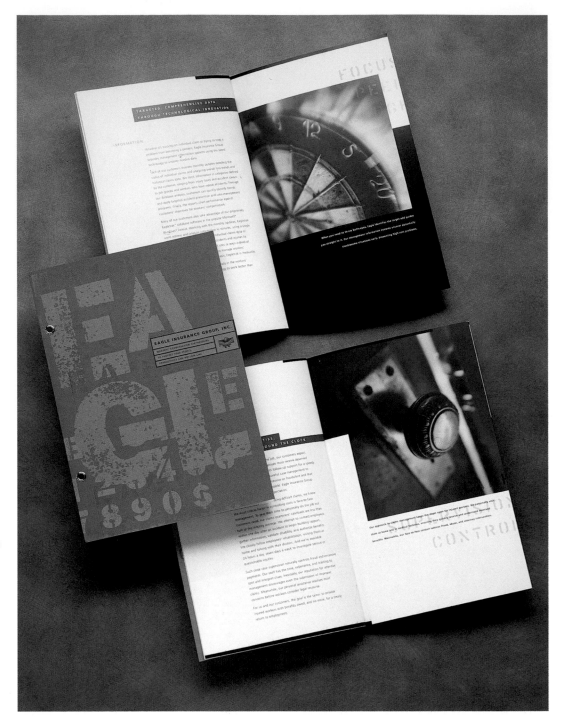

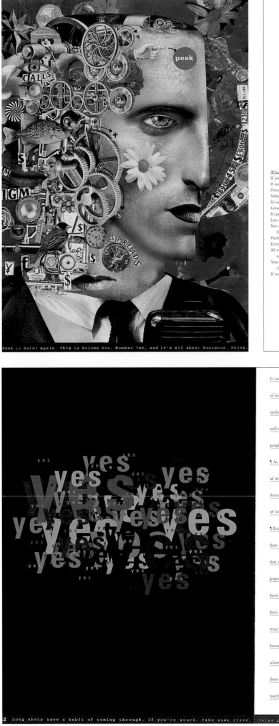

Art Director/Studio Bob Goebel/The Kuester Group

Designer/Studio Bob Goebel/The Kuester Group

Client/Service Potlatch Corporation, Cloquet, MN/Premium-coated printing papers

Paper Vintage Gloss 80# Cover, 100# Text

Type Bembo, Univers Condensed

Dimensions 8" x 12" (21.6cm x 30.5cm); unfolds to 25" x 12" (63.5cm x 30.5cm)

Pages 16 plus cover

Software QuarkXPress

Printing Offset

Color 4, process; 1, match; 1 varnish

Binding Saddle stitched

Initial Print Run 50,000

Concept This brochure reinforced Potlatch's educational strategy for providing regular communication with target audiences. The "Peek" series of brochures focused on one theme and used the paper industry to relate to it. This particular brochure focused on business. The design was fun and innovative.

Special folds or features Gatefold on back cover; die-cut hole for masthead.

Cost-cutting techniques All printed in-line on press. Made extensive use of stock photography/ illustration.

Katy's Place

Art Director/Studio Jeff Miller/Muller + Company
Designer/Studio Jeff Miller/Muller + Company
Photographer Dan White
Typographer Jeff Miller
Client/Service Katy's Place, Kansas City, MO/A place for women and children with HIV/AIDS
Paper Signature Dull
Type Futura, Goudy, Hardtype
Dimensions 9½" x 12" (24.1cm x 30.5cm)
Pages 12
Software QuarkXPress, Adobe Photoshop, Adobe Illustrator
Printing Offset
Color 6, match
Binding Saddle stitched
Job Length 30 hours

Cost Design was donated

Concept HIV/AIDS is a subject that can only be discussed in appropriate terms. The moody, shaking imagery of the piece lended itself to an emotional reaction by the viewer. The photographs were stripped out on the sides to make them appear worn or damaged, which added to the emotion behind the subject.

Special production techniques Cyan-type photographs were printed as tritones (blue, blue and yellow). All inks were dull, which created an effective mood for the piece.

Art Directors/Studio Brad Copeland, George Hirthler/Copeland Hirthler design + communications

Designers/Studio Todd Brooks, Kathi Roberts/Copeland Hirthler design + communications

Photographer Chris Hamilton

Writer Melissa James Kemmerly

Client/Service World Color Press, New York, NY/Printing

Paper Classic Crest Duplex Tarragon/White 120# Cover (cover), Consolidated Reflections Gloss 100# Text (text), Mohawk Bright White Natural Parchment 60# Text (flysheet)

Type OCRB1, Matrix Italic, Caslon

Dimensions 11" x 14" (27.9cm x 35.6cm); unfolds to 28" x 22" (71.1cm x 55.9cm)

Pages 36 plus cover and flysheet

Software QuarkXPress, Adobe Photoshop, Adobe Illustrator

Printing Laser, emboss/clear foil

Color 4, process; 8, PMS; 4 varnishes

Binding Saddle stitched/glued

Job Length 536 hours

Initial Print Run 25,000

Cost $110,000

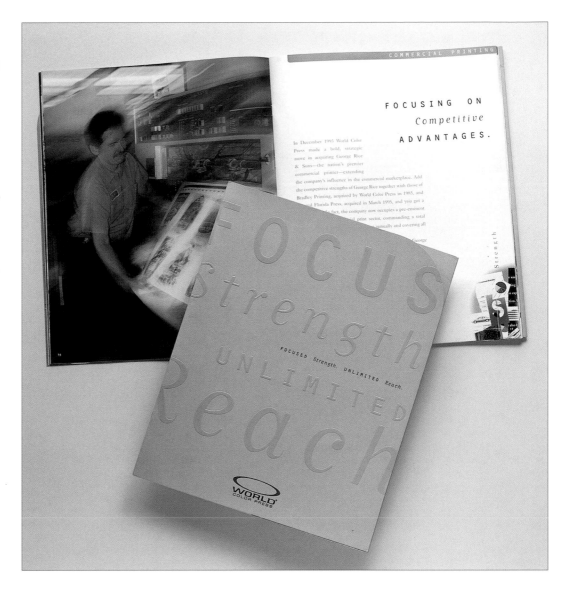

Concept The company had been on a purchasing spree within the industry and was preparing for an initial purchasing option. The brochure helped define the company from a new business perspective as well as provided investors with enough financial information to evaluate the stability of the company.

Special folds or features Brochure saddle stitched into the cover; flap folded over; pocket glued to the center panel.

Special production techniques A special match ink was used on the cover for a tone-on-tone effect. On the time line, special tint varnishes were used.

Cost-cutting technique Since the company owned printing companies all over the country, the project was printed at George Rice and Sons in Los Angeles at no cost except for paper.

The Classic Look

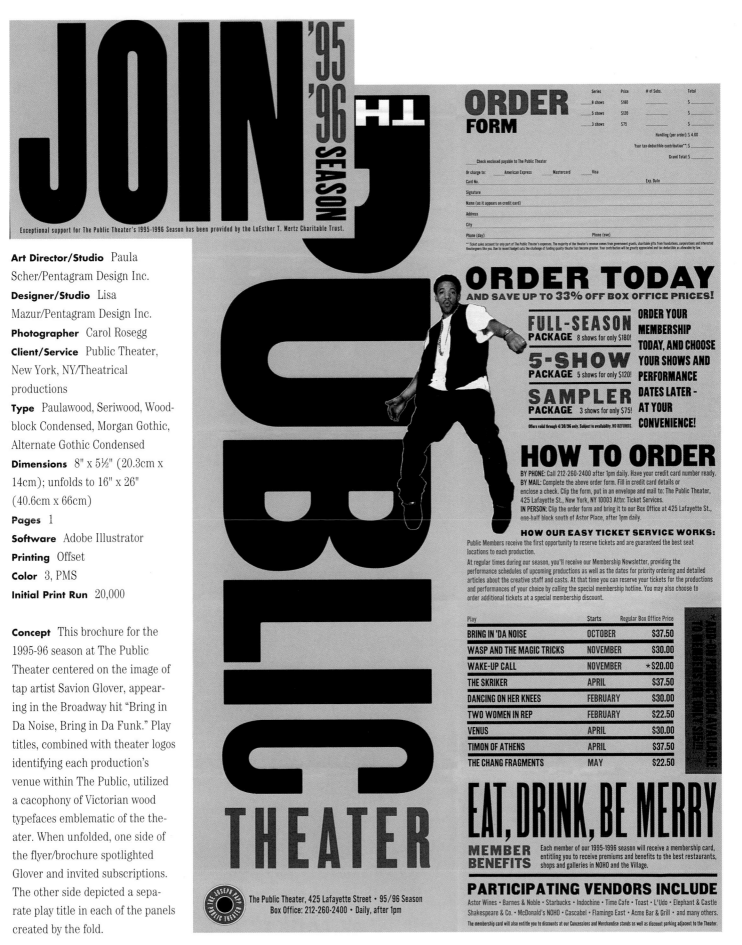

Art Director/Studio Paula Scher/Pentagram Design Inc.

Designer/Studio Lisa Mazur/Pentagram Design Inc.

Photographer Carol Rosegg

Client/Service Public Theater, New York, NY/Theatrical productions

Type Paulawood, Seriwood, Woodblock Condensed, Morgan Gothic, Alternate Gothic Condensed

Dimensions 8" x 5½" (20.3cm x 14cm); unfolds to 16" x 26" (40.6cm x 66cm)

Pages 1

Software Adobe Illustrator

Printing Offset

Color 3, PMS

Initial Print Run 20,000

Concept This brochure for the 1995-96 season at The Public Theater centered on the image of tap artist Savion Glover, appearing in the Broadway hit "Bring in Da Noise, Bring in Da Funk." Play titles, combined with theater logos identifying each production's venue within The Public, utilized a cacophony of Victorian wood typefaces emblematic of the theater. When unfolded, one side of the flyer/brochure spotlighted Glover and invited subscriptions. The other side depicted a separate play title in each of the panels created by the fold.

Philips Media

Art Director/Studio Robin Perkins/Clifford Selbert Design Collaborative

Designers/Studio Brian Lane, Brian Keenan/Clifford Selbert Design Collaborative

Photographer Scott Hensel

Client/Service Philips Media/CD-ROM publishers, distributors

Paper Scuba Neoprene (uncoated, coated stocks)

Type Franklin Gothic

Pages 50

Software QuarkXPress, Adobe Photoshop, Adobe Illustrator

Printing Laser, lithography, screen printing

Color 3

Job Length 6 weeks

Initial Print Run 60,000

Concept These brochures were two components of a marketing system. A single binder housed a VHS video cassette, two CD-ROMs, five pages of tabs and marketing information. The Media Distribution brochure summarized the philosophy and goals of Philips Media. The other brochure was a catalog of interactive software. The design communicated the fun, amusing, entertaining world of Philips Media. It energized the sales team and presented Philips Media's strength in its international and national distribution force. The catalog used the image of a CD-ROM as an overlay onto photographs. The CDs became glasses and tables, anything circular.

Art Director/Studio Steven
Wedeen/Vaughn Wedeen Creative

Designers/Studio Steven
Wedeen, Adabel Kaskiewicz/
Vaughn Wedeen Creative

Client/Service US West
Communications, Phoenix,
AZ/Telecommunications company

Paper Starwhite Vicksburg Tiara
Smooth White 80# Text

Type Missive, OCRA

Dimensions 8½" x 11" (21.6cm x
27.9cm)

Pages 8

Software QuarkXPress, Adobe
Photoshop

Printing Offset

Color 4, process

Binding Saddle stitched

Initial Print Run 4,500

Concept This brochure depicted
an incentive plan for telecommu-
nications employees of US West
Communications. The four-color
process background graphics used
muted versions of primary colors
(red, blue, yellow) in addition to
others. The colorful, block graphic
elements gave a contemporary
look to a normally mundane factu-
al document. This informational
guide enticed employees to partic-
ipate in the program.

3 Sixty (2)

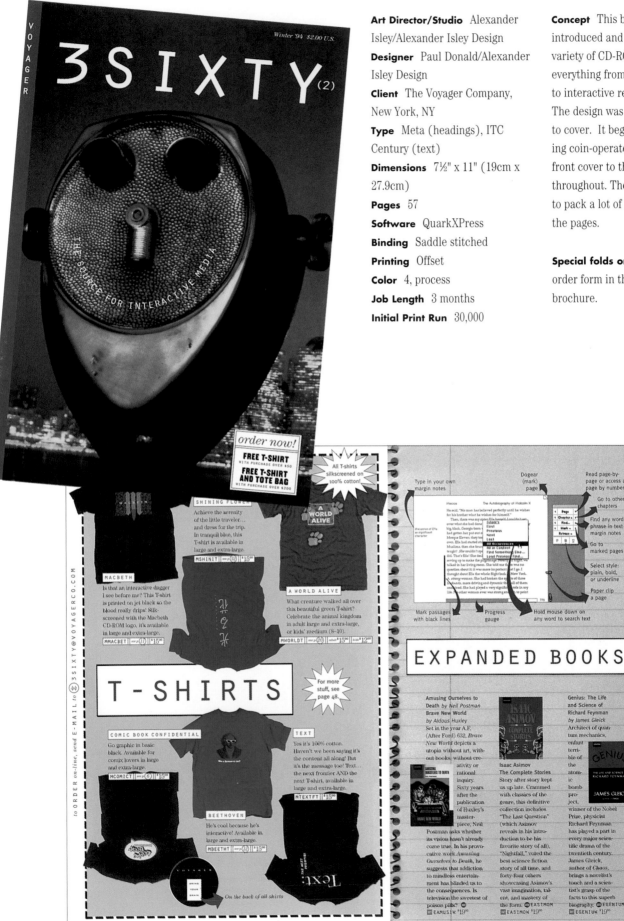

Art Director/Studio Alexander Isley/Alexander Isley Design

Designer Paul Donald/Alexander Isley Design

Client The Voyager Company, New York, NY

Type Meta (headings), ITC Century (text)

Dimensions 7½" x 11" (19cm x 27.9cm)

Pages 57

Software QuarkXPress

Binding Saddle stitched

Printing Offset

Color 4, process

Job Length 3 months

Initial Print Run 30,000

Concept This brochure/catalog introduced and explained a wide variety of CD-ROM offerings— everything from books to movies to interactive reference utilities. The design was clever from cover to cover. It began with the smiling coin-operated telescope on the front cover to the foray of images throughout. The layout managed to pack a lot of information into the pages.

Special folds or features Foldout order form in the back of the brochure.

index

A B O U T T H E T E C H. R E Q U I R E M E N T S

If a program is available on the Macintosh platform, the product description contains an Ⓜ. If it's available on Windows, there is a Ⓦ. We've also created a simple number/letter code describing the optimal hardware configuration required to run each title. You can find this in the index, which starts on page 48. For details on the code, see below. Questions? Call 1-800-446-2001. Ask us. We'll help you figure it out.

Ⓜ **MAC** — Any Macintosh with a CD-ROM drive.

TYPE 1 — Any Macintosh with color display and a CD-ROM drive.

GENERAL — All products require a hard disk drive with up to 10 MB free space, and may require up to 2,260K of free RAM unless otherwise noted.

KEY TO MODIFIERS
a: May require up to 3,200K of free RAM.
b: May require up to 3,500K of free RAM.
c: Requires 640x480-resolution (13") or larger monitor.
d: Requires speakers or headphones if CD-ROM drive is external.

EXPANDED BOOKS (EB) — AB PowerBooks, and all Macintoshes with 13" monitors.

technical specifications

Ⓦ **WIN**

TYPE 1
386SX or higher processor
640x480, 256-color display
4 MB RAM (8 MB recommended)
MPC-compatible CD-ROM drive and sound card with speakers or headphones
Microsoft Windows 3.1, MS-DOS 5.0 or later

TYPE 2
486SX-33 or higher processor
640x480, 256-color display (accelerator recommended)
8 MB RAM
MPC-2-compatible CD-ROM drive and sound card with speakers or headphones
Microsoft Windows 3.1, MS-DOS 5.0 or later

EXPANDED BOOKS (EB)
386SX or higher processor
640x480, 16 color/grayscale display
4 MB RAM
Microsoft Windows 3.1, MS-DOS 5.0 or later. Books with audio annotations (marked with an asterisk) require an MPC-compatible sound card with speakers or headphones.

COPY BY AUSTON APPLEWHITE, DESIGN BY ALEXANDER ISLEY DESIGN, NEW YORK
"3SIXTY" TITLE BY MARA GOODNECK AND JOHN RORKE · OPPOSITE FIELD

BAM Spring 1995 and 1996

Designers/Studio Michael Bierut, Emily Hayes/Pentagram Design Inc.

Client The Brooklyn Academy of Music, New York, NY

Dimensions 7" x 11" (17.8cm x 27.9cm)

Pages 32 in each

Color 4, process

Binding Saddle stitched

Concept The design behind the Spring 1996 brochure branched from the 1995 season brochure (striped cover). The Spring brochure was mailed to sell advance tickets to the Spring 1996 season at the Brooklyn Academy of Music. As seen in the earlier brochure, Pentagram had created a distinctive typographic style for BAM using fragments of the typeface News Gothic. For the spring season, brighter colors were selected and the type used on the cover and throughout the headlines suggested emerging flowers.

Art Director/Studio John Muller/
Muller + Company

Designer/Studio John Muller/
Muller + Company

Photographer Ben Webbte

Paper Signature Gloss

Dimensions 12" x 12½" (30.5cm x
31.7cm)

Pages 12

Software QuarkXPress, Adobe
Photoshop, Adobe Illustrator

Printing Offset

Color 4, process; 2, match

Binding Saddle stitched

Initial Print Run 30,000

Concept The design was bright
and bold to sell Lee's colorful line
of kids clothes. The graphics and
photographs selected to accompa-
ny the clothing line were just as
intense as the clothes. Careful
selection of artwork ensured that
the ads would appeal to children
as well as parents.

The Alter Group Chameleon Brochure

Art Director/Studio Michael Stanard/Michael Stanard Design

Designers/Studio Lisa Fingerhut, Michael Stanard/Michael Stanard Design

Photographer John DeSalvo

Client/Service The Alter Group, Chicago, IL/Commercial real estate development

Paper Centura Gloss, Consolidated

Type Copperplate 33bc, Helvetica Condensed

Dimensions 9" x 12" (22.7cm x 30.5cm)

Pages 16, self cover

Software QuarkXPress, Adobe Photoshop

Printing Offset

Color 4, process; 1, PMS; varnish

Job Length 1 month

Initial Print Run 25,000

Cost $15,000 design and production; $30,000 printing

Concept The concept of changing times and being flexible as a business tied in well with the chameleon. The brochure nearly doubled as an educational piece on the color-changing lizard. In addition to the large, colorful images, catch phrases were displayed at the top of each page like a banner. The right-hand page offered the illusion, the left-hand page the reality. The progression was predictable but entertaining. The final reality statement is "Many companies try to look like the Alter Group . . . but they're easy to spot."

Special production techniques Michael Stanard Design assures the "politically correct"—that no chameleons were harmed for this brochure.

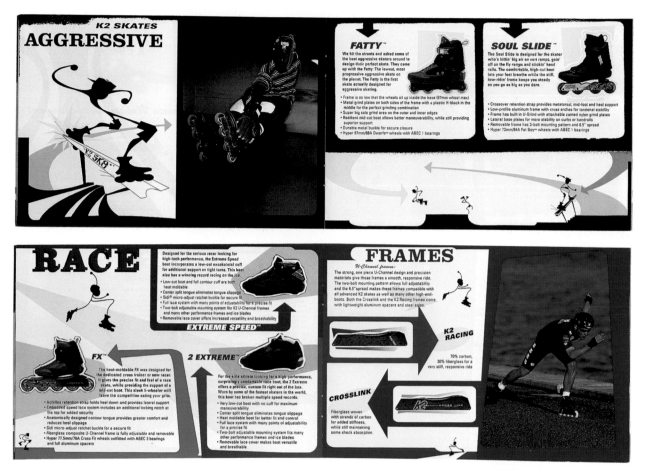

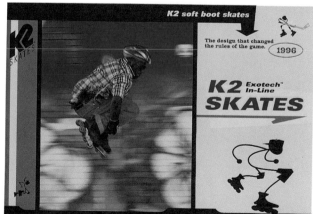

Art Director/Studio George Estrada/Modern Dog

Designer/Studio George Estrada/Modern Dog

Illustrator George Estrada

Photographers Scott Markewitz, Jeff Curtis, Greg Montigo

Client/Service K2 Exotech, Vashon Island, WA/In-line skates, equipment and apparel

Paper Champion Benefit (cover), Vintage Remarque Velvet (text)

Type Arrowmatic, Clarendon, Brush Script, Univers Bold Extended, Univers 5, 67 Condensed

Dimensions 8" x 5½" (20.3cm x 14cm)

Pages 24 plus cover

Software QuarkXPress, Adobe Photoshop, Adobe Illustrator

Printing Offset

Color 4, process

Binding Saddle stitched

Initial Print Run 65,000

Concept K2 was basically brand new in the in-line skate market (1994 was their first year). They wanted to maintain the technical look while moving in a more fun, street graphic direction. This design was packed with strong color and movement. The "stick figure" illustrations added a youthful, graffiti-type touch as they appeared to mimic the motions of the actual photographs.

Butterfield & Robinson Expeditions 1996

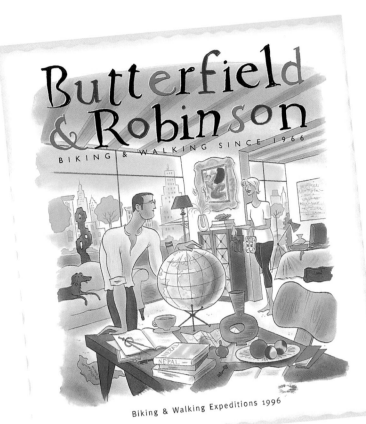

Biking & Walking Expeditions 1996

Studio Viva Dolan Communications & Design

Dimensions 9½" x 12" (24.1cm x 30.5cm)

Pages 16, self cover

Color 4, process

Binding Saddle stitched, perfect bound (Europe brochure)

Cost $25,000

Concept The saddle-stitched brochure summarized walking and biking tours coordinated by Butterfield & Robinson throughout the world. Each page was a vignette of the itinerary and attractions for places like Mexico, Israel and Kenya. Bound into the center was a Butterfield & Robinson newsletter that gave updated information on schedules and inviting articles on previous trips. The perfect-bound brochure (black cover) focused on trips in Europe. With much the same information format as the other brochure, this one was more glossy and appeared to be more expensive. The combination of playfulness in the illustration and the good location photography was a good mix. In each brochure, there were eight levels of information on each trip page.

Cost-cutting technique Paper was ordered as "special makings" to suit press size, so there was no wastage.

Belize
Exploring Mayan Ruins and the Barrier Reef

Our journey takes us from lost Mayan pyramids to the islands off Ambergris Caye.
If your idea of a great winter escape combines archaeology, ecological rain forest walks, and snorkelling on the world's second-longest barrier reef, we've found everything you're looking for in Belize. To top it off, we've also lined up the best accommodation in the Americas this far from civilization. From luxurious thatched lodges deep in the jungle, you can spend a day exploring Mayan sites, then relax on the verandah sipping Pimms or a cold Belikan Beer. We explore both sides of Belize: the former English colony that blends Creole, Spanish and native cultures; and the ancient Mayan world embodied in the majestic ruins of Tikal and Xunantunich.

Belize
8 DAYS / 7 NIGHTS
Nov '95 Dec Jan '96 Feb
Mar Apr Nov Dec
START / FINISH
Belize City
PRICE
US$3,250
($500 single supplement)

Days 1 & 2 From *Belize City*, we head inland to **Chaa Creek Cottages**, a beautiful thatched lodge in a remote jungle farm setting. Walk along the Maya Panti Medicine Trail, explore ancient Mayan caves and the excavation site of Xunantunich, then canoe along the Macal River into San Ignacio. **Day 3** By four-wheel-drive to *Tikal*, the largest and most renowned Mayan site in Central America. We explore the ruins, walking through mist-shrouded jungle to Temple IV. From this former vantage point of priests and kings, you can imagine the city of 100,000 that flourished here a thousand years ago. The incredibly advanced culture of the Maya is recorded in the carvings and half-deciphered hieroglyphs that adorn the temple walls. At day's end, we cruise along Lake Petén Itzá to **Hotel Camino Real Tikal** and relax in this unexpected oasis. **Days 4 & 5** Fly to *San Pedro* on Ambergris Caye for two days of exploring the barrier reef. Leisurely snorkelling, beachcombing and seafood lunches at Elvi's, our favourite local watering hole. Two nights at Victoria House, right on the ocean. After a final breakfast, return flight to *Belize City*.

in the plaza of a Mayan site. Wildlife and birding walks through the jungle, with options for horseback riding on the Punta Cacao Trail and canoeing on Laguna Verde. **Days 6, 7 & 8** Fly to *San Pedro* on Ambergris Caye for two days of exploring the barrier reef. Leisurely snorkelling, beachcombing and seafood lunches at Elvi's, our favourite local watering hole. Two nights at Victoria House, right on the ocean. After a final breakfast, return flight to *Belize City*.

2

Mexico
Walking Among the Silver Cities of the North

"What do you mean, 'Who's Frida Kahlo?' I read that chapter to you on the plane."
In the 16th century, conquering Spaniards discovered silver in the hills of northern Mexico. As riches flowed from the mines, the cities of Guanajuato, Querétaro and San Miguel de Allende became jewels of the Spanish crown. Fabulous churches and homes lined the central plazas, and multicoloured houses spilled down the surrounding hillsides. Today the Silver Cities are well off the beaten path, but you can still taste the flavours of colonial Mexico in a *paseo* through the town square or an afternoon at a rural hacienda, in walks to historic monasteries, abandoned mines, and across high desert terrain dotted with cacti and burnt ochre cliffs.

Mexico
8 DAYS / 7 NIGHTS
Nov '95 Dec Jan '96 Feb
Mar Apr Oct Nov Dec
START / FINISH
Morelia / Querétaro
PRICE
US$2,185
($375 single supplement)

Days 1 & 2 Rendezvous in *Morelia* for two nights at **Villa Montana**, the impeccably groomed estate of the French Count Philippe de Reiset. We walk in the surrounding Santa Maria Hills, journeying from Progresso to Jaripeo. **Day 3** From the silver mining village of San Cayetano we walk to *Guanajuato*, one of Mexico's most fascinating towns, with its maze of underground streets and shaded plazas. We spend one night at the **Parador San Javier**, located in the centre of town across from the ornate opera house. **Days 4, 5, & 6** On to *San Miguel de Allende*, a cultural magnet since American painter Stirling Dickinson founded an art school here in the 1930s. We spend three nights at the elegant **Casa de Sierra Nevada**, a collection of colonial buildings that once were home to the Archbishop of Guanajuato and the Marquise of Sierra Nevada. Our days include memorable walks to the hot springs at Atotonilco and nearby archaeological sites. Back

in town, we spend our afternoons visiting folk artists and the many galleries and shops that line the cobbled streets. **Days 7 & 8** A spectacular walk across the plateau from Buena Vista to Santa Rosa. We spend our final days in *Querétaro* at the **Meson de Santa Rosa**, a stately restored hacienda in the heart of this colonial town, whose guest rooms overlook courtyards filled with fountains and birds.

3

Biking on your mind?

After 30 years of biking in Europe, we still appreciate
the respect most local people show toward cyclists.
Many towns have designated bike lanes and pathways.
And rural areas are crisscrossed by lightly-travelled
paved roads linking picturesque towns, none more than
a few miles apart. Pedal at your own pace, feeling closer
to the world, and detour as the mood hits you.

FRANCE
ALSACE

Distinctive Alsatian wood-beamed houses line the streets of Colmar.

When invading German troops outflanked France's Maginot Line at the start
of World War II, it was just the latest chapter in a centuries-long struggle
for control of Alsace. Through successive invasions, Alsatians have fought to
sustain a distinct identity in their culture and cuisine. From the marquetry
workshops of Obernai to the renowned kitchens of Auberge de l'Ill, this trip
discovers the true Alsace. We meet in refined Strasbourg, home of the
European Parliament, then bike between the Rhône River and the foothills of
the Vosges, visiting medieval castles, local wine producers and picturesque
towns dating back to the Huns and the Holy Roman Empire.

BIKING
the wine
villages of eastern
France

ALSATIAN
TART FLAMBÉE

ALSACE CLASSIC BIKING
8 DAYS / 7 NIGHTS
US$3,390 ($470 single supplement)

Rendezvous in Strasbourg, ancient crossroads of Europe.
An easy ride through vineyards around Obernai. Next
day, visit with master craftsman Jean-Charles Spindler,
who reveals the secrets of marquetry. On to medieval
Molsheim, then back to our inn, **La Cour d'Alsace**, in the
heart of wine country. Through the villages of the Route
de Vin to Sélestat and **L'Abbaye la Pommeraie**, a former
Cistercian abbey, now an elegant Relais & Château
hotel. Ride through tobacco and corn fields to the WWII
Maginot Line, then briefly cross the Rhine into Germany.

Morning ride through the vineyards or up to the 16thC
castle of Haut-Koenigsbourg. Lunch in quaint, medieval
Riquewihr, then a private tour of one of the region's
wine producers. The day ends at Kaysersberg with a
castle tour and stroll through streets. Overnight at the
Residence Chambard, dining in its Michelin-starred
restaurant. Ride past the ruined châteaux of the Lords of
Ribeaupierre to the 18thC **Château d'Isenbourg**, sipping
apéritifs on the hotel's garden terrace. Bike, walk or just
enjoy the pool and spa. Last day, by coach to Strasbourg.

Alsace

9

WORLDWIDE
BIKING & WALKING
EXPEDITIONS

TURKEY
Walking in Cappadocia
and along the Turquoise Coast
8 days / 7 nights US$3,195 ($575 single supplement)

NEPAL
Walking the Himalayas
from Annapurna to Everest
12 days / 12 nights US$3,895 ($825 single supplement)

ISRAEL + JORDAN
Biking and walking the
Holy Land from Galilee to Petra
9 days / 8 nights US$3,495 ($325 single supplement)

BELIZE
Walking from Mayan ruins
to the Caribbean barrier reef
8 days / 7 nights US$3,250 (single supplement $500)

KENYA
Walking safari-style in
Samburu and the Masai Mara
10 days / 9 nights US$6,850 ($1,250 single supplement)

BALI
Walking to enchanted
temples in an island paradise
9 days / 8 nights US$3,750 (single supplement $975)

MEXICO
Walking to the Silver Cities
of the Spanish conquistadors
8 days / 7 nights US$2,385 ($375 single supplement)

SOUTH AFRICA
Biking and walking the Western Cape
8 days / 7 nights US$3,550 ($450 single supplement)

CHILE + ARGENTINA
Walking in Patagonia and Easter Island
12 days / 11 nights US$7,450 (single supplement $1,085)

NEW ZEALAND
Biking and walking
the spectacular South Island
9 days / 8 nights Bike: US$3,110 ($500 single supplement)
Walk: US$2,650 ($500 supplement)

MOROCCO
Biking and walking in the
pre-Sahara and the Atlas Mountains
9 days / 8 nights US$3,495 ($500 single supplement)

Call for our catalogue of Biking and Walking Expeditions
in Latin America, Africa, Asia and the Pacific: 1-800-678-1147

Butterfield & Robinson
BIKING & WALKING SINCE 1966

Europe '96

Slow Down to See the World

One

WITH **ONE** FOUNDATION

WITH **ONE** TRADITION

WITH **ONE** DIRECTION

WITH **ONE** GOAL

Designers/Studio Michael Bierut, Emily Hayes/Pentagram Design Inc.
Photographer Dorothy Kresz
Client Princeton University

Concept

In 1995, the development department at Princeton University launched a major capital campaign keyed to the school's 250th anniversary. Pentagram coordinated all the materials related to the campaign, including brochures, invitations, programs, folders, newsletters, stationery, buttons, sweatshirts and environmental graphics. Client Judith Friedman proposed "With One Accord" as the theme for the campaign, words that appear in the last verse of Princeton's alma mater. This theme and the campaign were introduced to the Princeton community with a small book simply titled "One." In it, phrases like "With One Goal" and "With One Foundation" were paired with images containing the number "1" that would be instantly recognizable to Princeton alumni—a detail from the cornerstone of the campus's most historic building, the stadium scoreboard and a New Jersey U.S. Route 1 sign.

1995-96 Season Brochure for Seattle Children's Theatre

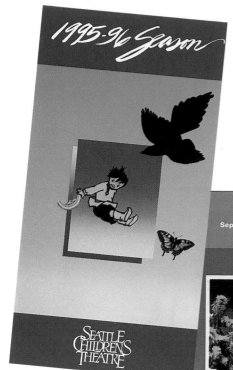

Art Director/Studio Rick Eiber/Rick Eiber Design (RED)

Designer/Studio Rick Eiber/Rick Eiber Design (RED)

Illustrator Richard Kehl

Photographer Chris Binnion

Client/Service Seattle Children's Theatre, Seattle, WA/Professional theater company

Paper Orion Satin 70#

Type Palatino, Helvetica Neue

Dimensions 5⅜" x 10½" (13.6cm x 26.7cm)

Pages 24, self cover

Software QuarkXPress, Adobe Photoshop, Adobe Illustrator

Printing Offset

Color 4, process

Binding Saddle stitched

Job Length 160 hours

Initial Print Run 95,000

Cost $40,000

Concept Each spread was devoted to one play. This design provided each play with plenty of room for graphics and text. The twenty-four-page book gave the theater a substantial feeling. Original calligraphy and easy-to-read type were used throughout. This brochure also served as a self-mailer.

Special production techniques Two versions with a black plate change only between the subscriber and teacher version.

Cost-cutting techniques The same images were used for the brochure, posters, bookmarks and note cards by rescaling the illustrations. The size for the brochure was based on the maximum sheet available on the web press.

1

September 22 - October 29, 1995
Charlotte Martin Theatre

NAOMI'S ROAD

NAOMI'S ROAD
By Joy Kogawa
Adapted by Paula Wing
Directed by Linda Hartzell

Vibrant characters, music and costumes from Japanese folklore provide a provocative backdrop of hope and strength in this story of a Japanese-Canadian family's efforts to survive their government-forced internment during World War II.

Naomi Nakane is living the life of a carefree seven-year-old when she and her older brother Stephen suddenly find themselves on a strange and fearful journey, victims of a distant war. Like 22,000 other Japanese-Canadians during the 1940's, the Nakane family's home and belongings are confiscated while Japan is at war with Canada. Separated from their parents and sent to an internment camp in the mountains of British Columbia, Naomi and her brother must discover new ways to find comfort, exercise their imaginations, and hold on to their pride. Naomi often dreams of Momotoro the Peach Boy, a character from a Japanese story told to her by her mother, while Stephen dreams of being free to play the piano again.

Told from Naomi's unique and imaginative point of view, *Naomi's Road* is a stirring theatrical testament to the courage, dreams and resilience of all young people.

Recommended for children age 8 and older

SEATTLE CHILDREN'S THEATRE

"Naomi's Road is strong and challenging theatre for young audiences, a show with something important to say and a uniquely theatrical way of saying it." – The Toronto Star

6

April 5 - June 9, 1996
Charlotte Martin Theatre

Alice's Adventures in Wonderland

ALICE'S ADVENTURES IN WONDERLAND
By Deborah Lynn Frockt
Adapted from the stories of Lewis Carroll
Directed by Linda Hartzell

Lewis Carroll's beloved classics, *Alice in Wonderland* and *Through the Looking Glass*, are given magical new dimension in this world premiere adaptation created especially for Seattle Children's Theatre by *Winnie-the-Pooh* playwright Deborah Lynn Frockt.

A white rabbit in a waistcoat whizzes past, words of nonsense fill the air and Alice is off and running – into the world of Wonderland. Loving the thrill of a good adventure and curious to a fault, Alice finds things beyond imagination in this journey of a lifetime. The impatient white rabbit is just the first in a cast of characters encountered by Alice which include Humpty Dumpty, Talking Flowers, the Caterpillar, Tweedledum and Tweedledee, the White Knight, the Queen of Hearts, the Cheshire Cat, and of course all the odd company one might find at a Mad Tea Party!

Recommended for children age 4 and older.
Doorway To Theatre Series

SEATTLE CHILDREN'S THEATRE

Incorporating puppetry, poetry and imaginative movement, the wonder-filled world of Alice's adventures is a perfect play for young children and a fantastical journey for every audience member.

THE CLASSIC LOOK

99

Iwerks Entertainment Brochure

Art Director/Studio Robin Perkins/Clifford Selbert Design Collaborative

Designers/Studio Brian Lane, Brian Keenan, Heather Watson, Jason Hashmi/Clifford Selbert Design Collaborative

Photographer Gregory Zabilski

Client/Service Iwerks Entertainment, Burbank, CA/Virtual entertainment

Paper Iconofix 100# (cover), Iconofix 70# (text)

Type Modified Franklin Gothic

Pages 56 plus cover

Software QuarkXPress, Adobe Photoshop, Adobe Illustrator, Macromedia Fontographer

Printing Lithography

Color 4, process; 1, PMS; varnish

Binding Saddle stitched

Initial Print Run 60,000

Cost $100,000

Concept This brochure streamlined all the marketing materials (brochures, videos, ads and posters) into one catalog and one video. This brochure/catalog gave Iwerks Entertainment a simpler identity and acted as a portfolio of Iwerks' varied media/entertainment products. Bold graphics made an immediate visual impact on the consumer.

Special folds or features The back cover had a pocket.

Art Director/Studio Thomas C. Ema/Ema Design Inc.

Designer/Studio Thomas C. Ema/Ema Design Inc.

Photographer Dan Sidor

Client/Service Aren Design, Vail, CO/Architectural millwork

Paper Potlatch Eloquence, UV Ultra (flysheet)

Type Garamond 3 Italic

Dimensions 8½" x 11" (21.6cm x 27.9cm)

Pages 16, self cover and flysheet

Printing Offset

Color 4, process; 4, PMS; 2 varnishes

Binding Saddle stitched

Initial Print Run 1,000

Cost $30,000

Concept Initially designed in 1988, this brochure had a sense of timelessness. In 1996, the brochure was still in use and maintained a current "freshness." Each spread was designed with one photo, one word and one PMS accent color. This made the brochure relatively easy to update as the company saw a need. A flysheet was added in the front of the brochure so the owner could "sign" his work.

Cost-cutting techniques The brochure was designed to be printed on a forty-inch, five-color press; one form, self cover, resulting in a ten color over ten color brochure.

World Trade Center Club Brochure

Art Director/Studio Milton Glaser/Milton Glaser, Inc.

Designers/Studio Milton Glaser, Christine Zamora/Milton Glaser, Inc.

Photographer Matthew Klein

Client/Service Windows on the World, New York, NY/Private club affiliated with Windows on the World Restaurant

Paper Vintage Dull 80#

Type Plantin, Franklin Gothic, Trade LT

Dimensions 5¼" x 7½" (13.3cm x 19cm)

Software QuarkXPress

Printing Offset

Color 4, process; 2, PMS

Binding Perfect

Initial Print Run 15,000

Concept The simple cover belied the brilliance of the contents of this brochure. The inside cover spreads were full-color scenics of New York City. The text invited, enticed and allured the audience to become a member of this elite club with photographs and descriptions of food, ambiance and relaxation. According to the designer, this brochure "attracted a good number of members to the club."

Special folds or features Inside four-page gatefold.

Cost-cutting technique "Pocket" size reduced the paper cost.

FROM DAY ONE, A CLUB LIKE NO OTHER.

A world-class restaurant, close to perfectly run, is only the first of the endless pleasures of membership. But it's a stunning one.

Sure, you could close your deal in a doughnut shop if you wanted. But wouldn't you rather do it while sampling the sumptuous Grand Buffet, over a panorama of the greatest city in the world?

Your membership confers instant confidence, glorious sustenance, and the comfort of true companionship. Your Club brilliantly transforms any business date from a duty to a delight. Or allows you to escape entirely for a genial hour or two.

A myriad of subtle details lifts your Club to perfection, grants your every wish and makes you the envy of non-members.

8

CLOSE BUT NO CIGAR (CONT'D).

"On its busiest days some 2,000 men gather in the Bohemian Grove to eat camp food and put on shows (some of them reputedly in drag), listen to speakers and bond in a 2,700 acre compound near the Russian River in Monte Rio, California. The retreat is run by the Bohemian Club, a private organization that, over the years, has fended off pressure to admit women..."
—The New York Times

Our improvement: Women and men welcomed as members. Of course.

"...Many of the clas were founded by p other clubs. J.P. Mc founded the venera when The Union Cl membership..." —.

THE WORLD CONCIERGE: ALL HUMAN (HALF DATABASE).

The World Concierge is a multi-lingual, unstumpable, all-knowing paragon. The Admirable Crichton, plugged into a computer.

Want a reservation? No problem.

Need tickets for a Broadway show? The Knicks? The City Opera or the Met? The New York City Ballet or Alvin Ailey? Streisand? Or Sting? The Chili Peppers? Foo Fighters? No problem.

A limo to the airport? A gift certificate? A souvenir menu? A personal shopper? A pedicure in your office? Like lightning, they're yours.

Want a photographer? A doctor? Want to get married? Or just send a fax? That's what we're here for.

The World Concierge performs all miracles.

18

19

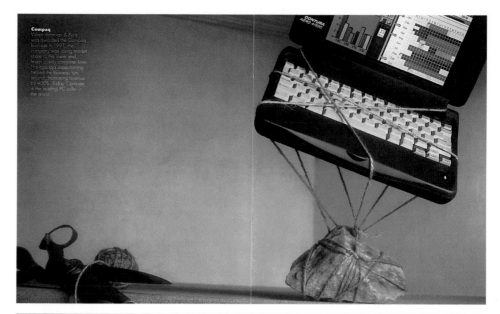

A lot of advertising is like wallpaper. It's beautiful, but it doesn't say anything.

RALPH AMMIRATI

What's in a name?

Designers/Studio Michael Bierut, Sara Frisk/Pentagram Design, Inc.
Client Ammirati Puris Lintas
Dimensions 9¾" x 12" (24.8cm x 30.5cm)
Pages 40
Color 4, process
Binding Saddle stitched

Concept When New York ad agency Ammirati and Puris merged with international firm Lintas to form Ammirati Puris Lintas, the agency's creative leaders wanted to create a printed piece that could be distributed to their employees worldwide. This piece would announce the new name, introduce the work of Ammirati and Puris to an international audience and serve as a clear statement of the new company's mission. Pentagram suggested that the oversized brochure show not individual ads, but instead show details from some of the agency's best-known campaigns, from BMW to Burger King. Blown up to full-bleed scale, the images alternated with similarly enlarged quotes from A&P's founding principals. Subsequent books made to the same format have featured the history of Lintas and elaborated the agency's creative philosophy.

Chihuly/Chateau Ste Michelle Artist Series Brochure

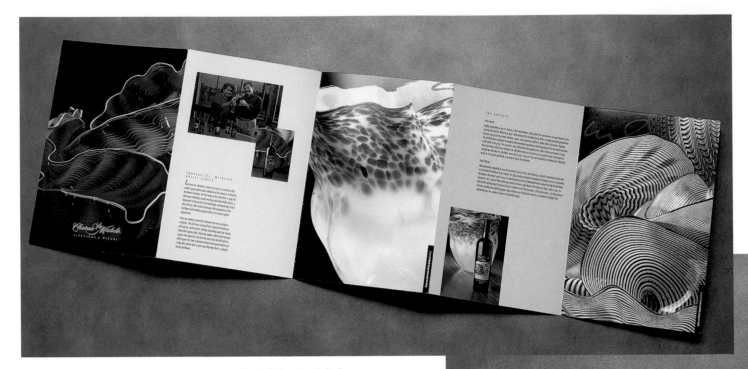

Art Director/Studio Randy Lim/Studio MD

Designer/Studio Randy Lim/Studio MD

Client/Service Stimson Lane, Woodinville, WA/Winery

Paper Lustro Dull Recycled 100# Cover

Type Gill Sans Condensed

Dimensions 7" x 11" (17.8cm x 27.9cm); unfolds to 35" x 11" (89cm x 27.9cm)

Pages 8

Software Adobe Photoshop, Macromedia FreeHand

Printing Offset

Color 4, process; 2 varnishes

Binding Accordion fold

Initial Print Run 1,800

Concept This brochure showcased six distinct labels, each depicting an exquisite Chihuly glass form. The glass forms were brilliant art pieces and to show them to their full potential, they were sized as full-bleed images on each panel. To reflect the shininess of the glass sculptures and wine bottles, a gloss varnish was added to the photographs while a dull varnish was used on the background colors surrounding them. This elegant brochure was accomplished on recycled stock!

Special folds A five-panel accordion fold showcased the collection of six handblown glass sculptures while maintaining a balance of art and product.

Special production techniques To make the gloss varnish even shinier, it was dry-tapped.

Cost-cutting technique The design firm did all the photo retouching and varnish masks.

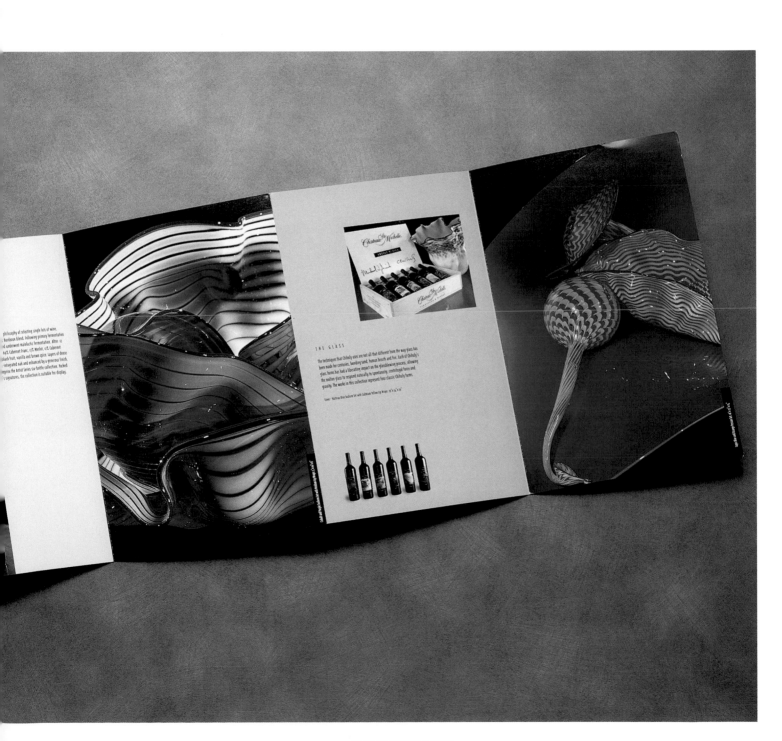

Part Five

Ecological Inspirations

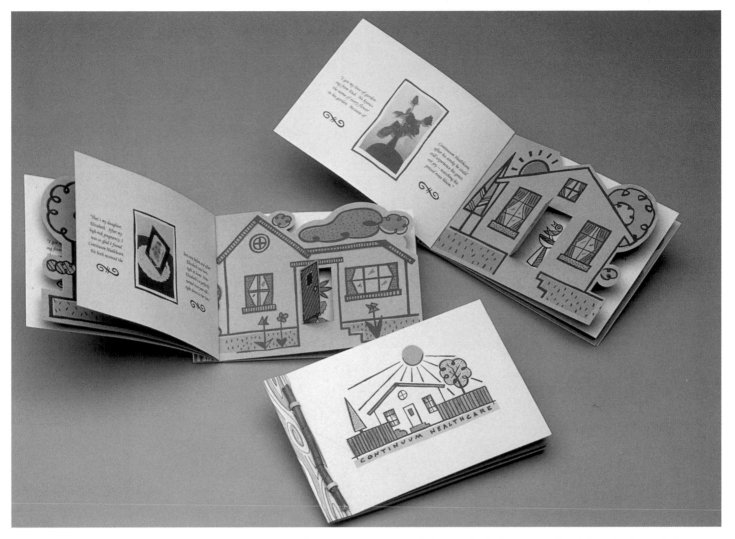

Art Director/Studio John Sayles/Sayles Graphic Design

Illustrator John Sayles

Photographer John Sayles

Client/Service Continuum Healthcare/In-home health care services

Paper Curtis Tuscan Terra: Marigold, Eucalyptus, Pacific Blue

Type Footlight

Dimensions 7⅜" x 5" (18.7cm x 12.7cm)

Pages 7 plus cover

Printing Offset

Color 2, match

Binding Small twig and rubber band

Initial Print Run 1,000

Concept The warm look of the brochure effectively communicated the personal nature of this in-home health care service. Readers could interact with the brochure's die-cut windows and doors, and the illustrative style reinforced the message.

Special features Each page was drilled with two holes, providing a place to secure the twig binding, which was attached by hand and secured with a rubber band. The pages were scored near the binding to allow them to open more easily.

Special production techniques Inside pages were die cut in the shape of houses. The doors to the houses were also die cut, allowing them to be opened and shut.

Cost-cutting techniques Continuum's staff collated and bound the piece, eliminating outside assembly costs.

Everyday Things Made Extraordinary

Art Director/Studio Lori Siebert/
Siebert Design Assoc.

Designer/Studio Lori Siebert/
Siebert Design Assoc.

Illustrators Curtis Parker, John
Patrick

Photographer Bray Ficken

Client/Service Howard Paper/
Paper company

Paper Howard Linen

Dimensions 12" x 6" (30.5cm x
15.2cm)

Pages 10

Color 4, process; metallic gold,
match

Binding Saddle stitched

Concept Howard wanted to ele-
vate a workhorse 50 percent recy-
cled paper. This paper was avail-
able in a variety of colors, finishes
and sizes. To exemplify its versa-
tility and usability, the designer
found stories about how everyday
things such as sandwiches and
Velcro were "discovered." The
cover theme, "Everyday Things
Made Extraordinary," wove its way
throughout the brochure in both
the stories and the variety of
paper finishes that were used.

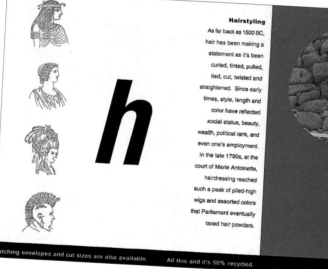

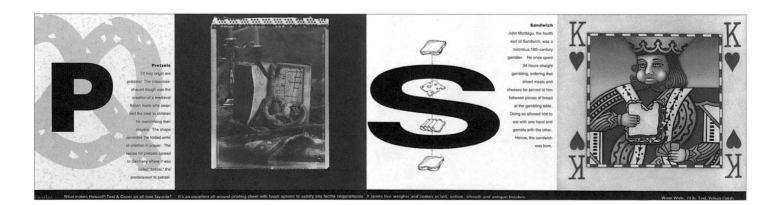

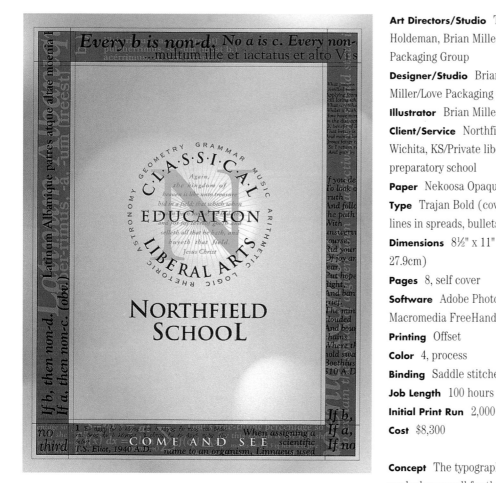

Art Directors/Studio Tracy Holdeman, Brian Miller/Love Packaging Group

Designer/Studio Brian Miller/Love Packaging Group

Illustrator Brian Miller

Client/Service Northfield School, Wichita, KS/Private liberal arts preparatory school

Paper Nekoosa Opaque 65# Cover

Type Trajan Bold (cover, headlines in spreads, bullets)

Dimensions 8½" x 11" (21.6cm x 27.9cm)

Pages 8, self cover

Software Adobe Photoshop, Macromedia FreeHand

Printing Offset

Color 4, process

Binding Saddle stitched

Job Length 100 hours

Initial Print Run 2,000

Cost $8,300

Concept The typographic concept worked very well for the client; their goal was to remind parents of the jumbled thoughts from various areas of study that circulate through children's heads as they go through their school day. Layered type conveyed thoughts weaving in and out of the images and captured the chaos of information that students must deal with. The body copy served to draw parents out of the chaos and into the unique curriculum offered by Northfield. The hazily lighted background represented thoughts, and if the parents really noticed the particulars of the typographic images, they saw samples of actual Northfield lessons.

Cost-cutting technique

Photography (as initially suggested by client) was avoided by creating computer-generated typographic images; thus, no photo fees were incurred.

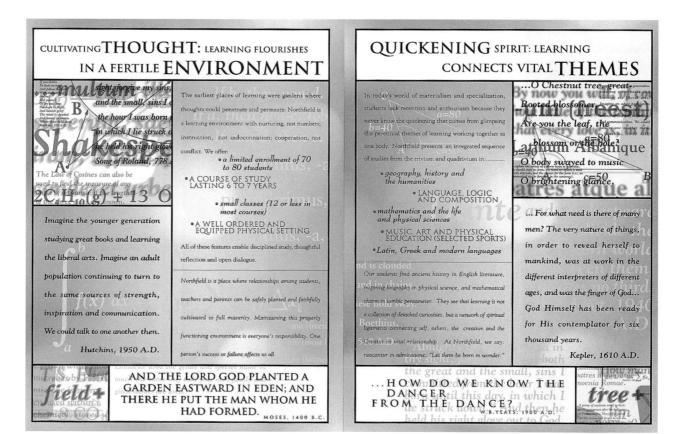

Seattle Scene Brochure

Designer/Studio Mark Popich/The Leonhardt Group

Photographers Tony Grob, Mark Popich

Client The Mayor's Film and Video Office of Seattle, Seattle, WA

Paper Springhill Incentive

Type Univers Condensed Bold

Dimensions 8½" x 11" (21.6cm x 27.9cm); unfolds to 22" x 17" (55.9cm x 43.2cm)

Pages 8

Software QuarkXPress, Adobe Photoshop

Printing Offset

Color 2, PMS

Binding None; folding only

Job Length 90 hours

Initial Print Run 5,000

Concept The client needed this piece to break through the clutter and attract the attention of a jaded audience. The front cover design was loud and direct with its oversized minimal type and single image. The "Paper and Coffee" vernacular used on the front and back covers localized it to Seattle.

Cost-cutting techniques All images were scanned on a desktop scanner. The photography was borrowed or shot by the designer and all of the writing was done by the designer.

THE SEATTLE SCENE

SEATTLE? WHO WOULD DO A SHOOT IN SEATTLE?!

Art Director/Studio Whitney Critchley/Modern Dog

Designer/Studio Coby Schultz/Modern Dog

Illustrator Coby Schultz

Photographer Luis Sanchez, Charles Peterson

Client/Service Nordstrom, Seattle, WA/Clothing and accessories

Paper Influence Soft Gloss 80# Text (cover), Influence Soft Gloss 60# Text (text)

Type Bauhaus, Free Style, Clarendon, Hand-lettering

Dimensions 8⅜" x 11" (21.3cm x 27.9cm)

Pages 24 plus cover

Software QuarkXPress, Adobe Photoshop, Adobe Illustrator

Printing Offset

Color 4, process; 2, PMS

Binding Saddle stitched

Initial Print Run 500,000

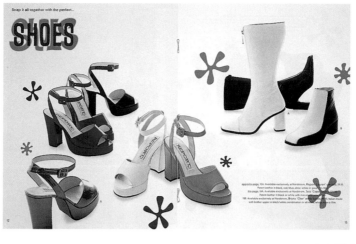

Concept Because this brochure was a completely new approach to the typical Nordstrom look, the designer addressed each spread and style of clothing separately. This made the catalog cohesive in its variety. The spreads shown here depict a sample of the differences that can be found in the catalog. The graphics complemented the clothing and spoke to the youthful target audience.

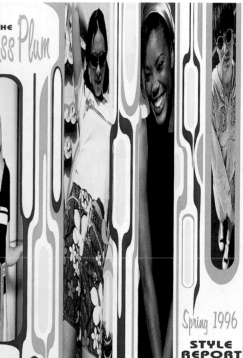

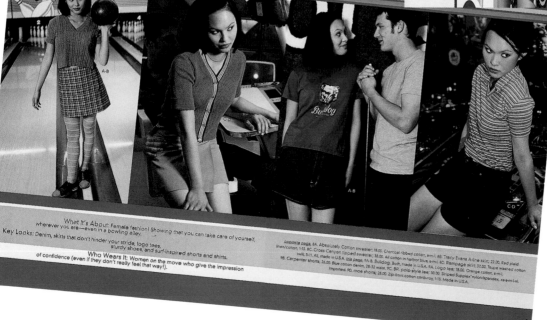

Greek Life: Get a Feel for It

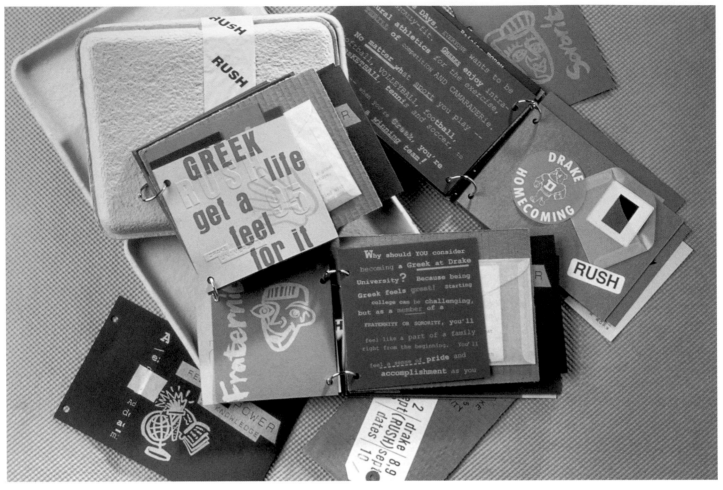

Art Director/Studio John Sayles/Sayles Graphic Design

Illustrator John Sayles

Client/Service Drake University, Des Moines, IA/Private university

Paper Curtis Retreeve: Cinnabark, Eggplant, Sea Mist; Curtis Tuscan Antique Midnight Blue; corrugated cardboard; chipboard

Type Various serif and sans serif typefaces, hand-rendered type

Dimensions 8¾" x 6" (22.2cm x 15.2cm)

Pages 16

Software QuarkXPress

Printing Offset, embossing

Color 2, match

Binding 2 looseleaf rings

Initial Print Run 850

Concept The theme, "Greek Life: Get a Feel for It," was the inspiration for the use of a variety of materials in the brochure. The brochure invited students to open the envelopes, unfold the secured pages and hold the 35mm slide up to the light. They were "getting a feel" for both the brochure and Greek rush at the same time.

Special features Some items were tipped on, such as stickers and rubber stamped tags. Several glassine envelopes held 35mm slides and additional information. The cover was an actual metal printing plate, burned but never used to print an image. The brochure's title was embossed onto the metal plate. Cardboard trays were used in the food presentation. Two trays contained the brochure and were secured with tape printed with "Rush."

Special production techniques Each page was different from those around it, and hand collation was necessary. The looseleaf rings that bound the piece were also hand applied.

Cost-cutting techniques Cost for the materials was kept low by using "leftovers" from other projects by the design firm. Students collated and packaged the brochure for mailing, eliminating the need for a mailing fulfillment center.

Art Director/Studio Brad Norr/Brad Norr Design

Designers/Studio Brad Norr, Michael White/Brad Norr Design

Illustrators Brad Norr, Michael White

Photographer Steve Kemmerling, stock

Client/Service Smart Set, Minneapolis, MN/Electronic pre-press service bureau

Paper Stock File Folder (cover); Hopper Cardigan, French Dur-O-Tone, Warren Lustro (text); Strathmore Renewal (pamphlet)

Type Various

Dimensions 9⅜" x 12 ⁷⁄₁₆" (23.8cm x 31.8cm)

Pages 12 plus cover

Software QuarkXPress, Adobe Photoshop, Adobe Illustrator

Printing Offset

Color 4, process; 3, match

Binding Saddle stitched

Initial Print Run 3,000

Cost $14,000 (printing only; design was a trade)

Concept The goal of this brochure was to look unusual in order to attract art directors and ad people. To accomplish this effect, the designers created a "file folder full of stuff." This also allowed them to represent the wide range of interests of Smart Set staffers, from grungy type and motorcycles to fine type and comic books.

Special folds or features This brochure needed a lot of hand-work. It was hand stitched to allow pages to peek out of the top and bottom. There were tipped-on elements on the cover, the center spread and the inside back cover. The psychedelic pamphlet was hand inserted.

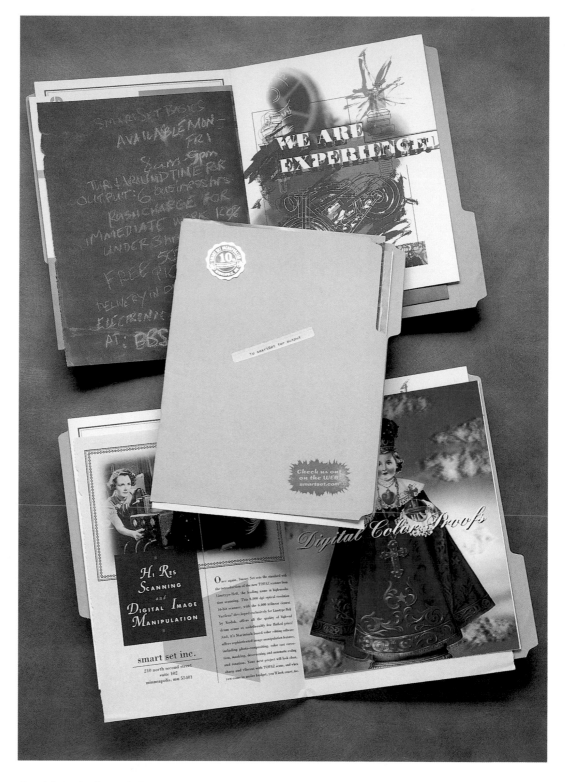

Special production techniques To print the psychedelic pamphlet, three fluorescent match colors were substituted for process colors. The pamphlet was then perforated to look like acid tabs.

Urban Realism—Exhibition Brochure

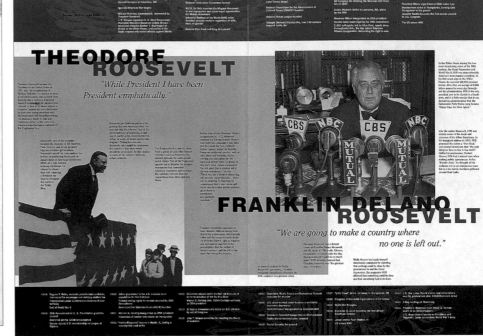

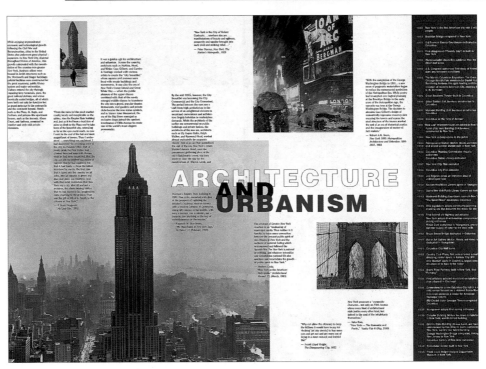

Art Director/Studio Scott Adams/Columbus Museum of Art

Designer/Studio Scott Adams/Columbus Museum of Art

Photographer UPI/Bettman, various others

Client/Service Columbus Museum of Art, Columbus, OH/Art museum

Paper Hopper Proterra Flecks Chalk 70# Text

Type Clearface, Helvetica Black, News Gothic

Dimensions 11" x 18¾" (27.9cm x 47.6cm)

Pages 16

Software QuarkXPress, Adobe Photoshop

Printing Offset

Color 4, process; 1, match (cover); 2, match

Binding Saddle stitched

Initial Print Run 5,000

Job Length 50 hours

Cost $12,000 plus copywriting

Concept The exhibition that this piece accompanied focused on urban images made during the first half of the twentieth century.

The paper had a highly gritty, recycled, newsprint-like quality. The copy was written as small news-bites of information. The layouts reflected the chaotic, yet organized feel of the urban landscape by having text fall loosely into the grid and by utilizing concrete and street maps as background textures.

Special features All credit information was assembled on a first page foldout so that the reader could easily refer to all credits from page to page. This also helped keep the page spreads uncluttered.

Cost-cutting techniques Because of the almost newsprint quality of the paper, a great deal of the paper cost was reduced. Keeping the inside pages only two color also saved on printing costs.

Motorola Re-Flex

Art Directors/Studio Joel Fuller, Suzy Lawson/Pinkhaus
Designer/Studio Suzy Lawson/Pinkhaus
Illustrator Suzy Lawson
Client/Service Motorola, Boynton Beach, FL/Motorola paging product group
Paper Gilbert Esse White 80# Text
Type Copperplate, Futura
Dimensions 3½" x 5¾" (8.9cm x 14.6cm)
Pages 40
Software Adobe Illustrator
Printing Offset
Color 4, match
Binding Saddle stitched
Job Length 100 hours

Concept This brochure for Motorola showcased the two-way pager. The small size implied the size and shape of a pager, and the bold colors throughout depicted how simple it was to use the pagers. In addition, the graphics were variations of interwoven circles and ellipses that were used to define complete cycles of communication.

Cost-cutting technique The small size helped cut costs without diminishing the effect.

Rain Bird Field Report

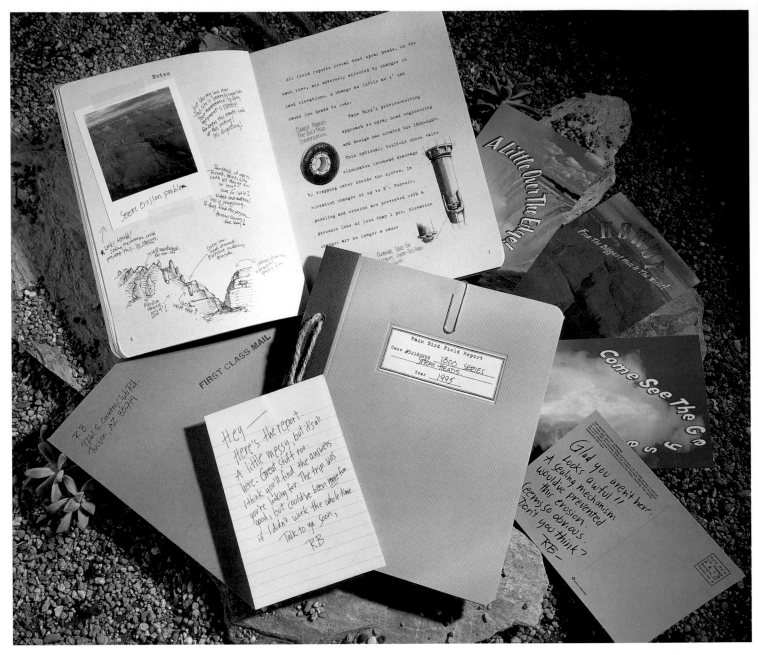

Creative Director Scott Timms

Art Director/Studio Pam Stone/Nordensson Lynn & Associates

Illustrator Bob Conge

Client/Service Rain Bird Sales, Inc., Tucson, AZ/Irrigation products

Paper Champion Benefit (cover), Simpson Quest (text), Simpson Evergreen (envelope)

Type Trixie Plain, handwritten notes

Dimensions 8" x 9" (20.3cm x 24.1cm)

Pages 16 plus cover

Software QuarkXPress, Adobe Photoshop, Adobe Illustrator

Printing Dryography™

Color 4, process

Binding Saddle stitched

Initial Print Run 12,000

Concept The concept went beyond the normal industry boundaries and cut through the dry, feature-oriented, product-heavy literature that the intended audience usually sees. The design was fresh and inviting to read. The project was displayed as a hand-written report complete with field notes and photographs, giving the brochure a personal touch. Because of the hand-assembled elements, the recipients got the impression that the piece was created just for them.

Special production techniques Hand assembly: hand tied, cord bindery, taped in "Polaroids."

Designer/Studio Eric Kass/Miller Brooks, Inc.

Client/Service Art Directors Club of Indiana/Professional organization

Paper French Speckletone Chipboard, French Dur-O-Tone Newsprint

Type Clarendon (text), News Gothic (forms), various others

Dimensions 8" x 11" (21.6cm x 27.9cm)

Pages 8 plus cover

Software QuarkXPress, Adobe Photoshop

Printing Offset

Color 3, match

Binding Saddle stitched

Job Length Lots in unbillable hours—a labor of love

Initial Print Run 1,000

Concept As "divine inspiration" for this brochure, the designer used a 1911 handbook entitled "Van Pelt's Cow Demonstration" from a used book sale. In the original book, the author, Hugh G. Van Pelt, wrote about judging beauty, form and effectiveness much the same way design work is judged in the annual ADCI Best Show. Several of the funny photos in the brochure were reproduced from the handbook. The sophisticated execution of a rural theme was used to illustrate the pride in being part of design in the Midwest.

Cost-cutting technique All of the design, printing and paper were donated.

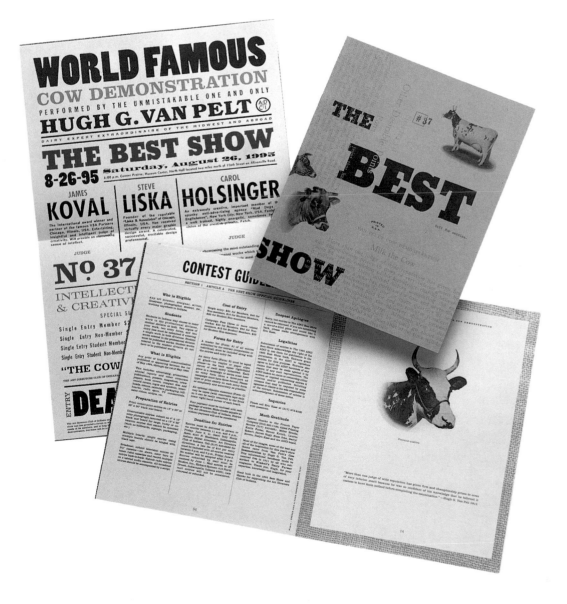

Media That Works

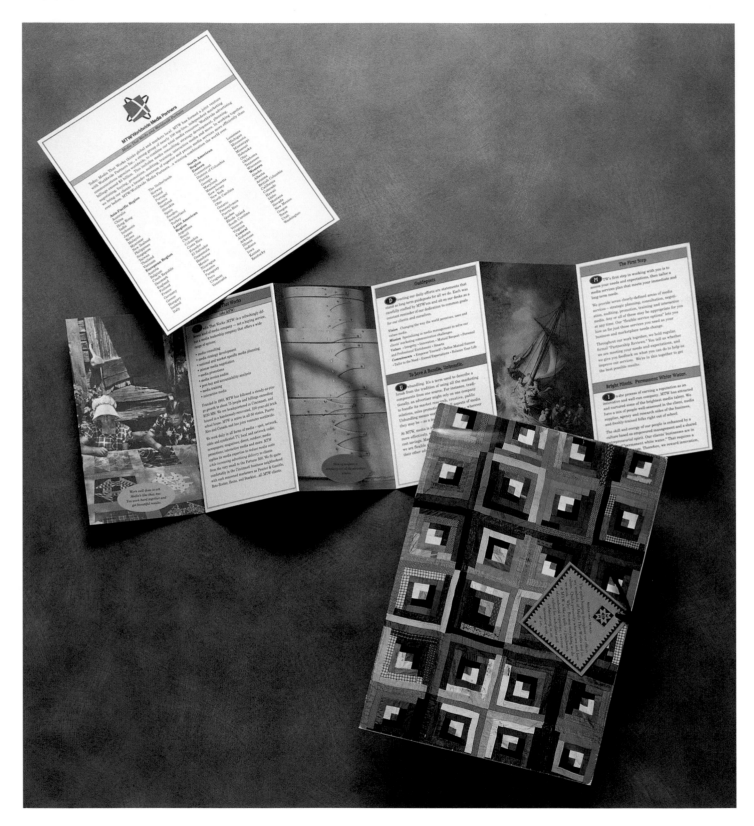

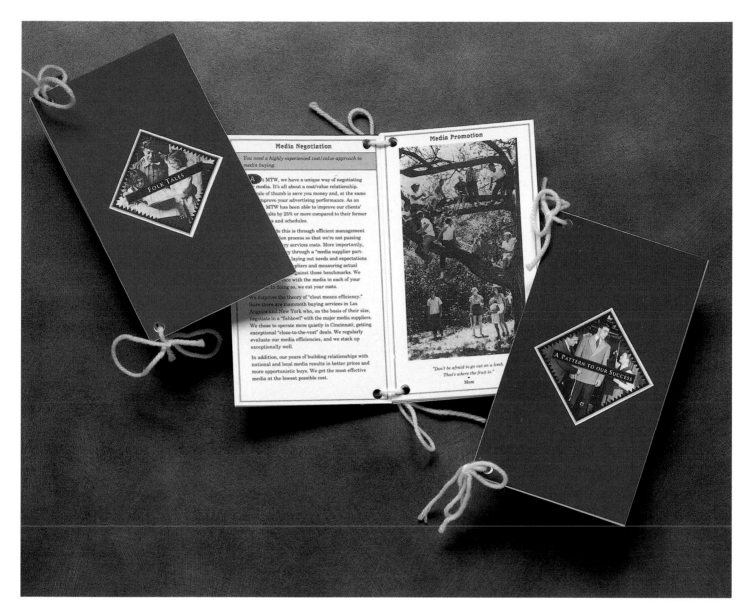

Art Director/Studio Lori Siebert/Siebert Design Assoc.

Designer/Studio Diane Gliebe/Siebert Design Assoc.

Client/Service Media That Works, Cincinnati, OH/Media buyers

Type Matrix In Line

Dimensions 9" x 12" (22.9cm x 30.5cm)

Software QuarkXPress, Adobe Illustrator

Printing Offset

Color 4, process

Binding Yarn

Initial Print Run 1,000

Concept The client, Media That Works, wanted to portray a "back-to-basics" image. Their offices were strewn with quilts and antiques, which the designer used as inspiration for this multifaceted self-promotion. This handmade feel strayed from the traditional slick, media buyer look. The brochure had several components including minibrochures that described the services and staff of Media That Works, an accordion-folded brochure that provided a step-by-step philosophy for the client and an eye-catching envelope that held the pieces together. The envelope was not sealed but was tied with yarn, which gave it a hands-on, inviting feel.

The Manhattan Project Bio

Designer/Studio Baiba Owens/Boom Design

Photographer Images supplied by client

Client/Service Doug DeAngelis, Sam E. Swing, New York, NY/Record production, remixing

Paper Storm Blue (foldouts), White Linen (information), Vellum (dividers), Dur-O-Tone Cover (cover), Blue Acetate (last page)

Type Helvetica Neue Ext, Helvetica Neue Light Ext, Letter Gothic, Garamond

Dimensions 6¾" x 6½" (17.1cm x 16.5cm)

Pages 13 plus cover and two fold-downs

Software QuarkXPress, Adobe Photoshop, Adobe Illustrator

Printing Laser

Color Black

Binding Rubber band with aluminum pipe

Job Length 125 hours

Initial Print Run 50

Cost $400

Concept For this brochure, the client needed something different and well produced, but not slick. The brochure reflected what they represented as a team: two young guys with an excellent list of artists, equipment and experience and without the attitude or high fees. The binding made it easy to update the piece with new artists and equipment.

Special folds or features There were two fold-down pages. The brochure was hand bound with rubber bands and aluminum pipes. Photo album corners were used to hold business cards on the inside back cover.

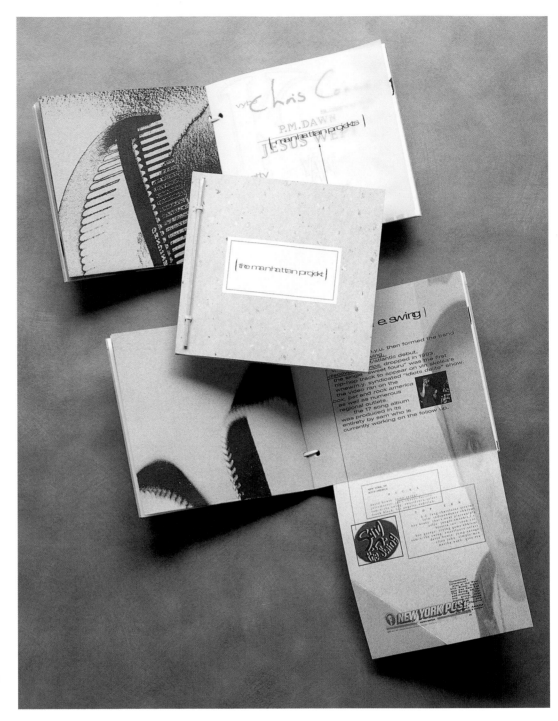

Cost-cutting techniques The only element designed specifically with cost in mind was the binding. The client would need to constantly update the equipment list and artists, and this allowed them to do so without having to reprint the entire piece.

Art Director/Studio John Sayles/Sayles Graphic Design

Illustrator John Sayles

Client/Service Greater Des Moines Chamber of Commerce, Des Moines, IA/Chamber of Commerce

Paper Curtis Tuscan Terra Flax (text), manila tags, corrugated cardboard (cover)

Type Stencil, Letter Gothic

Dimensions 13" x 9" (33cm x 22.9cm)

Pages 8 plus cover

Software QuarkXPress

Printing Offset, screen printing

Color 2, match

Binding Wing nuts

Initial Print Run 1,000

Concept By using materials frequently found in warehouse operations, the piece had a familiarity to the recipient right from the start. This piece was specifically targeted to companies who needed warehouse space and would consider a facility in the Midwest. The industrial feel provided by both the materials and graphics underscored the fact that Des Moines was a prime warehouse location. The die-cut arrow on the cover reinforced the "It's Your Move" theme of the brochure. The arrow/headline also encouraged the reader to turn the page.

Special features The piece was almost entirely hand assembled, and a number of tipped-on objects (including shipping labels and printed manila tags) were found on pages throughout the brochure. The wing nuts used for binding were hand applied as well.

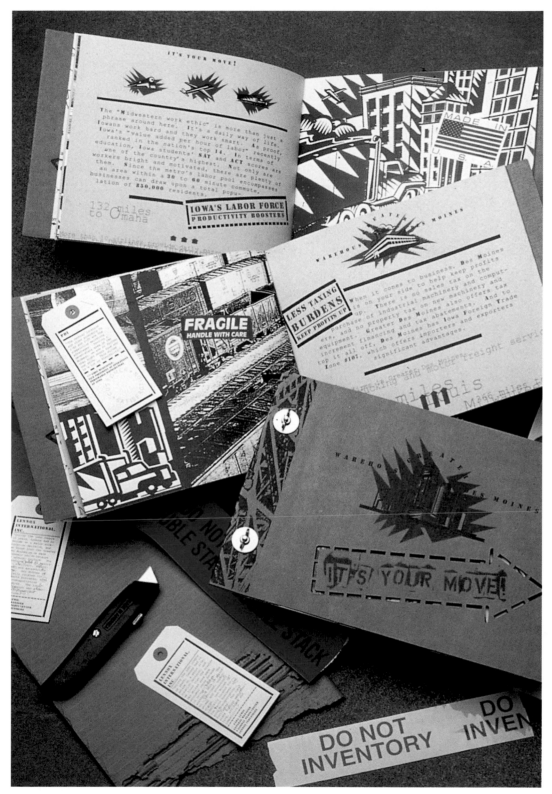

Cost-cutting techniques Only two colors of ink were used in the piece. Also, the industrial materials (the corrugated cover and manila pages) were less expensive than fine paper.

Packaging and Presentation

Art Directors/Studio Dave Malone, Barry Huddleston/ Huddleston Malone Design

Designers/Studio Dave Malone, Mary Jane Callister/Huddleston Malone Design

Illustrator Mary Jane Callister

Photographers Bob Bauer, Michael Schoenfeld

Client/Service Rowland Hall St. Marks/Private school

Paper Speckletone Cover (cover), Karma Dull 65# Cover (text)

Type Sabon (headings), Humanst521 (text)

Dimensions 9½" x 11" (24.1cm x 27.9cm)

Pages 24

Software QuarkXPress

Printing Offset

Color 4, process; spot varnish

Initial Print Run 10,000

Concept This brochure described the four levels of education with a "true-to-life" concept. Both the design and the voice used for the copy followed a building block theme. This was extremely well received by both parents and educators for two reasons: It reflected the true nature of a child's building and growing through the amazing process of education, and it communicated the fun and adventure a child experiences while going through this portion of his or her life.

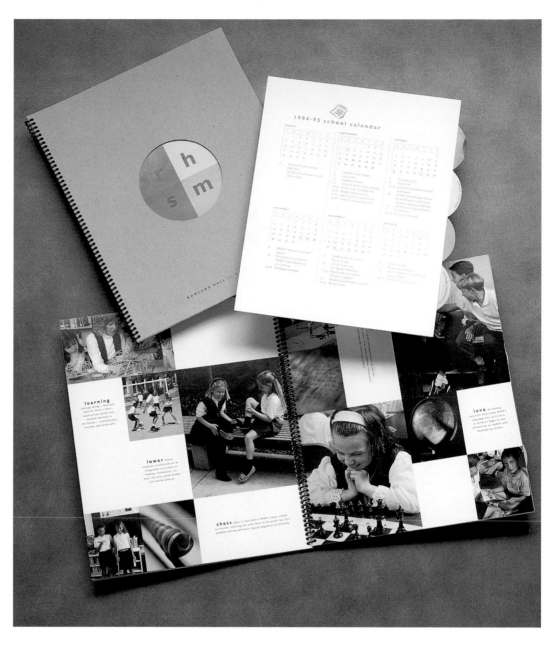

Special folds or features The tab pocket on the inside back cover was unique in order to accommodate the spiral binding.

Hickey-Freeman Autumn 1995 and Spring 1996 Catalogs

Design Team/Studio Gregg Glaviano, Melanie Bass, Judy Kirpich, Gretchen East/Grafik Communications, Ltd.

Photographers Various historic sources, Just Loomis (models)

Client/Service HartMarx, Chicago, IL/Men's suits

Paper Teton (covers), Quintessence Dull (text), Gilbert Gilder (Autumn brochure endsheet), UV Ultra (Spring brochure flysheet)

Type Berling

Dimensions Autumn brochure: 7¾" x 12" (19.7cm x 30.5cm); Spring brochure: 8½" x 11" (21.6cm x 27.9cm)

Pages Autumn brochure: 20 plus cover; Spring brochure: 20 plus cover and flysheets

Software QuarkXPress, Adobe Photoshop

Printing Offset, three-color engraving (Autumn cover), foil (Spring cover)

Color Autumn brochure: 6, process; 1 match; Spring brochure: 4, process; opaque white; green metallic

Binding Hand binding

Initial Print Run 5,000 of each

Concept The theme for these catalogs was "History in the Making." This concept worked because the client was looking to create memorable pieces that captured their pride in their American-crafted suits. Taking photographs of the models in Hickey-Freeman suits and juxtaposing them against a memorable character in history turned out to be a clever way to say, "How will you be remembered?" in the course of the day's events or history.

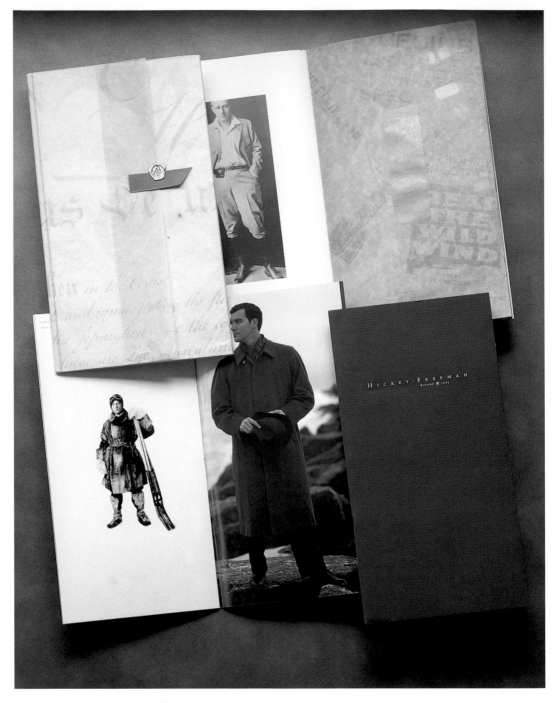

Special folds or features On the Spring brochure, the wax seal was applied by hand. The piece was also collated by hand because of endsheets and flysheets.

Art Director/Studio Lori
Siebert/Siebert Design Assoc.

Designer/Studio Lori
Siebert/Siebert Design Assoc.

Illustrators Juliette Borda, Lori
Siebert, Lisa Ballard

Client/Service The Contemporary
Arts Center/Museum

Paper Champion Benefit

Type Mostly hand done

Dimensions 7" x 10" (19cm x
25.4cm)

Pages 38

Printing Offset

Color 4, process

Initial Print Run 3,000

Concept The booklet was used as
a keepsake item for kids. The
writings in the book were from the
visiting artists: Joe Lewis II, Joe
Lewis III and Raven Brown.
During the program, kids were
encouraged to actively participate
and then form their own opinions.
The book involved the kids even
after the event because it provid-
ed them with the actual presenta-
tion as well as open spaces to
write their thoughts.

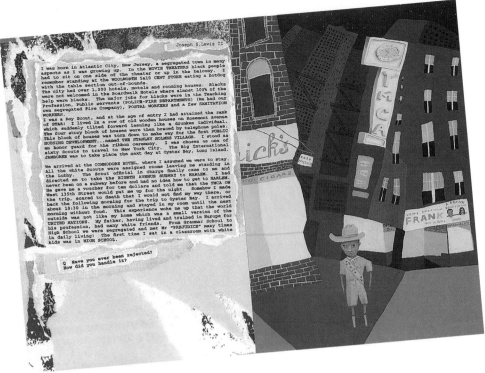

Living Environment Folder

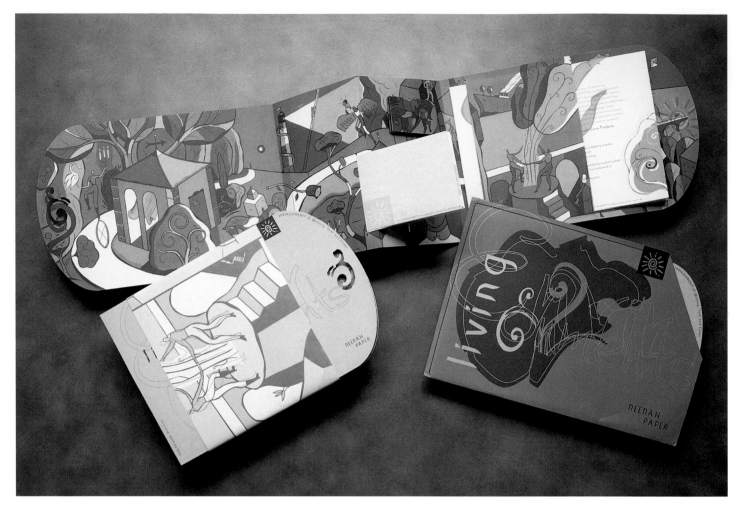

Creative Directors/Studio Brad Copeland, George Hirthler/ Copeland Hirthler design + communications

Designers/Studio Todd Brooks, Raquel Miqueli/Copeland Hirthler design + communications

Illustrator Phillipe Lardy

Client/Service Neenah Paper, Roswell, GA/Uncoated writing, text, cover papers

Paper Neenah Environment

Type Christmas Gift, Cirrus

Software QuarkXPress, Adobe Illustrator

Printing Offset, foil emboss

Color 4, process; 18, match; tint varnish

Binding Outside wrap sewn, letterhead pocket

Job Length 100 hours

Cost $36,000 (Neenah paid for printing)

Concept This brochure was part of a promotion for the Neenah Environment gradeline papers. It created interest in the market-place between gradeline revision promotions until the next promo-tion was launched. Using several special techniques including foil stamping, embossing, tint varnish-es and die cuts, this brochure emphasized the attractiveness of this gradeline. The colors were strong with the use of lots of browns, purples and earthtones to remind the customers that this was a recycled stock.

Special features Outer holder/envelope was sewn at a flag/canvas-type shop.

Special production techniques The art extracted for all of the pieces was from one main illustra-tion. This illustration was manipu-lated to match the paper stock colors.

Cost-cutting techniques The designer used the same tint var-nish on the backs of the letter-head, and gauged the letterhead and environment business card colors to create a uniform system.

Art Director/Studio Leslie Evans/Leslie Evans Design Assoc.

Designers/Studio Leslie Evans, Cheri Bryant/Leslie Evans Design Assoc.

Calligrapher Mary Lynn Blasutta

Client/Service Georgia Pacific Corp; Atlanta, GA/Paper manufacturer

Paper Hopper Protera Felt Flecks, Cardigan Felt

Type Sabon, Hand Calligraphy (Prêt A Créer)

Dimensions 7" x 7" (17.8cm x 17.8cm); unfolds to 14⅝" x 14⅝" (37.1cm x 37.1cm)

Pages Puzzle; 4 slip sheets; double cover wrap

Software QuarkXPress, Adobe Illustrator

Printing Offset

Color 1, match

Binding Die cut, scored, folded; held together by label wrap

Job Length 80 hours

Initial Print Run 10,000

Cost $43,000 (cost does not include paper)

Concept This project displayed one of the client's paper lines and the variety of available colors in a relatively small space. The promotion provided the customer with both a keepsake puzzle of bright colors and a reference tool for the paper stocks.

Special features The puzzles were printed on various sheets of different-colored papers, laminated, die cut and then disassembled and reassembled to make a multi-colored puzzle.

Special production techniques The hand assembly of the puzzle pieces was hard work. Workers were given possible color scenarios as guides to reassemble puzzles so that no color occupied two adjacent spaces.

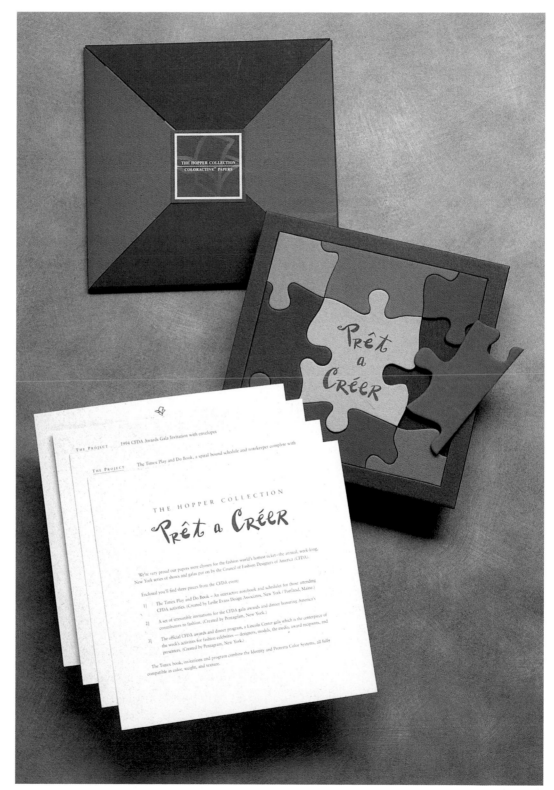

Gilbert Paper Sunflower Book

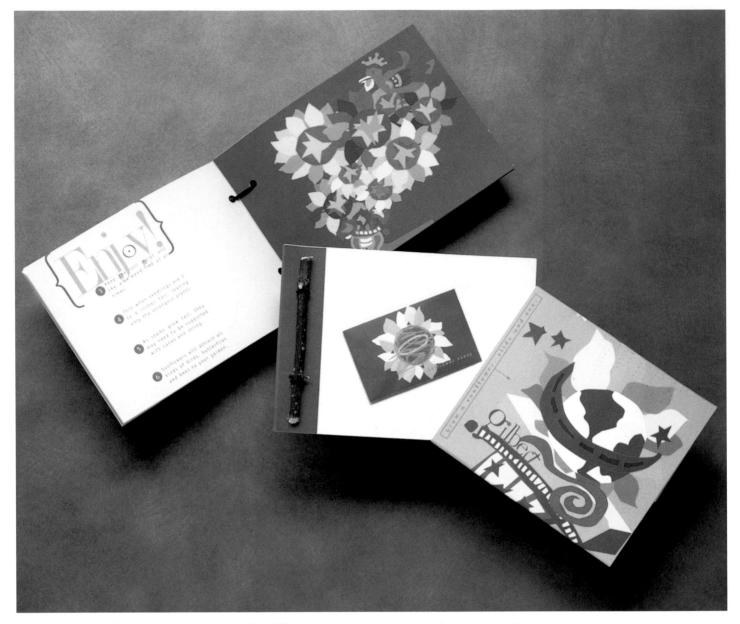

Art Director/Studio Tracy Rea/Tracy Rea & Associates, Inc.

Designer/Studio Tammy Lutze/ Tracy Rea & Associates, Inc.

Illustrator Tracy Rea

Writer Debi Keav

Client/Service Gilbert Paper, Menasha, WI/Premium uncoated and recycled papers

Paper Gilbert Oxford

Type Democratica (wrap), Officina (inside text)

Dimensions 7½" x 5½" (19cm x 14cm)

Pages 12 plus cover and outside wrap

Software QuarkXPress, Macromedia FreeHand

Printing Offset

Color 4, process

Binding Sticks with an elastic band

Initial Print Run 26,000

Concept As a promotion piece for Gilbert, this sunflower book served to show the quality of the recycled paper and subtly aligned nature with its use. Enclosed in the booklet, which used a stick to hold the binding together, was a packet of sunflower seeds complete with

instructions for proper planting. The illustrations were bright and cheerful and filled with images of plants and birds. What better way to reinforce the environmental importance of using recycled stocks? And what better way to show that recycled stocks can be used for quality publications?

Special folds or features The inside pages were French folded. The binding was hand assembled with a stick and elastic band. The custom envelope with sunflower seeds inside was hand tipped.

Art Directors/Studio Carrie English, Ken Roberts/Canary Studios

Designers/Studio Carrie English, Ken Roberts/Canary Studios

Illustrator Carrie English

Client/Service InPower, Inc., San Francisco, CA/Human resources software

Paper Simpson Gainsborough (cover), Simpson Coronado SST (text), Graphic Suisse Sihl Clear (flysheets)

Type Gill Sans (headings), Minion (text)

Dimensions 5¾" x 5¾" (14.6cm x 14.6cm)

Pages 38

Software QuarkXPress, Adobe Photoshop, Adobe Illustrator

Printing Offset, die stamp

Color 4, match

Binding Wire-O

Job Length 1 month

Initial Print Run 10,000

Cost $50,000

Concept InPower wanted an alternative to the "standard" brochure they already used. Fresh from an extensive multimedia project, Canary Studios wanted to create an "interactive" brochure. "The Lexicon" had a dual purpose. It clearly explained InPower's new terminology and acted as a gift to potential clients. It was a tremendous success in both areas.

Special production techniques All of the illustrations were created digitally in Adobe Photoshop. Sketches were scanned in, placed on a layer and drawn over. This made production much easier.

Cost-cutting techniques Since the files were already digital, they were able to go straight to film (no scanning, no stripping). This cut time and money from the schedule and budget.

A Tribute to Antonio Carlos Jobim

Art Director/Studio Petrula Vrontikis/Vrontikis Design Office

Designer/Studio Kim Sage/ Vrontikis Design Office

Photographer Anna Jobim, various others

Client/Service CS Productions— Carmen Rittenour, Malibu, CA/Special event music productions

Paper Potlatch Vintage Gloss

Type Bell Gothic, Letter Gothic

Dimensions 8½" x 11" (21.6cm x 27.9cm)

Pages 16 plus cover

Software QuarkXPress, Adobe Photoshop

Printing Offset

Color 4, process

Binding Saddle stitched

Job Length 125 hours

Initial Print Run 4,000

Cost $28,000

Concept The piece served as a program for an event at the Lincoln Center and as an historical record of Antonio Carlos Jobim's associations with other musicians. Each spread used a different letter of Jobim's last name as a background graphic behind memories, quotes and photographs. Potlatch was very impressed with the piece and put it in a recent promotion. They have reprinted it twice at 30,000 copies each.

Art Directors/Studio Allison Muench, J. Phillips Williams/Design: M/W

Designers/Studio Allison Muench, J. Phillips Williams/Design: M/W

Photographer Carlton Davis

Client/Service Takashimaya, New York, NY/Retail store

Paper Karma

Type Gill Sans, Scala Sans, Joanna

Dimensions 5" x 7" (12.7cm x 17.8cm)

Pages 32

Software QuarkXPress

Printing Offset

Color 4, process; 2, PMS

Binding Perfect

Initial Print Run 40,000

Concept The overall floral photograph on the front and back covers (with no logo) functioned as gift wrapping, which was especially appropriate for the catalog featuring holiday gift merchandise. The pages of the catalog were focused, each spread showing quality photographs and understated, classic descriptions. This brochure/catalog put a solid, perfect-bound book into the hands of customers.

Special features The outside edges of the brochure were sprayed red.

Cost-cutting techniques The studio photography on white backgrounds presented the merchandise in a "gallery-like" setting while saving on costs for locations and props.

Kansas City Art Institute Admissions Campaign

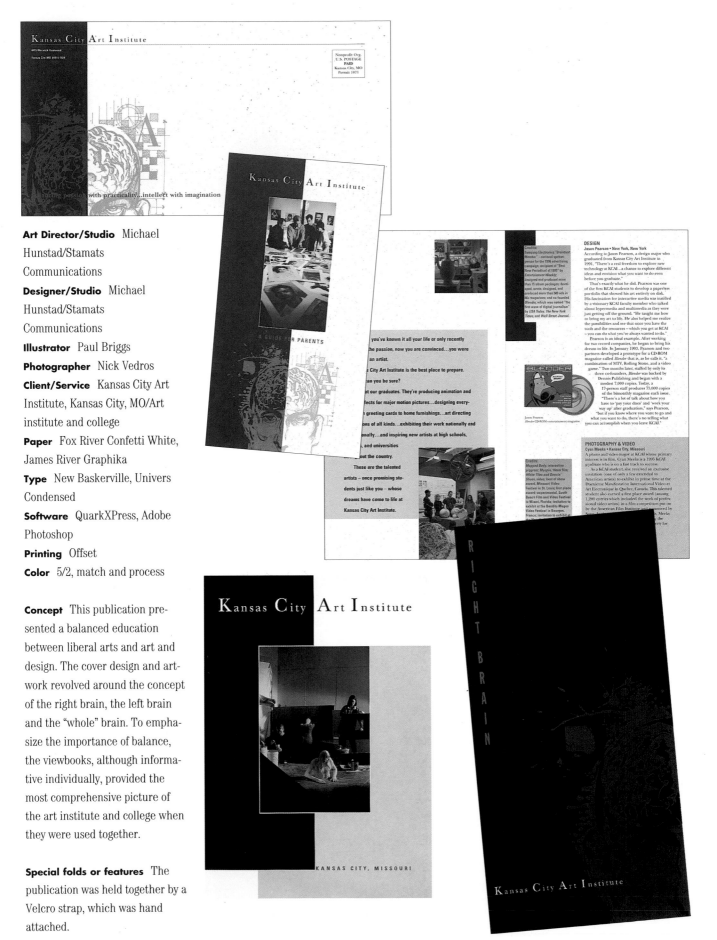

Art Director/Studio Michael Hunstad/Stamats Communications

Designer/Studio Michael Hunstad/Stamats Communications

Illustrator Paul Briggs

Photographer Nick Vedros

Client/Service Kansas City Art Institute, Kansas City, MO/Art institute and college

Paper Fox River Confetti White, James River Graphika

Type New Baskerville, Univers Condensed

Software QuarkXPress, Adobe Photoshop

Printing Offset

Color 5/2, match and process

Concept This publication presented a balanced education between liberal arts and art and design. The cover design and artwork revolved around the concept of the right brain, the left brain and the "whole" brain. To emphasize the importance of balance, the viewbooks, although informative individually, provided the most comprehensive picture of the art institute and college when they were used together.

Special folds or features The publication was held together by a Velcro strap, which was hand attached.

Art Director/Studio Shane W. Evans/Odd's & End's

Designer/Studio Shane W. Evans/Odd's & End's

Designer/Book Binding Doug Havaca

Client/Service Odd's & End's, Kansas City, MO/Self-promotion concept

Paper Strathmore Speckletone

Type Crackhouse

Dimensions Booklet: 5" x 7" (12.7cm x 17.8cm); Case: 25" (63.5cm)

Software Adobe Illustrator

Printing Laser, engraving, litho, hand wiped

Color Black, sepia

Binding Japanese hand-bound book binding

Initial Print Run 2

Concept This self-promotion piece showed the versatility of this designer. The variety of components made this piece one that wanted to be explored. The theme was pervasive throughout the series without a detail missed—from the wraps on the cigars to the hand-wiped intaglio plates, and from the details on the hand-bound booklet to the 1920s-style violin case.

Special production techniques Many of the special techniques were handwork. The detail wraps were hand applied and in the brochure were hand tipped litho prints and vellum overlay text on images.

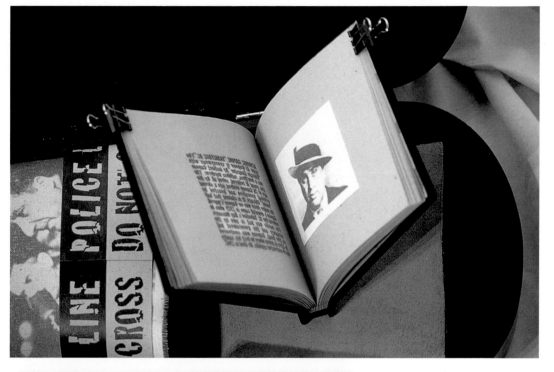

The Case for IMT

Art Director/Studio John Sayles/Sayles Graphic Design

Illustrator John Sayles

Client/Service IMT Insurance, Des Moines, IA/Insurance company

Paper Curtis Jersey blue, gray tag; manila tag; vinyl (front cover); corrugated (box)

Type Stencil, Courier

Dimensions Closed case: 18" x 12¾" (45.7cm x 32.4cm); Brochure: 12" x 9" (30.5cm x 22.9cm)

Pages 9 plus covers

Software QuarkXPress

Printing Offset, embossing, screen printing

Color 2, match

Binding Metal fastener between two drilled holes

Initial Print Run 150 cases, 300 brochures

Concept This piece was used to recruit new agents and independent companies to affiliate with IMT. The persuasive theme, "The Case for IMT," worked perfectly. It attracted attention because of its unique presentation: a corrugated "briefcase." Inside the briefcase, a fitted tray held a brochure that outlines "The Case for IMT."

Special production techniques The attaché was formed from corrugated cardboard. The IMT logo appeared in varnish on the face of the briefcase, and Velcro tabs on the straps held the case closed. The brochure cover was a single sheet of black embossed leatherette, scored to hold brochure pages inside and bound with a metal fastener. In the center of the cover, a metal file cabinet label holder featured a small card containing the title. Inside pages were screen printed on manila stock, and sections of copy were separated with tabbed dividers to carry through the visual theme.

Cost-cutting techniques In addition to being appropriate to the piece, the industrial papers used in the brochure were economical.

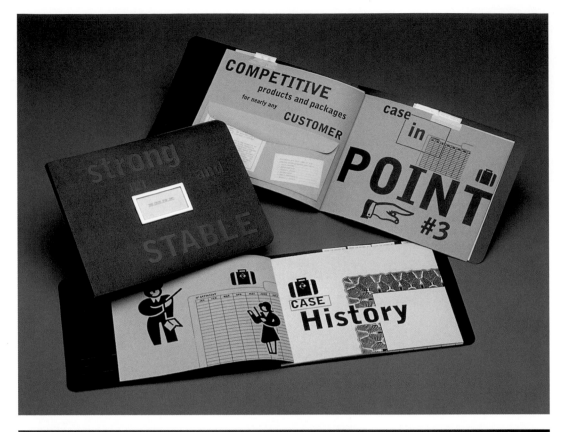

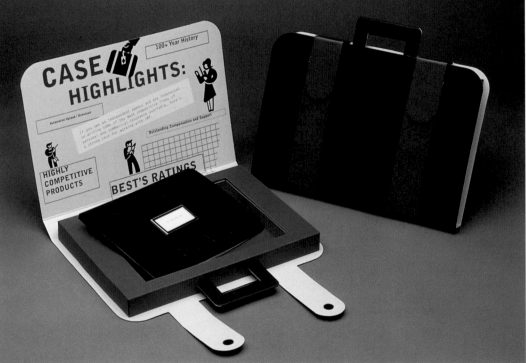

Art Director/Studio Supon Phornirunlit/Supon Design Group

Designer/Studio Sharisse Steber/Supon Design Group

Illustrator Sharisse Steber

Photographer IOC Archives, Allsport, Art Resource, Michael A. Schwartz

Client/Service United States Postal Service, Washington, DC/First day issue commemorative stamp souvenir

Paper Quintessence Cover

Type Belucian (title, copy), Berthold Script (drop caps)

Dimensions 8½" x 8½" (21.6cm x 21.6cm)

Pages 8, self cover

Software QuarkXPress, Adobe Photoshop, Adobe Illustrator

Printing Offset

Color 4, process

Binding Saddle stitched

Job Length 50 hours

Initial Print Run 10,000

Cost $3,500 (design only)

Concept This brochure celebrated a commemorative stamp for USPS that honored the centennial games. The client wanted to stress the history and nostalgia of these games as well as provide a global flavor of the participating countries. To accomplish this, icons or images of the historical games were scattered throughout the brochure.

Special features There was a die-cut pocket to hold stamps in place.

Novell Corporate Guidelines Brochure

Art Director/Studio Jack Anderson/Hornall Anderson Design Works

Designers/Studio Jack Anderson, Bruce Branson-Meyer, Larry Anderson/Hornall Anderson Design Works

Client/Service Novell, Inc., Orem, UT/Software manufacturer

Paper Lustro Dull

Type Times Roman, Futura

Dimensions 11" x 11" (28cm x 28cm)

Pages 17

Software QuarkXPress, Adobe Photoshop, Macromedia FreeHand

Printing Offset

Color 6, match

Concept The brochure served the client as an internal piece that contained rationale for the use and treatment of the Novell identity. This product was a production reference tool as well, as it provided reproducible logos and guidelines for their uses. This brochure personalized a relatively technical product line and company.

Special production techniques Photo images were used to illustrate how Novell connects "people-to-people," emphasizing the human elements of technology.

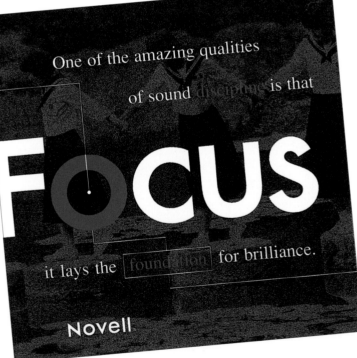

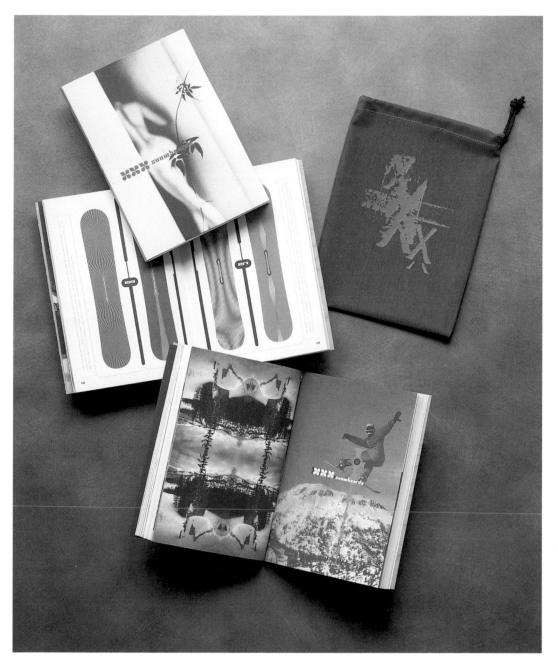

XXX Snowboards

Art Director/Studio Carlos Segura/Segura, Inc.

Designer/Studio Carlos Segura/Segura, Inc.

Illustrators Carlos Segura, Tony Klassen, Robin Metcalf

Photographer Jeff Sciortino, Photonica

Client/Service XXX Snowboards/ Snowboards and clothing

Paper Cougar White and Cream, French Dur-O-Tone Packing Carton 145#

Type Profon (2Rebels)

Dimensions 5¼" x 7½" (13.3cm x 19.1cm)

Pages 128

Software QuarkXPress, Adobe Photoshop, Adobe Illustrator, Adobe Dimensions, Ray Dream Designer

Printing Offset, embossing

Color 6, process

Binding Perfect

Initial Print Run 8,000

Concept This brochure was first a catalog and foremost a keepsake. Aside from the clothing products advertised, this catalog contained a trip diary; a calendar; an expeditions log; 1-800 numbers for resorts, airlines and car rentals; mileage charts; and ethics/snowboarding trips. The catalog was then packaged inside a waterproof pouch.

Special features Cover flaps folded into the bound cover. The back cover panel contained a clip that held a plastic panel for avalanche cards.

Special production technique The waterproof pouch was made using excess cloth from the clothing production line.

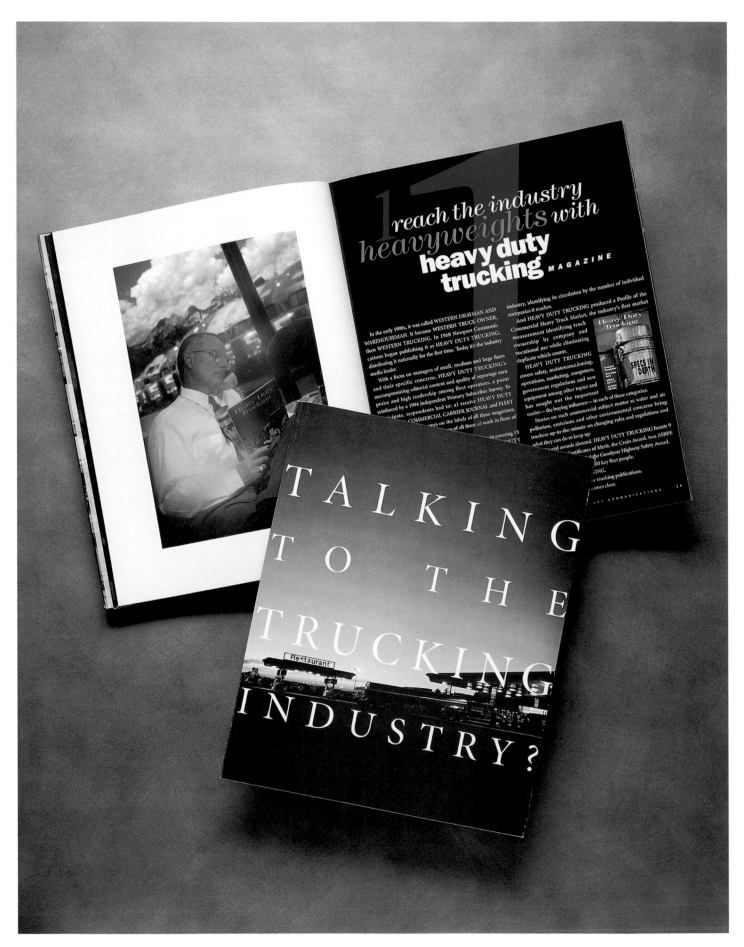

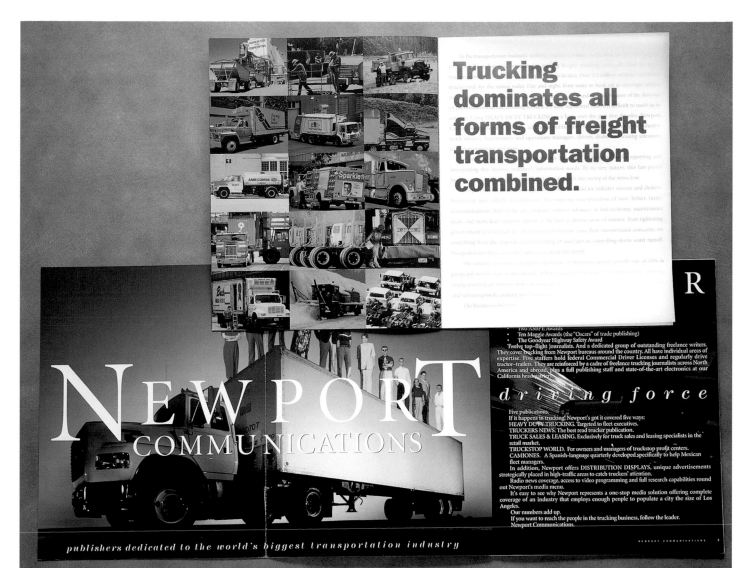

Art Director/Studio Mike Salisbury/Mike Salisbury Communications Inc.

Designers/Studio Mary Evelyn McGoogh, Regina Grisveld/Mike Salisbury Communications Inc.

Photographers Henry Blackham, Mike Salisbury

Client/Service Newport Communications, Irvine, CA/Trade publications

Type Garamond, News Gothic

Software Adobe Photoshop, Adobe PageMaker

Printing Offset

Color 4, process

Binding Saddle stitched

Job Length 1 year

Initial Print Run 20,000

Cost $100,000

Concept This brochure was impressive. It not only demonstrated for the first time all the magazine titles this company publishes, but also communicated their expertise in their field of specialty and showcased endorsements from readers and advertisers.

Special features This brochure featured several gatefolds and tissue inserts.

Cost-cutting techniques The designer used existing photography for most of the truck photos.

Overlake Press 1996 Calendar

Art Director/Studio David Lemley/David Lemley Design

Designer/Studio David Lemley/David Lemley Design

Illustrator David Lemley

Client/Service Overlake Press, Kirkland, WA/Printer

Paper Chip Board (cover), Quintessence Remarque Dull and Gloss 65# Cover, Fox River Confetti Yellow 65# Cover, Simpson Evergreen Craft and Aspen Cord 65# Cover, Karma White Matte 65# Cover, French Construction Factory Green 65# Cover

Type Gill Sans, Industria (headings); Eurostile, Univers, Futura, Frutiger, Kabel, Franklin Gothic, Bodoni Antiqua, Modula, Michelangelo, Adobe Garamond, Times Roman, ITC Anna, Commercial Script, Gill Sans, Governale, ITC Leawood, Metropolis, Zapf Dingbats (text)

Dimensions 9" x 12" (22.9cm x 30.5cm)

Pages 14

Software Adobe Photoshop, Adobe PageMaker, Macromedia FreeHand

Printing Offset, letterpress

Color Variety of process, match and varnishes

Binding Wire-O, two-prong paper fastener

Job Length 220 hours

Initial Print Run 1,000

Cost $50 per calendar

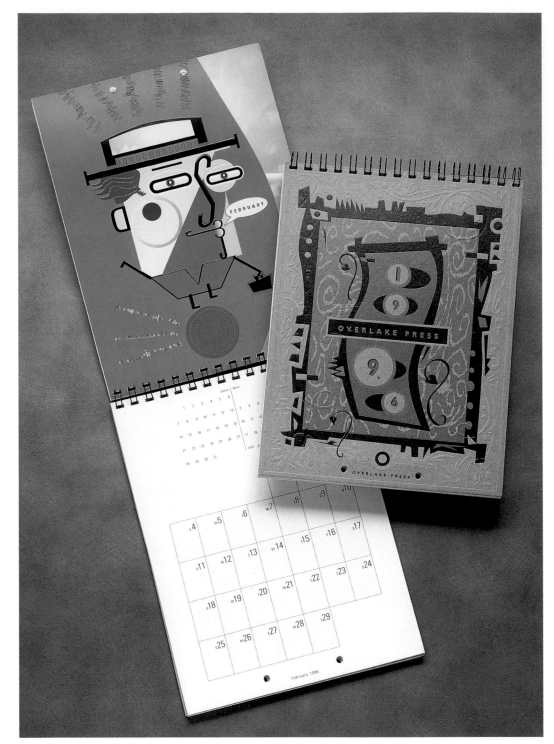

Concept The initial intention of this calendar was to be something different that would make graphic arts professionals choose to hang it as opposed to any of the dozens of richly printed calendars they received around the New Year. The design also intended to show that Overlake Press was a "knowing company," a printing business that was in touch with the local design community and had not only a general understanding of the wants and needs of designers, but the mastery skills required to help them achieve their printing goals. The theme "Typography and Technique" presented endless opportunities throughout the calendar to show technique and acted as an attractive reference tool. Each month of the calendar presented an attractive design with specifications for the typeface, colors or special techniques used on that page.

Cost-cutting techniques Most of the pages were printed on one side of the sheet and then folded back-to-back, resulting in the appearance of two-sided printing and providing a heavier stock weight than standard cover stock.

Art Director Grafik Communications, Ltd.

Design Team Susan English, Judy Kirpich, Julie Sebastianelli

Illustrator Hal Mayforth

Photographer Thomas Bergman, Ron Kimball

Client S&S Graphics, Inc., Laurel, MD/Printing and related services

Paper Centura Cover Dull Plus 100# (cover), Centura Dull Plus 80# Cover (text), Teton Tiara 80# Cover (sleeve)

Type Schneidler (headings), Gill Sans (text)

Dimensions 7" x 7¼" (17.8cm x 18.4cm)

Pages 28

Software QuarkXPress

Printing Offset, foil-stamping

Color 4, process; 2, PMS (1 metallic); 2 varnishes

Binding Black Wire-O

Job Length 225 hours

Initial Print Run 5,000

Cost $50,000

Concept This design solved the need for a multiuse sales piece for a diverse audience of CEOs and print buyers. It also used broad-based humor to appeal to clients who might not be interested in the technical details of printing capabilities.

Special folds or features The carrier sleeve was die cut and glued in house. The foil-stamping was also completed in house.

Special production techniques Scitex Micro Assembler, Prisma and Prismagic workstations were used to put together watercolor art separations with spot art.

Cost-cutting techniques The paper was provided by the mill in exchange for additional copies for its promotion; the illustrator discounted his cost somewhat in exchange for copies.

Novell Remote Connectivity

Art Directors/Studio Dave Malone, Barry Huddleston/Huddleston Malone Design

Designer/Studio Dave Malone/Huddleston Malone Design

Illustrator Greg Johannes

Client/Service Novell, Inc., San Jose, CA/Networking, software services

Paper Neenah Classic Columns Patina 80# Cover (text), Bright White 80# Cover (cover)

Type Futura, Century Old Style

Dimensions 7½" x 10½" (19cm x 26.7cm)

Pages 16

Software QuarkXPress, Adobe Illustrator

Printing Offset

Color 4, process; spot color

Binding Plasticoil

Initial Print Run 25,000

Concept This brochure had a "keep me" quality to it and was successful for two reasons. First, it was a lot of fun to explore and required the reader's participation. The pages turned independently at the top, middle and bottom to create both different cartoon characters and different network solutions. Everyone—the clients, partners, employees (and even their kids)—kept it to go through it time and time again. Second, the interchangeable pieces quickly accomplished the communication of "mix and match your network solutions" for Novell. This was repeatedly conveyed both conceptually and literally throughout the booklet.

Art Director/Studio Hal Apple/
Hal Apple Design, Inc.

Designer/Studio Alan Otto/Hal
Apple Design, Inc.

Illustrator Hal Apple, Alan Otto

Photographer Jason Ware

Design Assistants Jill Ruby,
Andrea Del Guercio, Rebecca
Cwiak, Jason Hasmi

Client/Service Hal Apple Design,
Inc., Manhattan Beach, CA/Design

Paper Protera Flecks Cover
Curry, Quintessence Dull 65#
Cover, Confetti Envelope,
Strathmore Renewal

Dimensions 8" x 11" (20.3cm x
27.9cm)

Pages 16 plus inserts

Software QuarkXPress, Adobe
Photoshop, Adobe Illustrator

Printing Offset

Color 4, process

Binding Self-folding

Job Length 300 hours

Initial Print Run 1,500

Cost $8,000

Concept This brochure epito-
mized name recognition.
Anecdotes of apples and their his-
tory were woven into all of the
inserts, illustrations and case
studies. As an extra touch, the
designer bought private-label tea
to further personalize the presen-
tation. The apple-cinnamon tea
was visually a big hit with clients
and potential clients. The rest of
the brochure was made almost
entirely of inserts, which made it
extremely flexible for individual,
custom presentations. The design-
er could also send the tea-mailer
separately, or enclose it with the
folder and inserts.

Special features The folder was
hand folded, but scored, embossed
and die cut at the bindery.

Cost-cutting techniques To
reduce costs, some of the produc-
tion work was bartered with the
designer's vendors. The emboss
die was also used for other office
stationery.

Record Performance Incentive Program

Art Director/Studio Steven Wedeen/Vaughn Wedeen Creative

Designers/Studio Steven Wedeen, Lucy Hitchcock, Vivian Harder/Vaughn Wedeen Creative

Illustrator Vivian Harder

Client/Service US West Communications, Phoenix, AZ/Telecommunications company

Paper French Cement Green 70# Text (sleeve), Simpson Starwhite, Vicksburg Double Thick Smooth Tiara 130# Cover (jacket, brochure, card)

Type Copperplate, Centaur, Corvinus Skyline

Software QuarkXPress, Adobe Photoshop, Macromedia FreeHand

Printing Offset

Color 4, process

Initial Print Run 4,000

Concept This incentive program called "Record Performance" was packaged exactly like an LP record album, with a record-shaped booklet for information, a record sleeve for additional information, a sleeve and other game-like inserts. The unusual format and packaging captured attention and "turned on" interest.

Special features There were several die-cut components including the round record-shaped booklet, which was scored and saddle stitched on center.

Cost-cutting technique The components were "ganged" on a few different sheets for printing economy.

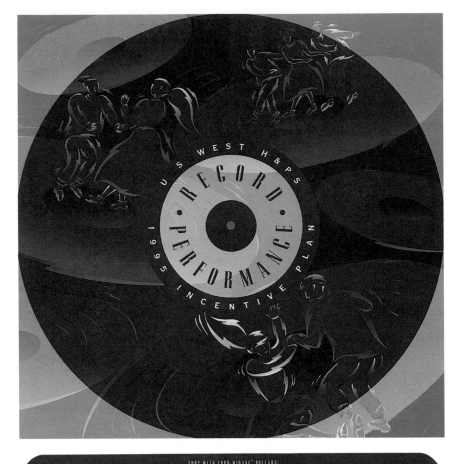

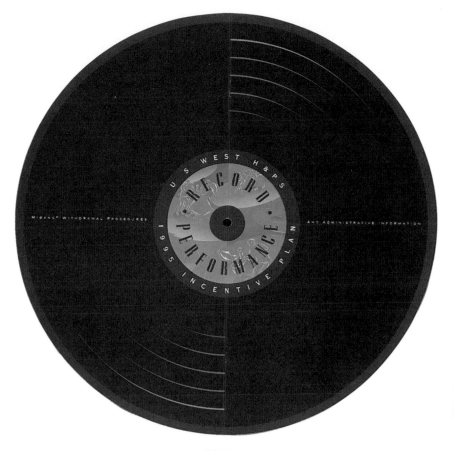

Conqueror Engineering Brochure

Studio Viva Dolan
Communications & Design
Client/Service Appleton
Papers/Paper manufacturer
Binding Fold, trim
Job Length 35 hours
Cost $10,000

Concept The client wished to
have something that would be
kept by the recipient to demon-
strate the folding characteristics
of Conqueror Paper. To achieve
this concept, the designer chose
the engineering as the focus.
Using a paper doll-type format,
the brochure provided a punch-
out car that could be folded to
create a three-dimensional model
complete with freestanding wind-
shield and driver.

Special folds or features Kiss
cut die of automobile.

Special production techniques
The illustrations were colored in
Adobe Photoshop.

Cost-cutting techniques Because
final illustrations were provided to
the film house on disk, no scans
were required. Also, the job was
run on the same sheet with sever-
al other small jobs for this client,
which saved costs on paper and
printing.

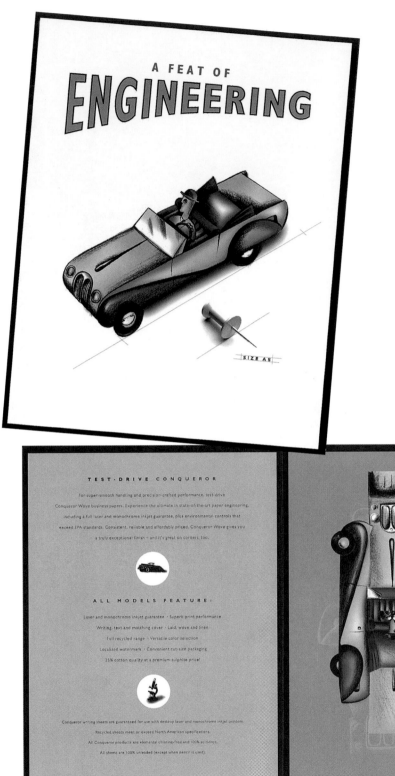

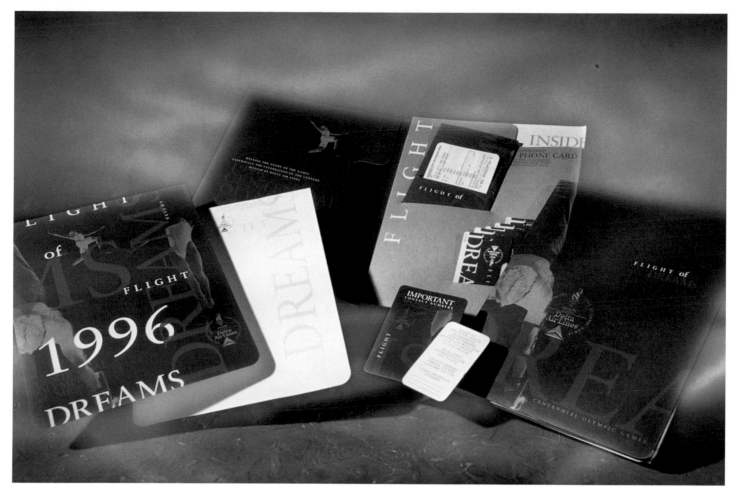

Art Directors/Studio Brad Copeland, George Hirthler/ Copeland Hirthler design + communications

Designer/Studio David Butler/Copeland Hirthler design + communications

Writers Jason Hirthler, George Hirthler

Client/Service Delta Air Lines, Atlanta, GA/Airline transportation

Paper Curtis Tuscan Antique 65# Cover (cover), Monandock Astrolight 80# Cover (text)

Type Sabon

Dimensions Various

Pages 25 plus cover and postcard

Software QuarkXPress

Printing Offset, embossing

Color 2, PMS

Binding Staple, drill

Job Length 50 hours

Initial Print Run 500

Cost $20,000

Concept Delta needed a striking piece to invite approximately 2,000 VIP guests to Atlanta for the Olympic Games. The "Flight of Dreams" piece was one component within a broader package of posters, ticket jackets, banners, garment boxes and minibrochures that all played off of a core concept developed for the program: Wings and Dreams.

Special folds or features Pages were scored and the cover was glued to the pages. The staple was hidden by the cover.

Cost-cutting techniques The designer used the Tuscan Antique on the cover, which was close to the corporate color of Delta. This was a two-color piece with an expensive look.

Rosalind Russell Arthritis Brochure

The Rosalind Russell Arthritis Center at UC San Francisco was founded in 1978 to support the advancement of arthritis research and to posthumously honor the woman who almost single-handedly focused the nation's attention on the seriousness of the disease. In having the courage to publicly share her personal struggle with severe rheumatoid arthritis and by serving on a landmark presidential commission, Rosalind Russell helped pave the way for the major international research effort that continues today.

Over the years, our Center has served as a critical funding resource for a steadily expanding number of talented investigators. Their studies have sustained UCSF's position at the forefront of arthritis research. Currently, the Center is helping to support the work of the nine leading scientists highlighted in the following pages as well as several young faculty members and fellows working under their direction. These teams are asking many of the fundamental questions that must be answered to find the causes of the group of diseases known collectively as arthritis and to develop more effective, less toxic treatments.

The Rosalind Russell Arthritis Center provides major donors an unusual opportunity to invest directly in leading edge research. With federal funding for scientific studies diminishing, the need for private support has never been greater. Your help will enable us to continue to make progress in reducing the pain and disability imposed on more than 37 million Americans by this devastating disease.

Sincerely,

Ephraim P. Engleman

Ephraim P. Engleman, M.D.

Art Director/Studio John Bielenberg/Bielenberg Design

Designer/Studio Teri Vasarhelyi/Bielenberg Design

Photographer Christopher Springman

Agency Matthew Krieger & Associates

Client/Service Rosalind Russell Medical Research Center for Arthritis, University of California, San Francisco, CA/Arthritis research

Paper Potlatch Karma Matte Bright White 80# Cover

Type Gill Sans, Times

Dimensions Brochure: 11" x 11" (27.9cm x 27.9cm)

Pages 12

Software QuarkXPress

Printing Offset

Color Process black; 2, PMS; overall dull varnish

Binding Saddle stitched

Job Length 180 hours

Initial Print Run 1,500

Cost $50,000

Concept This brochure was classy with its use of halftones and duotones on oversized 11" x 11" (27.9cm x 27.9cm) pages. It created a unified image of a highly decentralized organization and was used to persuade wealthy individuals to contribute to this nonprofit cause. For distribution, a coordinating envelope with a muted image of a hand was used on the front cover. This image was a detail from "The Holy Family" by Peter Paul Rubens and is thought to be the earliest documentation of rheumatoid arthritis.

Cost-cutting techniques Printing a support brochure at the same time and on the same stock as the main brochure saved on paper and production costs.

At The Leading Edge of Arthritis Research

The Rosalind Russell Medical Research Center for Arthritis
University of California, San Francisco

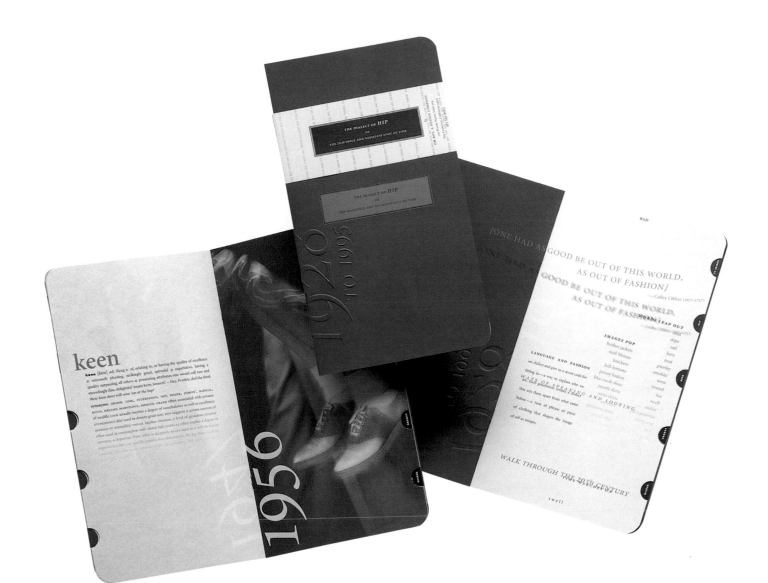

Art Directors/Studio David Salanitro, Andrea Brake/Oh Boy, A Design Co.

Designer/Studio David Salanitro/Oh Boy, A Design Co.

Photographer Sharon Beals

Client/Service Fox River Paper, Appleton, WI/Paper company

Paper Confetti Rust 80# Cover, Confetti Cream 80# Text

Dimensions 6" x 11" (15.2cm x 27.9cm)

Pages 12 plus cover

Software QuarkXPress, Adobe Photoshop, Adobe Illustrator

Printing Offset

Color Process black; 1, PMS

Binding Saddle stitched

Job Length 82 hours

Initial Print Run 30,000

Cost $40,000 (design, photo, copy: $21,320; printing: $18,680)

Concept As the winner of Fox River Paper's West Coast region award, this design studio was commissioned to design "The Dialect of Hip" for a promotion featuring winners from other regions. The most important aspect of the final design was to show interesting processes and design using Fox River Paper. To accomplish that aspect, this brochure featured opaque inks, metallic duotones, fading text, die cuts and embossing.

Special features Small emboss on the cover and perimeter die cut on the inside pages.

Beckett—Expression

Art Director/Studio Ray Mueller/Northlich, Stolle, LaWarre

Designers/Studio Lori Siebert, Lisa Ballard, Diane Gliebe/Siebert Design Assoc.

Client/Service Beckett Paper/Paper company

Paper Beckett Expression

Type Various

Dimensions 11" x 17" (27.9cm x 43.2cm)

Pages 38

Software QuarkXPress, Adobe Photoshop, Adobe Illustrator

Printing Offset

Color 4, process

Binding Perfect

Job Length 3 months

Concept To reflect the name of Beckett's paper line "Expression," this brochure began with an "X" die cut through the entire book. The theme of expression was taken further as each spread considered different emotions from apathy to greed to lust. The quality of color and graphics performed well on this paper, serving well the client's paper line, as well as providing the consumer with an oversized reference book with entertaining vignettes and illustrations.

Cost-cutting techniques When possible, existing illustrations and photography were used.

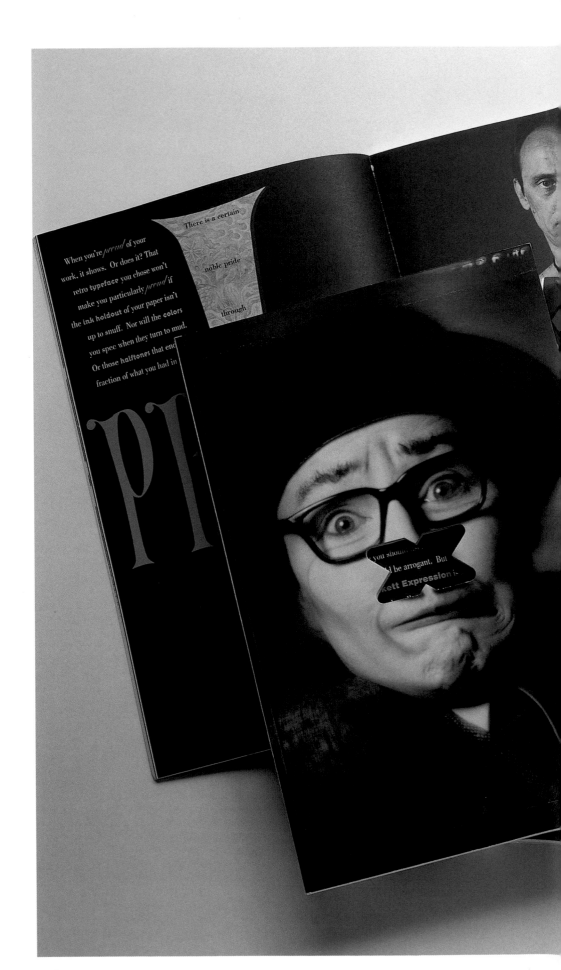

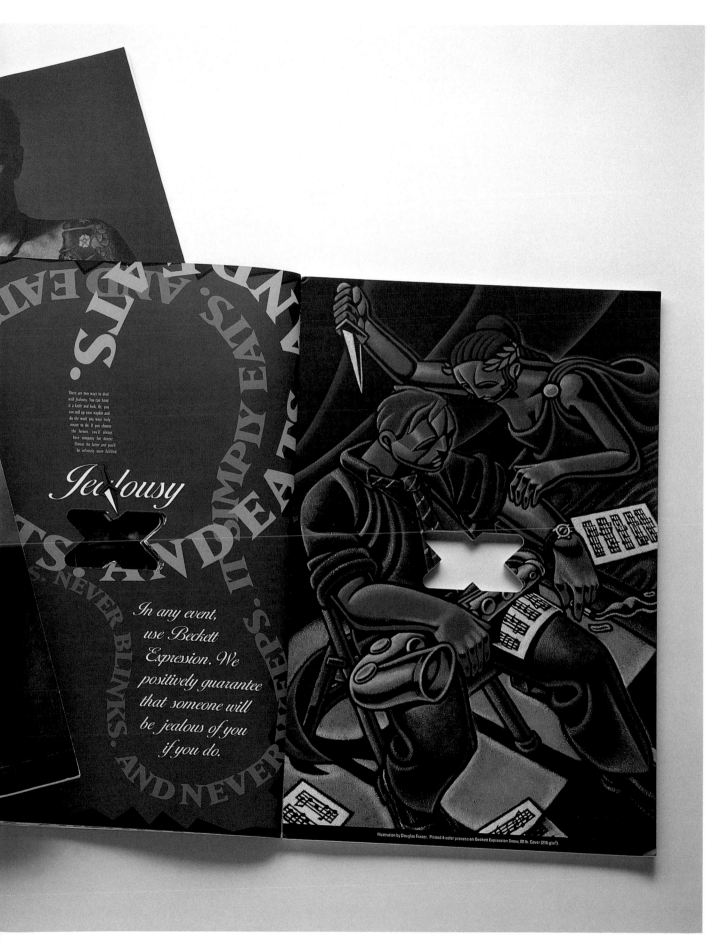

There are two ways to deal with jealousy. You can hand it a knife and fork. Or, you can roll up your napkin and do the work you were truly meant to do. If you choose the former, you'll always have company for dinner. Choose the latter and you'll be infinitely more fulfilled.

Jealousy

In any event, use Beckett Expression. We positively guarantee that someone will be jealous of you if you do.

Illustration by Douglas Fraser. Printed 4-color process on Beckett Expression Snow, 80 lb. Cover (216 g/m²).

QCP-800 Brochure

Art Director/Studio Jeff M. Labbe/Jeff M. Labbe Design Co.

Designers/Studio Jeff M. Labbe, Marilyn Louthan/Jeff M. Labbe Design Co.

Illustrator/Studio Charles Spencer/Anderson Design Co.

Photographer Kimball Hall Photography

Writers Eric Springer, Ed Crayton

Client/Service Qualcomm Inc., San Diego, CA/Manufacturers of digital cellular phones and digital technology

Paper French Paper Co. Construction Safety Orange 100# Cover, Dur-O-Tone Newsprint White 80# Text, Dur-O-Tone Primer Gold 60# Text, Dur-O-Tone Newsprint 80# Cover

Type Helvetica Black, Helvetica, Boy Wide

Dimensions 4" x 6¼" (10.2cm x 15.9cm)

Software QuarkXPress, Adobe Illustrator

Printing Offset

Color 4, process

Binding Saddle stitched

Job Length 200 hours

Initial Print Run 10,000

Cost $75,000

Concept Because CDMA was first used by spies in the 1940s, the concept to illustrate analog versus digital communication developed into something with a "secret/official appeal." The reader struggled through an analog conversation by

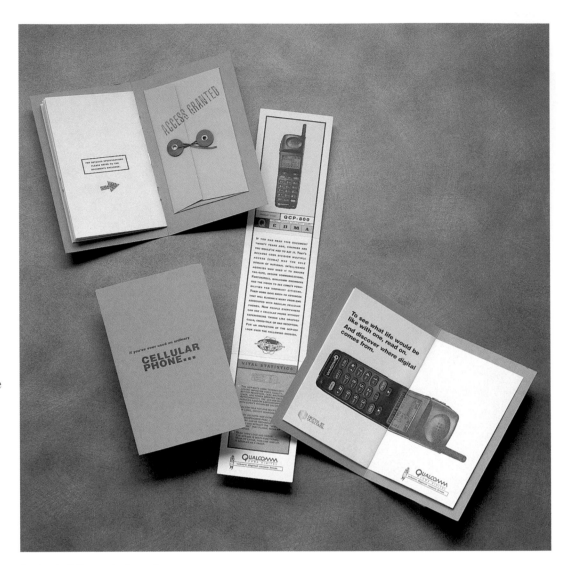

having to follow a single sentence through a number of pages. Finally on the last spread, two complete sentences and an image of a cellular phone were "awarded" to the reader. The back inside cover had a tipped-in envelope that housed a trifold mini-brochure with the specifications of the Qualcomm CDMA digital cellular phone.

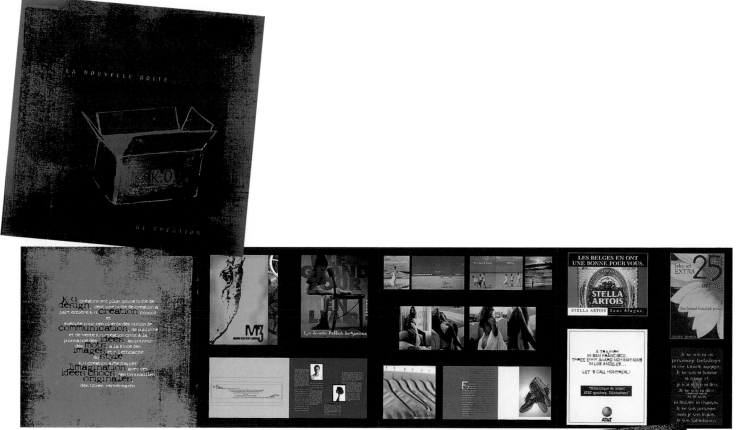

Art Directors/Studio Pol Baril, Denis Dulude/K.-O. Creation

Designers/Studio Pol Baril, Denis Dulude/K.-O. Creation

Client/Service K.-O. Creation, Montreal, Quebec/Graphic design

Paper Supreme Gloss 10 pt. (cover and sleeve), Supreme Gloss 8 pt. (text)

Type 2Rebels Deux (cover & back); Non Linear, Quatr'occhi, Milkshake (inside); all fonts from 2Rebels

Dimensions 6¾" x 6¾" (17.1cm x 17.1cm)

Pages 12 plus cover

Software QuarkXPress, Adobe Photoshop

Printing Offset

Color 4, process

Job Length 10 hours (in spare time)

Initial Print Run 750

Cost $3,400

Concept This piece served to display a sampling of the various design styles and treatments accomplished by K.-O. Creation. The overall black background served to give the piece a serious and professional feel. It also drew the viewer's attention to the sample designs. The quality of the miniature brochure images served as a gauge of the caliber of workmanship and attention to detail that K.-O. Creation provided to its projects.

Special production techniques The images on the three-panel fold inside were from different sources: some were scanned in house, some from the service bureau, others were on a CD and some were EPS files done in QuarkXPress. The designer reflected that the "preparation to

bring all the images to one mechanical took some time" and patience.

Cost-cutting techniques This brochure was printed with other pieces such as business cards to save on paper and printing costs.

directory of design firms

Only the names and addresses of individuals or studios who entered their work in this competition are included in this directory; to reach illustrators, photographers, or design studios who are listed in the project credits but who are not listed here, please contact the studio with whom they collaborated.

2Rebels
6300 Park Ave., #420
Montreal, Quebec H2V 4H8
Canada

AERIAL
58 Federal
San Francisco, CA 94107

After Hours Creative
1201 E. Jefferson B100
Phoenix, AZ 85034

The Alcorn/Fascione Studio
and Gallery
112 West Main Street
Cambridge, NY 12816

Alexander Isley Design
4 Old Mill Road
Redding, CT 06896

Automatic Art & Design
2318 N. High St., #9
Columbus, OH 43202

Bielenberg Design
2004 8th St., Suite D
Boulder, CO 80302
or
421 Tehama St.
San Francisco, CA 94103

Boom Design
444 Francisco #202
San Francisco, CA 94133

Brad Norr Design
126 N. Third St., #401
Minneapolis, MN 55401

Bradbury Design Inc.
330-1933 8th Ave.
Regina, SK SR4 1E9
Canada

Cahan & Associates
818 Brannan St., Suite 300
San Francisco, CA 94103

Canary Studios
600 Grand Ave.
Oakland, CA 94610

Charney Design
1120 Whitewater Cove
Santa Cruz, CA 95062

Clifford Selbert Design
2067 Massachusetts Ave.
Cambridge, MA 02140

Columbus Museum of Art
480 East Broad St.
Columbus, OH 43215

Copeland Hirthler
design + communications
40 Inwood Circle
Atlanta, GA 30309

David Lemley Design
2151 N. 140th St.
Seattle, WA 98133

Design: M/W
149 Wooster St.
New York, NY 10012

Ema Design Inc.
1228 15th St., Suite 301
Denver, CO 80202

Eskind Waddell
471 Richmond St. W
Toronto, Ontario M5V 1X9
Canada

Graffito/Active 8
601 N. Eutaw St.
Baltimore, MD 21201

Grafik Communications, Ltd.
1199 N. Fairfax St., 700
Alexandria, VA 22314

The Graphic Expression, Inc.
330 E. 59th St., 5th Floor
New York, NY 10022

Hal Apple Design, Inc.
1112 Ocean Dr., Suite 203
Manhattan Beach, CA 90266

Hamblin Design
635 Miguel Canyon Rd.
Watsonville, CA 95076

Hornall Anderson Design Works
1008 Western Ave., Suite 600
Seattle, WA 98104

Huddleston Malone Designs
56 Exchange Pl.
Salt Lake City, UT 84111

Jeff Labbé Design Co.
1970 Jefferson St.
San Francisco, CA 94123

K.-O. Creation
6300 Park Ave., #420
Montreal, Quebec H2V 4H8
Canada

Kiku Obata & Company
5585 Pershing Ave., Suite 240
St. Louis, MO 63112

The Kuester Group
80 S. Ninth St., Suite 300
Minneapolis, MN 55402

The Leonhardt Group
1218 3rd Ave., #620
Seattle, WA 98101

Leslie Evans Design Associates
10 Moulton St.
Portland, ME 04101

Lierman & Associates, Inc.
2105 Park Ct.
Champaign, IL 61821

Love Packaging Group
N/Plant2/Graphics Dept.
410 E. 37th
Wichita, KS 67219

Media Force
5710 Wooster Pk., Suite 320
Cincinnati, OH 45227

Michael Stanard Design
1000 Main St.
Evanston, IL 60202

Mike Salisbury Communications
2200 Amapola Ct., Suite 202
Torrance, CA 90501

Miller Brooks, Inc.
11712 N. Michigan Rd.
Zionsville, IN 46077

Milton Glaser, Inc.
207 East 32nd St.
New York, NY 10016

Modern Dog
7903 Greenwood Ave. N.
Seattle, WA 98103

Muller & Company
4739 Belleview
Kansas City, MO 64112

Nesnadny & Schwartz
10803 Magnolia Dr.
Cleveland, OH 44106

Nordensson Lynn Advertising
1926 E. Ft. Lowell Rd.
Tucson, AZ 85719

Odd's & End's
4032 Holmes St.
Kansas City, MO 64110

Oh Boy, A Design Company
539 Bryant St., Suite 304
San Francisco, CA 94107

Pensare Design Group
1510 H St. NW
Washington, DC 20005-1088

Pentagram Design
204 Fifth Ave.
New York, NY 10010

Peterson & Company
2200 N. Lamar St., Suite 310
Dallas, TX 75202

Pinkhaus
2424 S. Dixie Hwy.
Miami, FL 33133

plus design inc.
25 Drydock Ave.
Boston, MA 02210

Purdue University Office
of Publications
279 Little St.
West Lafayette, IN 47906

Rick Eiber Design (RED)
31014 SE 58th St.
Preston, WA 98050

Sayles Graphic Design
308 Eighth St.
Des Moines, IA 50309

Segura Inc.
1110 N. Milwaukee Ave.
Chicago, IL 60622

Siebert Design Associates
1600 Sycamore
Cincinnati, OH 45210

Sommese Design
481 Glenn Rd.
State College, PA 16803

Square One Design Inc.
970 Monroe NW
Grand Rapids, MI 49503

Stamats Communication Inc.
427 6th Ave. SE
Cedar Rapids, IA 52406

Brett Stiles
2504 Rockingham Dr.
Austin, TX 78704

Studio: MD
1512 Alaskan Way
Seattle, WA 98101

Sullivan Perkins
2811 McKinney, Suite 320 LB111
Dallas, TX 75204

Supon Design Group
1700 K St. NW, Suite 400
Washington, DC 20006

Tracy Rea & Associates, Inc.
9969 Southwind Dr.
Indianapolis, IN 46256

Vaughn Wedeen Creative
407 Rio Grande NW
Albuquerque, NM 87104

Viva Dolan
1216 Yonge St., Suite 203
Toronto, Ontario M4T 1W1
Canada

Vrontikis Design Office
2021 Pontius Ave.
Los Angeles, CA 90025

Wet Paper Bag Graphic Design
6421 Arthur Dr.
Fort Worth, TX 76134

White Design, Inc.
4510 East Pacific Coast Hwy.,
Suite 620
Long Beach, CA 90804

index of design firms

copyright notices

More Great Books
for Knock-Out Graphic Design!